W9-CGP-413

My Mississippi

My Mississippi

WILLIE MORRIS

Photographs by

DAVID RAE MORRIS

UNIVERSITY PRESS OF MISSISSIPPI / JACKSON

Publication of this book was made possible in part by the Phil Hardin Foundation

www.upress.state.ms.us

Copyright © 2000 by University Press of Mississippi
Text copyright © 2000 by David Rae Morris and JoAnne Prichard Morris
Photographs and Photographer's Note copyright © 2000 by David Rae Morris
All rights reserved
Designed by John A. Langston

Manufactured in the United States of America

04 03 02 01 4 3

Library of Congress Cataloging-in-Publication Data

Morris, Willie.
My Mississippi / Willie Morris ; photographs by David Rae Morris.
p. cm.
ISBN 1-57806-193-8 (cloth: alk. paper).—ISBN 1-57806-309-4 (ltd.ed.: alk. paper)
1. Mississippi—Description and travel. 2. Mississippi—Pictorial works.
3. Mississippi—Social life and customs—20th century.
I. Morris, David Rae. II Title.
F345 .M67 2000
976.2'063'0222—dc21
00-034942

British Library Cataloging-in-Publication Data available

To William and Elise Winter,
distinguished Americans, courageous Mississippians, and unfailing friends
AND
To Jane Ellen McAllister, who taught patience and perseverance;
Jerry, whose inspiration moved many so brightly;
and Susanne, whose spirit embodies love and courage

CONTENTS

PUBLISHER'S NOTE

Our first conversation regarding the book that came to be *My Mississippi* took place in September 1998. In discussing the narrative, we told Willie that readers of this book should not hear only echoes of his previous writings. True professional that he was, Willie Morris plunged into research for the book and also traveled around the state so that he could see familiar sights and terrain with fresh eyes.

Keeping to his deadline, on 17 July 1999 Willie delivered to the press the draft manuscript for *My Mississippi*. He had noted on it facts that needed to be checked and ideas and additional subjects that he wanted to develop. Willie and his editor were to meet on 3 August to discuss the final editing. Unfortunately he died on 2 August.

The manuscript that Willie Morris completed has been edited and the facts that he wanted verified have been checked. Everything that he noted for development, of course, has been left as is. Thus while *My Mississippi* is very much Willie Morris's book, it is not the one that would have been published had he been alive.

The press thanks the following persons who worked to prepare the manuscript for publication: Carol Cox, Clarence Hunter, Jo G. Prichard, Peyton Prospere, Ginger Tucker, Ruth Williams, Chrissy Wilson, and, above all, JoAnne Prichard Morris.

INTRODUCTION

One evening not long ago a small group of us Mississippians met at Nick's restaurant in Jackson with a distinguished gentleman from Hollywood. For years the visitor had produced the annual Academy Awards ceremonies for national television, and now he was doing research for a documentary film on contemporary Mississippi, which would be shown several months hence at the Kennedy Center in Washington, D.C. Our gathering included a former governor, a veteran award-winning journalist, a writer, a book publisher, a historian, a schoolteacher, and a doctor who had served as chairman of the board of the Institutions of Higher Learning longer than anyone in history.

The man had never before been in the state; his questions were intelligent, curious, and rudimentary. What were the realities of present-day Mississippi? What were the most vital concerns of its citizens? How did people live? How did they treat each other? Had the state changed? What would it be like as it entered the twenty-first century?

The responses were Mississippi to the core: spirited, ironic, passionate. Yet all of us there acknowledged in our deepest beings, and this could be discerned from the lengthy pauses and bemused mutual glances, that it was singularly arduous to explain Mississippi, not merely to a sojourner but indeed to ourselves, for the simple reason that much of it is so tacit and elusive and stubborn and mysterious. "We all love Mississippi," the historian said that evening, "but sometimes she does not love us back." He was suggesting, rightly I believe, that she is a most difficult and capricious mistress.

Her poet and chronicler William Faulkner said, "To understand the world, you have to understand a place like Mississippi." At the juncture of the new millennium, contrasts and contradictions still abound in our society as never before. We call it "the Hospitality State," but it is best known nationally for its racism, poverty, and mistrust of outsiders. It is at or near the extremes on most social and economic scales, from infant mortality and teenage pregnancy to support for education and per capita income. No less a neutral eminence than the *Encyclopaedia Britannica* puts this in stark terms which leap from the page and cannot be easily ignored:

Education, health, welfare, and other measurements of the quality of life in Mississippi necessarily must be considered in the perspective of the state's long history of segregation and racial discrimination. The high infant mortality and illiteracy rates, low educational achievement scores, and welfare dependency are linked to a century of poverty, injustice, discrimination, and a resistance to modernization that has impeded the development of the state's natural and human resources.

Eudora Welty, who took her memorable photographs while traveling Mississippi as an employee with the Works Progress Administration in the 1930s, remembers: "The Depression was not a noticeable phenomenon in the poorest state in the Union."

A place whose people are often obsessed with the past, Mississippi is considered by many Americans to be regressive, even uncivilized, with an unyielding white majority, smaller than it was but still in control,

which apparently does not care for meaningful economic and human improvement that might move it up from the bottom and continues to elect people who keep it that way. In 1964, the world-renowned Cambridge University historian D. W. Brogan, the ranking English expert on the United States, described the state as "the most savage and backward of the fifty American commonwealths." Perhaps, given all this, it may be that one of the most positive characteristics of the state can be found in the resilience of its people.

Yet, Mississippi continually contributes many of the nation's most progressive and creative individuals and ideas in fields ranging from literature and the arts to communications, space technology, medicine, and athletics: "first per capita in talent and imagination," I sometimes like to say. Predominately rural and agricultural, it is also home to pioneering high-tech industries. Its people have a long and well-known history of rebellion, divisiveness, and oppression, yet Mississippians from all walks of life and of all political opinions, races, and ethnic backgrounds have an unsurpassing love for and dedication to their native soil. It is a complex and contradictory state that is also a place of great and enduring beauty. Physically beautiful in the most fundamental and indwelling way, it never leaves you. The martyred civil rights leader Medgar Evers once said, "I love Mississippi. I choose not to live anywhere else. I don't know if I'm going to heaven or hell, but I'm going from Jackson." To be a native Mississippian, the scholar Maryemma Graham has written, "is to be confronted with the desire to both celebrate and condemn one's heritage, to explain and to expose the inadequacies and imperfections, while at the same time clinging to the native soil. . . . Perhaps no other heritage in this country is as distinctly a part of all of us as this one is." Margaret Walker Alexander, the cosmopolitan black novelist, poet, and professor at Jackson State University who died in 1998, wrote, "I believe that despite the terrible racist image Mississippi has had in the past, despite her historic reputation for political demagoguery, despite racial violence and especially lynching, despite all the statistics about being on the bottom, Mississippi, and especially urban Mississippi,

offers a better life for most black people than any other state in which I have lived or visited."

When I was beginning work on this book, there was an affecting moment on the national television show *Larry King Live.* The host was interviewing the legendary NFL Hall of Fame Chicago Bears running back Walter Payton of Columbia, Mississippi, and Jackson State University. He had just been diagnosed with a rare liver disease. A call came in from Jackson, obviously a white man, who told Payton that the thoughts and prayers of the entire city were with him and that his illness had stirred renewed interest in organ donations throughout Mississippi. The camera was on Walter, who was so moved he could not respond except by crying. After a moment of poignant silence Larry King said, "That's home," and Walter repeated through his tears, *"That's home."*

Bill Minor, dean of the state's newspaper writers and winner of the first annual John Chancellor Award for Journalistic Excellence, came to Mississippi in 1948 from Louisiana. "There is a weird pulling power about this state," he has observed. "Many people I've known have left and come back. I don't know what it is. It is a very strange place, Mississippi." A professional pollster retained by the Jackson *Clarion-Ledger*, the state's most widely read newspaper, reported that he had never seen anything like it. "I've never been anywhere," he said, "where people identified themselves more with their state." On an extended visit in 1994 the Russian writer Sergei Chakovsky suggested that sometimes a place's identity must be glimpsed indirectly. "You cannot understand Russia with reason," he said, and considered the same was likely true of Mississippi. "Mississippians are like Russians in that they take time out to be human." I knew a black South African student at the University of Mississippi whom the University of Moscow had courted before he decided to come here. "When I first came I was afraid I'd made a big mistake," he told me. "But Mississippi grows on you. It seems so removed, but it's vividly real. I'll miss it when I go home. I don't understand why your national media wants a uniform U.S.A."

Hollywood screenwriter Lewis Colick came here for several weeks in 1995 to research his script for di-

rector Rob Reiner's *Ghosts of Mississippi*, a movie about the final prosecution of Byron De La Beckwith thirty years after he assassinated Medgar Evers. Colick told me he had been frightened witless of coming to Mississippi. Then, against all expectations, this native of Coney Island in Brooklyn became enigmatically drawn to the place, its land and people and spirit. "I grew very quickly to absolutely adore Mississippi and to look forward to every visit. The burden of its past is almost like the landscape, the twisted magnolias and the cypress trees that grow out of the Natchez Trace. From the Old Capitol building during the Civil War to the Sun-n-Sand Motel in the 1960s—these buildings have borne witness to incredible events. Mississippi is still wrestling with very deep things. It's beguiling to be around people who've been shaped and molded and defined by where they live." Then he added, "Brooklyn is probably as legendary as Mississippi. We breed crazy characters, too. I discovered something of my childhood in Mississippi."

There are inchoate things that bind a people to a place, no matter where they are. On a recent trip to Los Angeles, my wife, JoAnne, and I were having lunch in the commissary of Universal Studios with Hollywood producers Larry and Charles Gordon (*Field of Dreams, Die Hard, Brian's Song, October Sky*). JoAnne grew up in Indianola, I in Yazoo City, and the Gordons in Belzoni—Delta towns within a forty-mile radius. So, as starlets paid deference now and again to the table, the talk was not of movies, not of writing, not of publishing, but of home: of people we knew, of things we did, of old events and habitudes and circumstances we had in common. Larry Gordon reached into his pocket and withdrew a program of the 1953 high school football game between Belzoni and Yazoo City. Among the four of us we knew almost everyone on both rosters, as well as the cheerleaders and majorettes. We talked of Buckwheat Wade, the tenacious 270-pound Belzoni tackle. I had not heard the name Buckwheat Wade in forty years and had to travel to Hollywood to remember him anew. The aura of all this was surely not dissimilar to that of the annual Mississippi Picnic in New York City's Central Park, celebrated now every June for twenty-five years, faithfully attended by white and black Mississippians—many of them luminaries in the theater, journalism, television, publishing, music, finance, and design—residing in Gotham and going to the picnic for the storytelling and memories.

Between 1890 and 1970, more people departed the state than came in. In 1970 more than 1.5 million native Mississippians were living elsewhere, exiles almost in the European sense. But by the 1970s this out-migration had mostly come to a halt. Not only that, but many people of both races were coming home. In a big spread under the title "South Toward Home" in 1997, *Newsweek* reported that the reverse migration of middle-class African Americans back to the South, including Mississippi, was up 92 percent over the 1980s and that "a net tide of 2.7 million—more than half of the post-1940 migration—will have headed South between 1975 and 2010."

In the late twentieth century all the accumulating efficacy of technology and mass communications is more and more creating an adherence to a national culture in the state, which has its positive qualities but leaves many with a fear of destructive homogenization. Mississippi, as, God help us, we all know, has often given itself to extremes, and through the years two of the most singular ones have been the desire, on the one hand, to dwell forever with all the myths and trimmings of a vanished culture which may never have truly existed in the first place, certainly not the way we wished it to, and the frantic compulsion, on the other, to reforge ourselves as an appendage of the capitalistic, go-getting, entrepreneurial North. The quest for the Yankee dollar, in the pejorative sense, has never been far from the better side of ourselves. Between these two extremes there have been complex lights and shadings, and considerable ambivalence and suffering. Mississippians watch the same television programs as other Americans, frequent the same shopping malls and national franchise chain stores and fast-food establishments, and live in the same kinds of suburbias.

When I was growing up, the closest thing Yazoo City had to suburbia was the hamlet called Little Yazoo, nestled in the undulating kudzu-infested hills on

old Highway 49, consisting of a general store which never had anything you needed, a bootlegger in the back of a dilapidated garage, a Negro undertaker who was the richest man in town, and a precarious unpainted establishment with a sign in front saying: "Roaches, minnows, worms, and hot dogs." But now suburbia is commonplace throughout the state. Between 1990 and 1998 the three fastest-growing counties in Mississippi were Rankin, Madison, and De-Soto—the first two as suburbs of Jackson, the third of Memphis—as the transplants sought less crime, better schools, and more open space. That, too, is part of this story.

It has been obvious that since the watershed 1960s Mississippi has involved itself in trying to reshape some of the more egregious social and economic realities of its dire and influential past. (In response to pressure from civil rights activists, federal legislation and court decisions have been central to many of the salubrious changes involving race, and not a few white Mississippians have been in the vanguard of these reforms.) Yet, in spite of these efforts, a pristine truth emerges unswervingly time and again and is there for all to see: in comparison with the rest of the nation, Mississippi's people do not fare well. However, I find hope for the future, for the promise of Mississippi reaching its true potential, in one vital statistic: at the beginning of the new century, the state ranks seventh in the country in population under the age of eighteen.

V. O. Key, in his classic *Southern Politics in State and Nation*, addressed race as being the defining actuality in Mississippi public affairs and hence in any significant hope for enlightened development. Some have cited the elimination of the race factor as being crucial to the social and economic advancement of the state. But it could well be that at the new millennium *class* is the more quintessential reality hampering the human amelioration of the commonweal. There is no denying that modern-day Mississippi shares a number of characteristics with Third World countries: its dependence on the federal government to sustain its economy, its reliance on land and land products for its major income, its catastrophic class divisions, its poor education and health services for a large portion of its population.

In the present day it is Mississippi's juxtapositions, emotional and in remembrance, and the tensions of its paradoxes that still drive us crazy. Faulkner understood how deeply we care for it despite what it was and is—the gulf between its manners and morals, the apposition of its kindness and violence. There is something that profoundly matters in a place which elicits in its sons and daughters, wherever they live, such emotions of fidelity and rage and passion. I myself have often felt a strong similarity with Ireland—in the spoken and written language, the telling of tales, the link with generations gone, the mischief and eccentricity of the imagination, the guilts and blunderings and impetuosities, the religiosity at the base of things, the admiration of the hoax and of brawny drink, the love of music, the relish of company and of idiosyncrasy for its own sake, the radiance and fire in the midst of impoverishment. Its people of all races and ethnic and economic backgrounds continue to have an abiding awareness of group identity rooted in a shared history and culture, ritual and custom. In his *Mind of the South*, published in 1941, W. J. Cash described the South as "not quite a nation within a nation, but the next thing to it." That was particularly true of Mississippi then, and I believe this indigenous essence still lingers.

In my work on this book certain ironies never failed to tease me. The poorest state in the union produced the man who was the originator of the Marshall Plan (William Lockhart Clayton), which saved Europe economically after the devastation of World War II; it even lays claim to the man who invented the dollar sign ($) and to the later migrant who had been the largest single financial contributor to the American War of Independence. The town of Marks, in the Delta, where Martin Luther King, Jr., near the end of his life wept openly at the wrenching scenes of poverty he saw there, is also the town which produced Fred Smith, founder and CEO of Federal Express. Rich as it is in literary tradition, Mississippi ranks fiftieth in the nation in literacy and in support of public libraries. Bilious society that it has always

been, it has designated milk as its official beverage. At or near the bottom in financial support of education, it was the birthplace of the Parent-Teacher Association (Crystal Springs in 1909) and of Parents for Public Schools, an organization founded in Jackson in 1989 that now has more than fifty local chapters across the country.

Assessing the U.S. Senate in 1939, *Life* magazine rated one of Mississippi's senators, Pat Harrison, as the best, most capable and admired member of that body, and the other, Theodore G. Bilbo, as the worst. Ranking forty-ninth nationally in physicians (and fiftieth in dentists), it has been home to some of the most daring medical advances, including the world's first heart and lung transplants, and one of its honored citizens, Arthur Guyton, is considered the foremost physiologist in the nation. Ranked first in households with no telephones and first in those without home computers and Internet access, it is the site of remarkable inroads in modern communication technology. Noted in the economic order for its high national rankings in cotton, catfish, and soybean production, not to mention broilers and eggs and the planting of trees, and coming up strong on cabbages and blueberries, it builds the most sophisticated ships in the long and storied annals of the United States Navy. Boasting more black representatives than any other state legislature, not until 1995 did it finally ratify the Thirteenth Amendment abolishing slavery.

Pietistic in its ritualized mores, it tolerates—indeed, *encourages*—some of the most colorful eccentrics and dissenters and hedonists to be found anywhere, and with this comes a crafty and artful sense of sin that in my lifetime has not noticeably softened, for fundamentalism still makes sinning more forbidden and hence more pleasurable. Mississippi is recognized for the vocal "family values" orientation of its most active conservatives, and, in the final decade of the century, the populace twice elected a governor perfervidly rhetorical in his fealty to such principles; the man was then embarrassingly covered in the state, national, and international media for his public unfaithfulness to his immensely popular wife of forty-five years and for the threats he made to a questioning TV reporter. First per capita among the states in the number of churches, in the 1990s it was likewise first in the construction of gambling casinos and second only to Nevada in gambling revenues. Cruel and savage as the history of its state penitentiary at Parchman has been, in 1975 Mississippi was the only state that allowed conjugal visits for married prisoners and provided cottages for those meetings. Cited as fiftieth in the United States in the amount of income taxes paid annually, it is first per capita in receiving federal subsidies for welfare, health, education, and related programs. Known as the first state to grant property rights to women (in 1837), a hundred and fifty years later it was written off early by the national women's movement as being an impossible place for passage of the Equal Rights Amendment. Eager for outside tourism and incoming Yankee spending, it named the gigantic Ross Barnett Reservoir (a sportsman's paradise adjacent to the capital city) after one of the most unabashedly race-baiting politicians of the twentieth century. And where else under legislative mandate are the birthdays of both Robert E. Lee and Martin Luther King, Jr., celebrated as an official holiday on the very same day each year?

Given the snarled confluence of its past and present, there is much in Mississippi in the year 2000 that can be likened to the artistic effect called pentimento. To quote Lillian Hellman, who wrote a book by that name, "Old paint on canvas, as it ages, sometimes becomes transparent. When that happens it is possible, in some pictures, to see original lines: a tree will show through a woman's dress, a child makes way for a dog, a large boat is no longer on the open sea." So everywhere beneath the palpably new Mississippi are the lingering reminders. Until recently, on the Hinds County Courthouse restroom door bearing the sign "Women," one could make out beneath the coat of paint the words "Colored Women." Beside towering office buildings and brutal concrete parking garages can be found vintage commercial structures hardly disturbed since the 1930s. Rivers are crossed by old rusty iron bridges mere yards from

substantial contemporary ones. Slivers of the original Highway 61 run parallel to the new one through deserted fields, without rhyme or reason. One summer forenoon not far from the cotton hamlet of Holly Bluff in western Yazoo County, I discovered quite by chance a spectral sight: right on top of a small Indian mound there was a modest cemetery for white people, a combination of weathered stones and newer ones. Much the same often holds true with human habitudes.

Mississippi historian David Sansing speaks of the "two souls, two hearts, two minds" of the state. There has always been what he calls the *other* Mississippi, the Mississippi not of illiteracy but of literary tradition, not of ignominy but of nobility, not of nihilism and injustice but of enlightenment and humanity. The values of the older community and the American dream were often very much alike. I myself have known Mississippi well over the last many years, both from the perspective of one who has lived in Europe and the American East and from deeply within. Why is it one of the unique places of America? How has it changed and how has it not changed? What does it wish of itself? Where has it come from and where is it going?

It has been a pleasure—more than that, an honor—to collaborate with my son, David Rae Morris, on this project. It is highly gratifying to work with someone you have known from the time he was five seconds old. Ever since his elementary school days, as I remember it, he has had a camera in his hand.

I am a seventh-generation Mississippian, which makes David Rae an eighth-generation one. He grew up in New York City and attended college in Massachusetts, but his first job was with the *Scott County Times* in Forest, Mississippi. Since then it has been his choice—or is it his fate?—to follow the Mississippi River itself in choosing his domiciles: Greenville, Mississippi; Vicksburg, Mississippi; Minneapolis; and now New Orleans, where he lives in an old house only two blocks or so from the river. On the sesquicentennial of our family village—Raymond, Mississippi—we dedicated a plaque to my great-grandfather (David's *great-great*) Major George W. Harper, writer and editor, town mayor and state legislator, and then gave talks on the occasion before a large crowd in the cemetery. My son prefaced his remarks by confessing that since he grew up in New York he was "one-half Yankee." When he had finished, the president of the Hinds County United Daughters of the Confederacy, who was sitting with us on the podium, patted David on the knee and said, "Young man, it's not *your* fault that you're one-half Yankee."

That perspective, I think, only enhanced the pursuit of his images. We agreed at the beginning that my words and his photographs should not be specifically connected, but rather complementary. I remember from our peregrinations around Mississippi the bugs on our windshield in the Delta springtime, the off-key echoes of high-school bands from the little Piney Woods football fields in the autumn, the supple twilights and sultry breezes on the coast, the hunting camps and picnics, the parades and pilgrimages, the catfish ponds and graveyards, the roadhouses and joints near the closing hour, the art galleries and concert halls, the riverboat casinos and courthouse squares, the historical landmarks of the old and industrial complexes of the new. In the words of the old Texas cowboy about his pal, David Rae Morris is a good man to ride the river with.

My Mississippi

THE LAND AND
A SENSE OF PLACE

It is the very power of this land that makes you both love and fear it.
It is what I am, and always will be till I die.

—THE GHOSTS OF MEDGAR EVERS

LET US BEGIN WITH THE LAND.

It was in its prehistory implacable, brooding, and unyielding, and most of it remains so to this day. Like many southern writers, I believe that the special quality of the land itself indelibly shapes the human beings who dwell upon it.

Mississippi occupies $\frac{1}{4,198}$ of the total surface of the earth, just a tiny fraction of the planet, which is itself only a minuscule part of the universe. The state consists of 46,865 square miles, being 180 miles across at its widest point and 330 at its longest. It is thirty-first in size among the fifty American commonwealths and ranks thirty-fourth in population. It became a state in 1817, the twentieth admitted to the union. Its population is 2.7 million, and the median age of its people is 33.4 years, 1.8 below the national average. Thirty-six and one-tenth percent of its citizenry are African American, the largest percentage of any state. Of its eighty-two counties, twenty-two have a black majority. In the census of 1940, the state as a whole was slightly more than 50 percent black, the only black-majority state remaining at the time, and the decline in black population since then is testimony to the out-migration that lasted until the 1970s. To comprehend Mississippi, the outlander and the native alike must recognize that this is still an emphatically white/black society, and that its white people and black people are deeply bound together—and, together, to the land.

Its purlieu is principally one of forests, which cover more than half the state, agricultural fields, and small towns. Metropolitan areas and factory complexes definitely take a second place. There are only seven cities with populations of more than thirty thousand. The state's most populous metropolitan vicinities are Jackson, Gulfport-Biloxi, and Pascagoula. Its most dramatic population increases in the 1990s were on the Gulf Coast, in the northwest corner of the state near Memphis, and in the counties surrounding Jackson; its most pronounced population decline was in the Delta. There are 12 acres for every person and 55.3 persons per square mile, which compares to the national average of 7.2 acres and 75.7 persons. Stretches of land exist where you see few people; the expansive horizons and the dearth of movement on the roads once prompted visiting writer William Styron to remark how much it reminded him of the countrysides of Poland and Russia, and visiting Russians likewise comment on how the powerful, unpeopled landscape reminds them of home. This perception of empty space is enhanced by six substantial national forests encompassing 1,155,518 acres of federal land, the largest holdings of public land in the state, as well as by three areas in the National Park System, twenty-eight state parks, and six reservoirs for flood control and recreation. Travelers have ranked the state first in the nation in environmental air quality.

Mississippi has four interstate highways connecting it to the nation at large: I-55 from the Louisiana to the Tennessee line at Memphis; I-59 from the southernmost Piney Woods town of Picayune to the Alabama border east of Meridian; I-20, which cuts on a direct west-east axis across the center of the state from Vicksburg to Meridian and beyond to the Alabama boundary; and I-10 in south Mississippi, which runs parallel to the coastline of the Gulf of Mexico. (The magnificently bucolic Natchez Trace runs from Natchez all the way to the extreme northeast of the state, and eventually to Nashville, but that glorious road is nothing like an interstate.) Once you leave an interstate, you are quickly in a genuine countryside of small villages, open distances, and

sparse populations, and that, as the song says, is what I like about the South.

The Tennessee-Tombigbee Waterway, known here as the "Tenn-Tom," with its intricate system of locks, connects the Gulf Coast to the Tennessee River in northeast Mississippi, a 235-mile-long inland water route utilizing the existing channel of the Tombigbee River. According to the compendious *Encyclopedia of Southern Culture* produced by the Center for the Study of Southern Culture at the University of Mississippi, the Tenn-Tom required the removal of two times more cubic yards of earth than the excavation for the Panama Canal, making it the largest earth excavation project in world history. It was a volatile undertaking, its antagonists charging that it was Deep South political pork barrel and environmentalists that it was destructive of the ecology, but on its completion in 1984 it linked fifteen states along thousands of miles of inland waterways. The Tenn-Tom also draws pleasure boats, water-skiers, and bass, bream, crappie, and catfish fishermen.

Water is everywhere—rivers, oxbows, lakes, bayous, creeks, ponds, swamps, and latter-day man-made catfish ponds. Need one be reminded that this was where life itself began—in the waters of sloughs, rivers, and creeks? Indeed, eons ago even in geological time the Gulf of Mexico covered more than one-fifth of today's Mississippi. The Petrified Forest outside of Flora in Madison County, the largest collection of trees petrified east of the Mississippi, is stark testimony to the tumultuous prehistoric streams that swept into this region as early as the Pleistocene period. Our state is laced with deep rivers running north to south, enveloped by mossy swamps and verdant woodlands.

The Almighty has been benevolent in regard to climate, providing a lengthy growing season, relatively agreeable subtropical weather, and adequate (perhaps at times *more* than adequate) rainfall. The normal annual mean temperature is sixty-two degrees; only Florida, Texas, and Louisiana have higher averages in the United States. The price we Mississippians pay for our moderate winters comes in the often torrid summers and oppressive humidity. And, as

in its human affairs, the state's meteorological composition can be one of palpitant extremes—inundating rainfalls, floods, hurricanes, gales and high winds, and tornadoes, which always seem to seek out house trailer settlements. In midwinter it can be thirty degrees one day and seventy the next. The highest recorded temperature was 115 degrees at Holly Springs in 1930, the lowest 19 below zero at Corinth in 1966.

There is a languor to our Novembers, when the foliage is profound and varied and the landscape is suffused with a poignant patina of golden warmth. During the rare snowfalls you can observe the wild frolic of young children who have never seen snow and the dogs trying to bite the descending flakes. Destructive ice storms are not out of the ordinary. An exhilarating, perfumed Mississippi springtime is forever a song in the heart, and those long-ago childhood nights when we "played out" in its warm and fragrant shadows are among my own finest memories. "I saw sixteen shades of green between Mathiston and Jackson today," the homegrown painter William Dunlap once commented after taking a drive one April morning.

"In the beginning it was virgin—" Faulkner observed in "Mississippi," the only nonfiction piece he ever wrote on his state, "to the west, along the Big River, the alluvial swamps threaded by black almost motionless bayous and impenetrable with cane and buckvine and cypress and ash and oak and gum; to the east, the hardwood ridges and the prairies where the Appalachian mountains died and buffalo grazed; to the south, the pine barrens and the moss-hung live oaks and the greater swamps less of earth than water and lurking with alligators and water moccasins where Louisiana in its time would begin."

Geologists have classified the state's six distinct major areas into lowlands, piney woods, hills, plains, and prairies: the Delta in the northwest, the rich alluvial crescent formed in the old floodplain of the Mississippi and Yazoo rivers; the Piney Woods of south Mississippi; the Gulf Coast; the Black Prairie; the Loess Hills–Central Hills; and the hilly, almost mountainous extreme northeast, the Tennessee River Hills.

To that I myself would add as a matter of history and culture the "Old Natchez District" from Vicksburg south through Port Gibson, Natchez, and Woodville to the Louisiana line, physically part of the Loess Hills. David Rae and I have tarried in each of these neighborhoods, discovering in our perambulations that differences not merely in physiography but in custom and personality continue to exist in considerable lucidity as we enter a new millennium.

The wonderful *WPA Guide to Mississippi*, published in 1938, is still a fine joy to peruse and follow, and there are elementary things in it that will never alter, mainly those pertaining to the everlasting land itself, but, at the turn of the century, it is inevitably a little frayed and dated and quaint and paternalistic.

Were a person to ask, "What is Mississippi?" he undoubtedly would be told, "It is a farming state where nearly everyone who may vote votes the Democratic ticket," or "It is a place where half the population is Negro and the remainder is Anglo-Saxon," or, more vaguely, "That is where everybody grows cotton on land which only a few of them own." And these answers, in themselves, would be correct, though their connotations would be wrong. For while the white people of Mississippi are mostly Democrats, Anglo-Saxons, and farmers, they are not one big family of Democratic and Anglo-Saxon farmers. Rather, Mississippi is a large community of people whose culture is made different by the very land that affords them a common bond. The people of the Black Prairie Belt, for instance, are as different culturally from the people of the Piney Woods as are the Deltans from the people of the Tennessee River Hills. Yet for the most part they all farm for a living, vote the Democratic ticket, and trace their ancestry back to the British Isles.

This is a land of ghosts: the vanished Indians. In 1540, when the rapacious Hernando de Soto traversed the almost impenetrable jungle of what would later be north Mississippi, the region was already populated by ancestors of the Chickasaw; add to that the Choctaw and Natchez and the smaller tribes, Yazoo, Choula, Algonquin, Tunica, Biloxi, Sacchuma, Alimamu, and Pascagoula. They worshiped the sun

and the sacred fires and, like a few contemporary Mississippians, believed in spirits. Then the Spaniards, greedy incubuses as they were, passed along the diseases of their animals to the natives, who had no immunity and died in ghastly epidemics. The Natchez were driven off by the French, and the Chickasaws and Choctaws were forcibly removed in the 1830s to the Oklahoma Territory and beyond. Miraculously, some six thousand Choctaws still remain in the state, on a reservation in Neshoba County, which now quarters a prodigious gambling casino replete with hotel, thirty-six-hole golf course, spa, six restaurants, and eight bars.

Otherwise, that faraway time lingers in the Indian names of the towns, mainly the small ones, and rivers and counties: Yazoo ("river of the dead"), Biloxi ("first people"), Tallahatchie ("rock river"), Tishomingo ("warrior chief"), Yalobusha ("tadpoles abounding"), Panola ("cotton"), Tunica ("little people"), Satartia ("pumpkin patch"), Noxubee ("stinking water"), Coahoma ("red panther"), Amite ("friendly river"), Iuka ("place of bathing"), Tchula ("fox"), Hiwannee ("caterpillar"), Conehatta ("white polecat"), Natchez ("to break off from"), Byhalia ("white oak tree"), Nanih Waiya ("slanting hill"), Hushpuckena ("little sunflower"), Ofahoma ("red dog"), Tupelo ("make a noise"), Neshoba ("wolf"), Okolona ("people gathered together"), Itta Bena ("home in the woods"), Winona ("first-born daughter"), Issaquena ("deer branch"), Senatobia ("rest to the weary"), Shuqualak ("hog wallow"), Tougaloo ("where the three creeks meet"), Wantubbee ("off-hand killer"), Osyka ("the eagle"), Bogue Chitto ("big river"), Yockanookany ("catfish land"), Coila ("little panther"), Pontotoc ("weed prairie")—and on and on in the mysterious, lost euphonious litany.

As children we came to the spooky old Indian mounds in search of arrowheads and earthen fragments of pottery. In the Delta flatness the mounds are the only rises, resembling miniature grassy hills. A substantial group of them, at the Winterville site on Highway 1 north of Greenville, includes a fifty-five-foot temple mound. Emerald Mound, not far from Natchez and the second-largest Indian mound in the

United States, dating from between A.D. 1250 and 1600 and covering eight acres, is like an elongated pentagon, with an oval-based temple at one end. Not far from Noxapater in east central Mississippi, Nanih Waiya, the sacred mound of the Choctaws, was their nucleus of life before the white settlers arrived. The Indians called it "Great Mother" and considered it the birthplace of their entire race; before the coming of the white man it was a large, fortified city from which the Choctaw nation was governed by its wise men. In Yazoo County, near Holly Bluff, where the Yazoo and Sunflower rivers run their course from the upper Delta and come close together, are the remnants of a highly advanced Indian settlement occupied continuously from at least 700 B.C. to A.D. 1600. Many mounds are here, including a huge central one, a forested promontory rising out of the cotton fields, where on stormy winter nights locals claim to hear ephemeral shouts and wails.

There were shifting sovereignties in ownership brought on by the often arcane Old World treaties. Faulkner describes how for a brief and evanescent time the native people here

had the privilege of watching an ebb-flux of alien nationalities as rapid as the magicians spill and vanishment of inconstant cards: the Frenchmen for a second, then the Spaniard for perhaps two, then the Frenchmen for another two and then the Spaniard again and then the Frenchmen again for that last half-breath before the Anglo-Saxon, who would come to stay, to endure: the tall man roaring with Protestant scriptures and boiled whiskey, Bible and jug in one hand and like as not an Indian tomahawk in the other, brawling, turbulent, usurious, and polygamous. . . . He endured, even after he too was obsolete, the younger sons of Virginia and Carolina planters coming to replace him in wagons laden with slaves and indigo seedlings over the very roads he had hacked out with little else but the tomahawk. Then someone gave a Natchez doctor a Mexican cotton seed . . . and changed the whole face of Mississippi.

"With us when you speak of 'the river,'" William Alexander Percy wrote in *Lanterns on the Levee*, "though there are many, you mean always the same

one, the great river, the shifting unappeasable god of the country, feared and loved, the Mississippi."

There is considerable ambiguity about where in 1541 de Soto actually "discovered" it. Several river landings from Rosedale to not far south of Memphis have at one time or another claimed the honor. In 1938, no less than an official presidential commission gravely concluded that the Father of Waters was first sighted by the Spaniard at Sunflower Landing near Rosedale, but this has been garrulously disputed. I once had an irascible friend, the son of a Delta planter, who after several brawny drinks at a Red Tops high school dance in Belzoni declared that de Soto first saw the river from a certain spot on his father's land around Friars Point; he was sure of this because he had recently found a rusty belt buckle under a cistern with the initials "H. de S." on it. I was not convinced. Never mind. The river itself is still there, as momentous to us now as it surely was to de Soto then.

Faulkner wrote unmitigatingly of the river, especially about the great flood of 1927, and before him, of course, so did Mark Twain: "And all this stretch of river is a mirror, and you have the shadowy reflections of the leafage and the curving shores and the receding capes pictured in it. Well, that is all beautiful; soft and rich and beautiful; and when the sun gets well up, and distributes a pink flush here and a powder of gold yonder and a purple haze where it will yield the best effect, you grant that you have seen something that is worth remembering."

It was my river, too, in so many ways. Twenty-eight miles to the west of my hometown of Yazoo City, it was a living presence to my contemporaries and me: the settlements along its mighty traverse, its bluffs and promontories and oxbows gleaming in the sun, its tales and lore, its fealties and treacheries. Twain once noted that the Mississippi receives and carries water to the gulf from fifty-four subordinate rivers that were navigable by steamboat. Not the least of these was the river that ran through my own town, the Yazoo, a notable winding stream that takes in the Tallahatchie, the Sunflower, the Yalobusha, and God knows how many less ambitious rivers and creeks in

its southward course through the Delta before it empties itself into the greater river a few miles north of Vicksburg. One of the palpable images of my boyhood was the Yazoo appearing and reappearing before us everywhere in its unremitting twists and turns through the swamplands and thickets, its grassy banks lined with willows, the cattails dancing in a whispery breeze, the duckwood thick and emerald green in the melancholy brakes of cypress, the cotton blossoms in the far-reaching fields dazzling white and soon to turn blue, then lavender.

My own three favorite views of the Mississippi are from the grounds of the modern-day Ramada Inn in Natchez, near a manse called The Briars where Jefferson Davis married Varina Howell; from a section called Jewish Hill in the old Natchez cemetery; and from a rough-hewn observation tower in a minuscule state park south of Rosedale. All three afford an inestimable perspective of the Mississippi, its sweep and majesty and power, making me proud that my state is named after it.

Not long ago we buried a beloved friend named Charlie Jacobs, who died at thirty-seven. He was an indomitable musician who, like another white Mississippi boy named Elvis, immersed himself in the authentic black rhythms and, as with George Washington Carver and the peanut, found more in the saxophone than was in the saxophone before he started. The funeral was held in an ancient family burial ground not far from the river in Bolivar County in the Delta—Charlie's great-great-grandfather was a transplanted Yankee who was governor of the state during the Civil War. All around us mourners, black men on tractors were plowing the earth for the cotton planting, and everywhere was the deep, rich aroma of the fresh inestimable land. From the map I had in hand, I noted that only a quarter mile or so away is a distinct and self-contained stretch of earth on the Mississippi side that is actually *Arkansas*, having been shifted there by some colossal change of course in the river years before. As Charlie's band played "I Walk Through the Garden Alone," I could feel in that moment of death-in-life the presence of the river, and what it means to all of us.

There is more commercial activity on the river now than there ever was in the halcyon days of Twain's paddle wheelers. What one sees today along the river's course from Natchez to Memphis are the tugboats, each being a trifling apparatus that possesses enough sinew to drag an interminable parade of massive paraphernalia. The U.S. Corps of Engineers and its hundreds of Mississippi employees have pretty much tamed most of the river, erecting concrete embankments here and there and contriving all manner of diversions and stratagems. But do not take too much for granted. Old houses and bluff-top streets in Natchez still disappear into the rushing torrents below. The Old Man is a capricious master, never to be trusted when he really gets angry.

Tucked away here and there all over the state of Mississippi are unaccountable edifices that demand serious attention. Just north of Vicksburg on old Catfish Row is Margaret's Grocery, which Reverend Dennis, Margaret's elderly husband, built for her out of mortar, brick, and block as a shrine to the Lord, America, and his wife. Reverend Dennis will give you his own private sermon there. One of the signs reads "All Is Welcome, Jews and Gentiles, Here at Margaret's Gro. and Mkt. and Bible Club." Some places have been here for many years, such as Mammy's Cupboard on Highway 61 south of Natchez, with its twenty-eight-foot-tall black woman on top of a rise, the small cupboard beneath her crinoline skirt offering Mississippi plate lunches and blueberry lemonades. The Palestine Garden in Lucedale is a re-creation of the Holy Land on twenty bucolic acres (a scale of one yard per mile), where you can admire the miniature Bethlehem, Jerusalem, Jericho, and numerous other biblical locales. D'Iberville on the coast quarters a two-story structure that contains more than twelve thousand beer cans and ten thousand beer bottles from eighty-five countries, Monaco to Togo to Mongolia. Almost anywhere in Mississippi bizarre distractions may leap out at you all of a sudden, such as the row of establishments outside Alligator with the separate signs on each store—Bruno's Quik Shop, Bruno's Package Store, and Bruno's Laundromat, leading one to believe that Mr. Bruno must be a good man to know if you live in Alligator. In the dying hamlet of Benoit there is the down-at-the-heels columned antebellum house, an anomaly among the collapsing unpainted shacks—a former planter's home, it turns out to be—where the movie *Baby Doll*, made from Tennessee Williams's only screenplay, was filmed. At Mrs. Hull's home in Kosciusko, the front lawn is filled with probably a hundred shoes on stakes that resemble wild tomato plants, along with typewriters, computers, and other bric-a-brac. This is known as a shoe garden. Mrs. Hull is called the shoe-lady in Kosciusko.

And some of the indigenous country stores are still scattered across the land, where you may buy anything from possum and homemade jelly and white-oak baskets to Vienna sausage and country sorghum and egg burgers: the Gibbes and Son General Store in Learned, a rambling little town in Hinds County set in woodlands and pasture that reminds me of New England; the Causeyville General Store south of Meridian, where on a recent visit we counted eight old country dogs slumbering on the front porch in the summer heat; the Bigbee Valley General Store in Noxubee County; the Lorman General Store on Highway 61 north of Fayette, which once housed a museum of local artifacts; the Pond Store southwest of Woodville not far from the largely abandoned ghost settlement of Fort Adams (the name derives from the pond in front of the store populated with geese and ducks; dogs and donkeys are all around, and at night from a nearby rise you can make out the lights of the sinister Angola prison just past the Louisiana line). The general stores display nostalgic tin signs advertising Coca-Cola, Nehi Strawberry, and Lake Celery, as well as patent medicine signs from the 1920s. The buildings often belong to the original owners' descendants, who love these stores and talk flamboyantly about their histories and the departed souls who once inhabited them.

As for the ubiquitous church buildings, they are surely the most diverse and eclectic found in any state in the union. Much history has taken place in some of the older churches, which were once home to slave owners and slaves alike, hospitals for both sides

during the Civil War, and sites of official community meetings. The black churches founded after that war continued to function as meeting places, scenes of social gatherings, places to go when people were hungry and in need, and, during the civil rights struggles of the 1950s and 1960s, as locations for strategy sessions, which is why many of them were burned to the ground during that catastrophic period.

The little one-room frame churches that inhabit the landscape, often with subdued graveyards, many of which contain handmade tombstones, tell the short and simple annals of the poor. In the Delta, along Highway 1 or 61 or 49W or 49E, these structures appear on the broad horizon as if they have grown from the very earth. Forlorn, block-like little Pentecostals and Adventists sit at the edges of towns, while in the more settled places are found the venerable and exquisite Episcopal churches. I have a fond feeling for the little Gothic Episcopal Chapel of the Cross near Gluckstadt (from the German meaning "happy town"), which is known for its fall festival and the legends of ghosts in the graveyard that is wrapped in an old wrought-iron fence. My favorite small neighborhood of patriarchal churches is in the courthouse square town of Woodville, south of Natchez and only eight miles from the Louisiana line, settled in the late eighteenth century. The Baptist church here, with its white columns and cupola, was founded in 1798 and is the oldest church in Mississippi. Not far from it is one of the oldest Methodist churches in the state, circa 1799, and a convenient stroll away is another white clapboard church with an enclosed foyer, the state's oldest Episcopal church building, St. Paul's Episcopal Church (est. 1824). The substantial nineteenth- and early-twentieth-century synagogues, usually found in the river towns, are not used very much anymore. There are grandiose Roman Catholic churches such as St. Mary's Catholic Cathedral in Natchez, the Romanesque Revival Our Lady of the Gulf in Bay St. Louis, with its statue of the Virgin in the wide paved court, St. Peter's in downtown Jackson, and St. Mary's on the main street in Yazoo City, as well as the smaller lovely ones, in-cluding the Church of the Annunciation in Columbus, the Chapel of the Yellow Fever Martyrs in Holly Springs, and Corpus Christi Catholic Church in Macon. St. Andrew's Episcopal Cathedral across from the Governor's Mansion in Jackson is one of the most graceful edifices in the capital city. And, always, there are enormous new Baptist and Methodist churches. At one such church in Jackson, I have heard, crowds come every Easter to see a replica of Jesus arise.

Cemeteries, too, are integral to this society, both as repositories of history and the passing generations and as serene, private places for visits. In the small towns children still come to cemeteries for games and picnics. Cemeteries remain a part of our daily life here—not so much the new, deracinated suburban ones with their identical plaques embedded flat in the earth to make lawn mowing easier, but the old abiding ones that cradle the bones of our ancestors. David Rae and I discovered solitary tombstones in the middle of nowhere, in overgrown thickets, in remote woodlands, at the edges of cotton fields. But we have also often been drawn to phantasmagoric cemeteries like the one in Natchez with its Mediterranean aura and the one in Greenville with its prominent statue of the Percy knight and to indelible small-town ones in Amory and Carrollton and Oxford. The old graveyard in Aberdeen is one of the most engaging in the state; many of the stone inscriptions refer to wives as "consorts," and the prominent engraving on one is of an unfortunate woman whose skirts are on fire, which was the cause of her actual demise. The equally striking cemetery in Holly Springs is sometimes called "the Arlington of the South" because of its numerous graves of Confederate generals and officers. The big cemeteries with Confederate and Union boys are all over the state. In Meridian, the Rose Hill Cemetery contains the graves of the king and queen of the Gypsies, and members of the tribe often pay their obeisances, leaving fruit and juices.

In a number of the cemeteries in north Mississippi, numerous little stubs of stones without inscriptions mark the graves of victims of the terrible yellow fever epidemics of the latter nineteenth century. In the ghost town of Rodney, the cemetery, which has

ornate wrought-iron fences, is overgrown with brush and thickets. In the Krebs Cemetery in Pascagoula the graves of the early settlers to the Mississippi Valley are so old that the inscriptions on the stones are indecipherable. One of the most arresting graveyard vistas among the many is in Ripley, county seat of Tippah County. Towering over this cemetery is the statue of William Faulkner's grandfather, W. C. Falkner, "the Old Colonel," who wrote a best-selling novel and rode with the rogue genius Nathan Bedford Forrest. The Old Colonel is carved in lasting stone not as a warrior but as a writer and thinker, with books stacked against the back of his leg. In the not-too-distant foreground within direct reach of his gaze, it must be noted, is a Pizza Hut.

The land itself and the sense of place are immutably connected to our history, for history and time have dealt with us and with the indwelling cognizance of our individuality. We are a singular people.

THE OLD NATCHEZ DISTRICT

Much of this region is traversed by one of the most memorable roadways in America, the Natchez Trace, which in its entirety extends from just south of Nashville to just north of Natchez. It began as the historic trail into the Old Southwest, and was made a national parkway during the Depression. Sometime in the future the Trace will reach all the way from Nashville to Rosalie on the river in downtown Natchez, and the sixteen-mile hiatus in the Jackson vicinity will be no more. The absence of billboards and of commerce of any sort, the unspoiled foliage and vegetation, the vintage gray beards of Spanish moss, give travelers the feeling that they are in a warp of old time itself, which, of course, they are. All of us in Mississippi adore the Natchez Trace, and thank FDR for having built it. And the neighborhood which envelopes it has as powerful a magnetism as any I have ever known.

The languid village of Port Gibson, just off the Trace, lies equidistant between Vicksburg and Natchez. It is stunningly lovely, with old churches and a synagogue and sedate antebellum mansions on lanes lined with immense trees draped in Spanish moss. On his march toward Vicksburg, Grant found the town "too beautiful to burn." It has a graveyard with long rows of Confederate dead and an ancient Presbyterian Church, its steeple surmounted by an eleven-foot-tall gilded hand with the index finger pointing to the heavens. (On one of my trips to the town, I noticed that the hand had been removed. I asked a woman behind the cash register in a quick-stop what had happened to it. "I think they're giving it a manicure," she said.) Groups of children are everywhere, playing and riding their bicycles. Elderly women in straw hats stroll along the main street, which is also old Highway 61—the Freedom Highway, the Blues Highway, one of the most singular of American thoroughfares. It begins in New Orleans and stretches north all the way to Thunder Bay, Canada.

To me, there is no more haunted, complex terrain in America than the countryside between Port Gibson and the river. In this seductive earth, the southwest corner of Mississippi, resides the colonial, territorial, Confederate, and American history of the state. Before the Civil War, this area to the south of Natchez was the richest per capita in the United States, all of it undergirded by slavery. The grand plantation homes, many of them now crumbling or derelict, were the apex of this culture. The woods are dark and profuse with creeping vines, snakes, and the ubiquitous hanging moss. The hills and entangled embankments are precipitous, the older roadways deep tunnels of green, and the river is never far away. Here, as in many other isolated fingers of Mississippi, you are about as far from the twenty-first century as you can get.

Up the road is the ghost town of Grand Gulf, where the river began to cut into the bluffs years ago, and where Confederate trenches, caves, and breastworks are still visible. Right up the road, in yet another ironic modern juxtaposition, is a substantial nuclear power plant. A few miles south is Rodney, once a thriving venue likewise long abandoned when the river changed its course, with its contours of collapsed buildings and churches encroached upon

everywhere by the lush woodlands. A saloon, a Masonic lodge, two churches, and a store are still there, and a cotton field occupies the former riverbed. When David Rae and I encountered an old man chewing tobacco and swatting flies on a slanting front porch, we asked him how many people now live in Rodney. "Not too many, I can tell you," he replied.

A few miles northwest up a sunken road is Bruinsburg, now deserted and surrounded by cypress woods along two forks of Bayou Pierre, where Grant and Sherman landed forty thousand men from the Louisiana side of the river in 1863, that war's closest equivalent to the Normandy beachhead. An eerie, preternatural quiet pervades the place. Nearby Alcorn State University, founded in 1871 as Alcorn A & M on the grounds of a church-affiliated college for the sons of rich white planters before the Civil War, was the first state-supported institution for the higher education of blacks in the nation. The campus is eight miles east of the river in bucolic, undulating terrain. Towering magnolias and live oaks festooned with moss cover the grounds. (Granting the honor of its official state flower to the *Magnolia grandiflora*, the state has suffered criticism of that flower as epitomizing cultural decadence, yet its own native son Richard Wright, who wrote grim stories of growing up in Mississippi, remembered from his youth "the drenching hospitality in the pervading smell of sweet magnolias.") The students sit in the shade reading books. The buildings have the aura of time: aged brick walls, tall white columns, iron stairways. When Medgar Evers came back from World War II combat in France, he was a student leader and football player here. Alcorn had seventy players drafted into the National Football League.

But in this whole history-drenched vicinity, the Windsor Ruins are the most striking landmark of all—twenty-two towering columns with huge cast-iron Corinthian capitals at the top of each, affording the weathered outline of an old destroyed plantation mansion built before the Civil War by slave labor and considered in its day the grandest in Mississippi. Now it is one of the enduring symbols of the state's long-lost cotton kingdom. As a riverboat captain, Mark Twain used these towers to chart his course. Functioning as a hospital during the Civil War, the building ran red with blood. Vines now cling to the fluted columns. The encompassing land is equally formidable, with brooding whispery forests all around. Once you have seen these ruins you will never forget them.

Farther south down the Trace, which converges with Highway 61 above Natchez, is the drowsy enclave of Washington, capital of the Mississippi Territory, graced by historic Jefferson College, the first college in the state. On a site where a huge spreading oak now stands, Aaron Burr had his pretrial hearings on the charge of treason. Not far down the highway is a lovely 1824 red-brick Methodist church with an incongruous neon sign in front (the original church here was the birthplace of Methodism in the Southwest Territory and site of the state's first constitutional convention), and just behind it in a tangled grove of underbrush and trees is a sight that has always tugged at my being: the crumbling old house of my ancestor Cowles Mead, acting territorial governor of Mississippi in 1807 (he arrested Aaron Burr) and founder of the Mississippi First Infantry, which was later commanded as the Mississippi Rifles in the Mexican War by Jefferson Davis. (Davis's famous cry—"Stand first, Mississippians!"—as the American army was in retreat at the Battle of Buena Vista got him elected to the U.S. Senate.) The Mead house has never received any of the Natchez restorers' largesse, and now it is disappearing into the enveloping earth, like others in the countryside near here, hidden in dense trees along deep sunken roads; these are some of the oldest houses in the Natchez District.

Natchez, founded by the French in 1716, is older than New Orleans. It is a magical place I go back to as often as I can, to walk its storied streets and lanes in sultry summer dusks among the magnolias and crepe myrtles or to take one of the carriage rides through the august faubourgs with their amalgam of aristocratic mansions and wonderfully restored cottages. They travel along the expansive greensward of the city park, where the bluffs look down on the eternal river. Natchez had borne the Spanish, French, and

English flags in a swift chronology of negotiated European settlements until the Spanish left in 1798, and it became American—and part of the Mississippi Territory. In the Civil War the town capitulated to the Federals with practically no resistance, the only casualty being a poor little girl who was decapitated by a shell from a Union gunboat in the river and who rests today in a grave in the old Natchez cemetery.

Because of its early surrender, the dozens of antebellum mansions in the town, set in their stately grounds, survived intact, unlike many in Vicksburg up the river. During the 1930s Depression the white ladies of Natchez concluded that their magnificent houses were their most efficacious commercial advantage, so, while most other American places were ripping down their honored structures for parking lots or glitzy latter-day tourist spots, the Natchez matrons began protecting their historic domiciles with a zealous fervor. They established stringent building codes and organized their now twice-yearly pilgrimages, during which luscious local belles are everywhere in period hoopskirts, which some visitors surely covet.

The old slave barracks and auction block are long gone, but a historical marker stands on the site of the second largest slave market in the South. Writer Richard Wright was born and reared here in deepest poverty, and a substantial plaque in recognition of him was erected not long ago in the center of town. Every year at the Natchez Literary Festival the Richard Wright Medal for Literary Excellence is presented to a deserving Mississippi writer.

The town also decided to restore the notorious Natchez-under-the-Hill, which languished for years, and I am glad they did. It was a veritable hellhole—"small, straggling, and shabby," Mark Twain had written of this vainglorious precinct. "It had a reputation, morally, in the old keel-boating and early steamboating times—plenty of drinking, carousing, fisticuffing, and killing there, among the riff-raff of the river, in those days."

THE PINEY WOODS

A large part of southern Mississippi lies in this high and rolling region, which has had an arduous economic past. The land was too thin for cotton, and until the late nineteenth century it was almost a frontier, populated by struggling farmers of Anglo-Saxon ancestry, until the advent of the railroads and the frenzied rapine, largely by northerners, of the great virgin pine forests, when the area became the foremost lumber supplier to the rest of the nation. After the forests were depleted, almost all the Yankee exploiters took their sizeable fortunes and moved on. In their wake some substantial towns survived; others shrank or died. The place became a lugubrious terrain of tree stumps and ghost towns, rotting mills and stagnant mill ponds, until its people had the sense to grow their own trees, the swift-growing yellow pines—"reforestation" it was called—and as the century progressed the Piney Woods grew into a relatively prosperous neighborhood of well-conceived forest industries, dairy cattle, and small farming.

The principal towns of the Piney Woods today, sturdy survivors one and all, are Hattiesburg, Laurel, Columbia, Picayune, Tylertown, Monticello, Poplarville, Lumberton, McComb, Crystal Springs, Hazlehurst, and Brookhaven.

Driving south of Jackson on Highway 49, past water towers and fields and lumber and cattle and pine cones and colorful flowers growing around modest houses and sheds, you can see once-plain little places still serviced by the railroad and now prosperous in appearance: the historic Piney Woods Country Life School; Mendenhall, with an old railroad hotel noted for its all-you-can-eat meals, the revolving table full of succulent meats and chicken and country vegetables straight from the farms; Mount Olive (hometown of the great quarterback Steve "Air II" McNair); Collins (hometown of the actor Dana Andrews); Wiggins (county seat of Stone County, the only county in the state that did not have a single slave, and famous as Dizzy Dean's home); and Perkinston (site of a venerable junior college that seems more pasture and woodland than campus). All along

the route are fresh produce stands. After the first devastating lumber boom and bust, the denizens learned that this fine, light land, unsuitable for cotton, was good for strawberries and tomatoes and cabbage and sugar cane: "not the sorghum of the northern and western counties, which the people of the true cane county called hog-feed," Faulkner noted, "but the true sweet cane which made the sugar house molasses."

The cultural nexus of the Piney Woods is the sawmill and academic town of Hattiesburg. Midway between Jackson and the Gulf Coast, it is the third-largest city in the state (population forty-six thousand), and has a pleasant, well-preserved downtown with a prosperous Depression-era residential area. Hattiesburg is the home of the University of Southern Mississippi, which has the second-highest enrollment among the state universities. It has the finest collection of children's book manuscripts and pictures in the country and boasts superlative athletic teams. Brett Favre, the dexterous quarterback for the Green Bay Packers and three-time Most Valuable Player in the National Football League, played his collegiate football here. Its theatrical school has produced some of the country's prominent set designers, cameramen, wardrobe designers, and lighting technicians. Its innovative polymer plastics school was the first in the country. The town has an air of sophistication, likely because it was a railroad center with diversified industries, never wholly dominated by the earlier grasping lumber industry. A large medical complex is located there and a sizeable convention center, and facilities draw visitors from the whole lower South; it has become a popular retirement community for people from all over the country.

Just outside Hattiesburg is the tiny Richburg community, where, on a hellishly hot day in July 1889, John L. Sullivan defeated Jake Kilrain in seventy-five rounds in the world's last heavyweight championship bareknuckle fight. Sullivan consumed a quart of whiskey during the fight, and Bat Masterson, the western lawman, served as referee.

Not far south of Hattiesburg on Highway 49 lie the sprawling perimeters of Camp Shelby, one of the oldest military installations in the country, where many thousands of Americans trained for duty in World War I, World War II, Korea, Vietnam, and the Persian Gulf. It is not uncommon to see long highway caravans of olive-drab army vehicles of every size and description heading somewhere on maneuvers. "Do you know Camp Shelby?" I have been asked time and again around the United States by men who spent time there.

A second substantial pine belt city is Laurel, on the northeastern fringe of the region and attended by Interstate 59. An unusual city that has never failed to intrigue me, Laurel, like Hattiesburg, not only survived the lumber disaster of the late 1920s but made a salubrious transition to stable industrial and cultural center in less than half a century. Unlike the forest barons in other reaches of the Piney Woods, who left the stumped and newly barren country as soon as it was ravaged, the Eastman-Gardiner Lumber Company devoted a significant portion of its burgeoning profits to the locality itself: parks, schools, churches, garden clubs, museums, libraries, and permanent homes for the workers—a testimonial to what outside profiteers could do if they cared for a place. In the observation of one historian, Laurel "was transformed from the spirited child of the Piney Woods into a pampered ward of Eastern capital," and "tough-fibered lumberjacks, whose previous experience with music had been bawdy songs around the campfire or a hymn sung lustily in church on Sunday, made down payments on pianos for their children's music lessons."

All this is apparent today. In a leisurely drive through the town, I saw no antebellum houses, of course, since Laurel was nothing but a gall berry flat before the Civil War, but the neighborhood around Fifth Avenue features block after block of lumber barons' mansions. The jewel of the town is the Lauren Rogers Museum, built by the Eastman family as a memorial to their only son, who died young and tragically. Its broad-columned portico and iron grille work by Samuel Yellin, the greatest blacksmith in American history, make it a most splendid building. Strolling through it is like visiting a European

castle. Paintings by Whistler, Constable, Reynolds, Rousseau, and many others are there, but the museum is especially noted for its silver and its oriental and Native American art collections. The library, also donated by the Eastmans, includes some rare and wonderful old books.

One of the greatest operatic voices of the twentieth century came from this Piney Woods town. The journalist Bern Keating has appropriately noted:

When Leontyne Price made her New York debut in *Il Trovatore*, she lifted the audience out of their seats in an explosion of astonished joy. Her triumph brought great pride but little surprise to opera lovers in her home state, for she had toured there as a nineteen-year-old student, singing trial concerts accompanied by her mentor, Mrs. Alexander Chisholm of Laurel.

Half of her audiences came only to see the spectacle, astonishing in that time, of a high-born white woman [the Chisholms were lumber barons, too] taking second place to a black girl. That magic voice stunned them all, true music lovers and curiosity seekers, so that her subsequent career, probably more triumphant than any since Caruso's, comes as no surprise to her fellow Mississippians, who are universally happy to see one of us making it in the big time.

It is a little odd, Keating and others have observed, that Laurel's most famous citizen should be black, because the town and the home county of Jones are set in a Mississippi enclave of almost purely white history. The county of Jones itself has one of the most volatile and controversial pasts of any region in the state. A figure named Newt Knight, liberator and guerilla expert or reprobate thief, depending on which accounts you read, and his followers seceded from Mississippi in 1862—the "Free State of Jones"— and waged Vietnam-like ambushes with double-barreled shotguns against pursuing Confederate troops. This tale, which many attribute to legend, is amply garnished in one of Laurel native James Street's steamy epic romances of the 1950s, *Tap Roots*, which we high school students in Yazoo City surreptitiously read at the time, usually hiding the paper-

back from our teachers in a civics textbook as we read.

In the recesses of nearby Smith County is Sullivan's Hollow, an elongated glen where a few clans or families with Northern Ireland and Highland names, as Faulkner wrote of it, "feuded and slew one another in the old pre-Culloden fashion yet banding together immediately and always to resist any outsider in the pre-Culloden fashion too: vide the legend of the revenue officer hunting illicit whiskey stills, captured and held prisoner in a stable and worked in traces as the pair to a plow-mule. No Negro ever let darkness catch him in Sullivan's Hollow." On another occasion two of the Sullivan brothers trapped the head of a sheriff between the rails of a fence and left him there, where he starved to death. In 1924, at a baseball game in Mize, an argument transpired over an umpire's decision and a mass fight broke out, during which two were killed and half a dozen severely wounded, although apparently they did not kill the umpire.

Mize, once known locally by the nickname "No Nigger" and traditionally notorious (along with much of the rest of this area) for its egregious Ku Klux Klan activities until the Klan pretty much disappeared, thanks to its own tawdry excesses and to FBI informers in the 1970s, is the unofficial capital of Sullivan's Hollow.

On the western periphery of the Piney Woods, just off today's Interstate 55, are Crystal Springs and Hazlehurst, the latter being the setting of Mississippian Beth Henley's Pulitzer Prize–winning play *Crimes of the Heart*. (It is incredible that so many small Mississippi towns have been written about with such grace and realism by the state's numerous writers.) With their copious production of tomatoes, cabbage, carrots, beets, strawberries, and nuts for indigenous and northern markets, both these towns have traditionally been part of a distinct economic unit of the state, this area being perhaps the foremost example of how the Piney Woods region put its thin soil to profitable use. Farther south on Interstate 55 is Brookhaven, in Lincoln County, once a laid-back Deep South village and now, along with adjacent Liberty and Pike counties, the center of south Mississippi's

dairy business. McComb, built as a railroad center in 1857 and currently the largest town between Jackson and New Orleans, has lingering pine forests all around and is noted for its excellent public school system. South of McComb, only five miles from the Louisiana line, is Magnolia, one of my favorite little towns in Mississippi, and aptly named because of the beautiful lanes of our state's *Magnolia grandiflora* on the banks of a stream running near the Pike County Courthouse. If a town in Mississippi is named Magnolia, I surmise, it had *better* be pretty.

THE GULF COAST

My wife JoAnne and I were driving south from Hattiesburg, and, somewhere past Wiggins, thirty miles or so from Gulfport, we began to smell salt in the air and knew the sea was not far away: the Gulf of Mexico. Suddenly the land became flat and open, low and marshy with huge oaks hung in Spanish moss appearing here and there and local people of all ages fishing from the banks. This abrupt vicinity is called the Coastal Meadow, which is one's introduction to the Mississippi coastline. Between the water and the remote backwood marshes is the Gulf Coast itself, the whole area dotted with streams and ponds and saturnine bayous.

Elizabeth Spencer begins her memoir *On the Gulf*: "If I could have one part of the world back the way it used to be, I would not choose Dresden before the firebombing, Rome before Nero, or London before the blitz. I would not resurrect Babylon, Carthage, or San Francisco. Let the leaning tower lean and the hanging gardens hang. I want the Mississippi Gulf Coast back as it was before Hurricane Camille."

Hurricane Camille ripped the area apart in 1969, leaving 138 dead and untold missing or injured. Time's patina was lost on "the coast," as all of us call it. Before Camille, there was a hush over the place, a wonderful suspension, a dreamy jasmined indolence. Much of that is gone now. The fine old Edgewater Beach Hotel, so large in my recollection, was dynamited many years ago to make room for a shopping mall. The coast is home to heavy industry such as shipbuilding, which the state, of course, badly needs. And, with the legalization of gambling in 1992, Vegas-style casino culture has been bringing in even more jobs and more change.

However, as Tennyson wrote, "Tho' much is taken, much abides." Despite the twelve casinos, much of the twenty-six-mile coastline is still unobstructed. Many of the old contours remain, and they tug at the heart: the old sheltered homes with their grand porches and outdoor staircases facing the sea, the palms and gulls and pelicans etched high against banks of clouds reaching to the heavens, the lazy summer atmosphere and winter greenery, the little screened bars and seafood joints, the meandering bayous with names like Mulatto, Rotton, Acadian, and Portage, the quaint and enduring byway towns called Pass Christian, Bay St. Louis, Gautier, Legendu, Lameuse. Unlike most of the inland places in this state, prohibition was never honored here, scene of casual revelry equaled only in the Mississippi River towns of Natchez and Vicksburg and the Delta. In the early autumn of 1956 I came here with a few of the boys and girls I grew up with in Yazoo City, for a farewell they were giving me before I left for college in England, and we stayed in a neglected columned house on the warming gulf surrounded by emerald-green live oaks and pungent blooming magnolias and drank Jax beer and watched the twilight over the water in a gathering storm to the words of a popular song of the day: *The sun went out just like a dying ember, that September . . . in the rain.*

In 1699, the French established the first permanent settlement in the Mississippi Valley in Ocean Springs, and, ever since, the coast has been by far the most heterogeneous region of the state. Roman Catholic and Mediterranean, it has the feel of cosmopolitanism and the sweep of history. "The people were Catholics," Faulkner wrote, "the Spanish and French blood still showed in the names and faces. But it was not a deep one, if you did not count the sea and the boats on it: a curve of beach, a thin broken line of estates and apartment hotels owned and inhabited by Chicago millionaires, standing back to

back with another thin line, this time of the tenements inhabited by Negroes and whites who ran the boats and worked in the fish-processing plants." In addition to the Castilian and Gallic antecedents, the modern ethnic mix includes Czechs and Yugoslavs and Poles who came years ago to work in the fishing trade, and, more recently, Vietnamese.

Rich vacationers have come here since the nineteenth century from New Orleans, the inland plantations, and the North, and many of their grand domiciles have survived the hurricanes. Southern plantation architecture with decorative cutout work and spacious verandas was the style and fit in salubriously with the blue waters and hot summer breezes.

Since 1880 the coast has been a prominent fish supplier for the nation and the world. The sandy soil is unsuitable to crops, but remains a paradise for onshore and offshore fishing, and the salty commercial fishermen give the place much of its indomitable character despite the casinos. The French and Spanish specifically designed the indigenous Biloxi catboat and Biloxi schooner for the shallow waters of the sound and the accompanying inlets and bays. On-shore fish—flounder, croaker, white trout, and speckled trout—and the offshore catch—redfish, king mackerel, lemon fish, and bonita—are abundant. The commercial industry specializes in shrimp, crabs, and oysters. Restaurants as far away as New York City serve these catches, which are shipped fresh every day.

On a clear day the silhouettes of the barrier islands around which much of the offshore fishing takes place can be seen from the old beach road. They are ten to twelve miles from shore and suffered severe damage during Hurricane Camille. Ship Island, with its Civil War–era Fort Massachusetts, has long been a popular destination. There you can see alligators, ospreys, bald eagles, otters, red-cockaded woodpeckers, feral hogs, and wild rabbits. Horn Island is the most natural of the barriers and the hardest to get to; it is part of the National Wildlife Preserve. The prolific coast artist Walter Anderson did much of his work there. He once took refuge from a hurricane by beaching his rowboat and crawling under it. The na-

tional park service has a little station on Horn Island. On Petit Bois, as well as on Horn, the wildlife is abundant and includes pesky little wild mice the color of the sand.

It is a land of legends and of time-honored folk ceremonies. Mardi Gras is observed annually before the beginning of Lent. Also, in Biloxi, a huge outdoor mass, the Blessing of the Fleet, followed by considerable partying, is celebrated every year before the boats depart for their deep sea destinations. The *WPA Guide* described the life of the fishermen, true to this day:

Weeks and months out among the oyster reefs and shrimp "strikes" have given them something of the romance compounded of unforgettable scenes; they have felt the quiet, thickly-moving Gulf, and have watched the horizon of long, low rollers washing at stringy islands, where dead stumps of conquered cypress mark a point that was land; they know the constant sound of wind in sails, and the taste of salt; and they have come home again to beach their schooners on bars that are white against the gray and green of moss-hung oaks.

Thought to be part of the oldest structure in the entire Mississippi Valley, the Old Spanish Fort, built in the early 1720s, is in Pascagoula. The Pascagoula River, colloquially called the Singing River, meanders not far from the Jackson County Courthouse. According to legend, on placid summer evenings the river sings like the chanting of the Biloxi Indians when they drowned themselves rather than be enslaved by a vengeful hostile tribe. Going west from Pascagoula on old U.S. 90 paralleling the sound, one comes to my favorite coastal town of all, Ocean Springs, located on an extraordinarily beautiful waterfront and surrounded by immense pecan orchards. Renowned architect Louis Sullivan of Chicago spent his summers here and designed the High Victorian Gothic Saint John's Episcopal Church on the main street. (It is believed that Frank Lloyd Wright actually did the design during his apprenticeship with Sullivan.) Ocean Springs was the hometown of the eccentric artist Walter Anderson and now quarters the

Walter Anderson Museum of Art, as well as the Community Center, where one of the most astounding testaments to Anderson's talent—his tribute to the city of Ocean Springs—is painted on the walls.

West of Gulfport, the beach road goes past many nineteenth-century summer homes to the village of Pass Christian, still a secluded community with a boulevard paralleling the water and domiciles surrounded by lush gardens of roses, crepe myrtle, and palms, and fences overgrown with wisteria and honeysuckle. Farther on, the main boulevard of Bay St. Louis, which runs by the crusty sea wall, seems grown out of unchanging time, another of the many coastal enclaves that have defied organized gambling and the elements. The "Old Town" has art galleries and antique shops, and the Creole design of many of the old homes is a reflection of the number of *Orleannais* who have traditionally come to the town on summer retreat.

I once spent a couple of days and nights in a restored bungalow on the grounds of Beauvoir. Built in the early 1850s by a Mississippi planter and situated near the water between Biloxi and Gulfport, Beauvoir became the home of Jefferson Davis after his release from a Union prison. He lived there for twelve years and wrote his compendious *Rise and Fall of the Confederate Government*, which once put me to sleep for eight nights in a row. Raised on break piers, with ceiling-high windows and a broad front staircase leading up to a commodious gallery, Beauvoir is surrounded by a magnificent grove of cedars, magnolias, and oaks. At night, after the tourists had trailed away, I had this spectral spot all to myself. One evening I entertained Mary Anderson, Walter Anderson's daughter, and her husband, Ed Pickard, in my cottage at midnight and impressed them when I used my private key to the main gate to the grounds. When they departed, I watched a fluttery TV for a while—the Persian Gulf War had started that very night. Then I walked up to the main house and sat on the front gallery and looked out over the water dappled by the lights of a passing Gulf Coast fishing boat. (I had earlier traced a map on the wall of my cottage to discover that if you headed due south in a boat from this very spot, your first landfall would be the Yucatan Peninsula seven hundred miles away.) After a while, intent on absorbing the ghostly presence of Jefferson Davis, I took a quiet walk past a graveyard of hundreds of Confederate soldiers who had died here when the place was a veterans' retirement home, and farther on quite fortuitously came across something I'd never dreamed of: the official Grave of the Unknown Confederate Soldier. I wondered who he was, where he came from, where he died—right here in Mississippi, perhaps, at Vicksburg or Brice's Crossroads or Raymond or Okolona or Champion Hill? I tarried there in the still darkness paying my lonely deference, and then went back to the cottage to turn my attention again to the American troops in the desert sands of Yemen, watching on the flickering TV as various Baptist preachers of the Gulf Coast harangued our soldiers to go in forthwith and deal with the Iraqi heathen, although I did not hear a single one of them volunteering to be on the lead tank.

THE NORTHEAST CORNER

At far remove from the Mississippi Gulf Coast, in geography, temperament, and history, is the northeast corner of the state, sometimes called the Tennessee River Hills, a wedge-shaped enclave between the Tombigbee and Tennessee rivers. When you travel from the south into this rugged terrain it suddenly, almost slyly, begins to assume the feel of the mountains: these are, indeed, the southern foothills of the Appalachian range. Almost no one associates this state in the remotest way with mountains; most Mississippians have never even set foot here, and there has been very little written of this remote uplands vicinity.

Allow the reliable *WPA Guide to Mississippi* to capture the mood and texture of this neighborhood as it was in the 1930s:

Here, living in as "old English" a style as their upland cousins of the Georgia and Carolina Piedmont, is a group of hill-born and hill-bred farmers who are fiercely independent, and who insistently retain the early Anglo-Saxon

and Scotch-Irish characteristics that their great-grand-parents brought to this section. Housed in compact "dog-trot" houses perched on steep hillsides, these people, like those of the Piney Woods, have always been the yeomen—the non-slave owners—of the state, possessed of an inherited distrust of the planter and of the aristocratic systems that great plantations breed. . . . Here tiny villages are perched perilously on peaks, and shallow plow marks crook dizzily down hillsides to cabins hanging miraculously to the edges of deep ravines.

Following the precipitous Highway 25 through this region during a couple of days in October, I saw permanent vestiges of that older, proud society. There are satellite dishes, however, in front of many of the remaining older dwellings. Wisps of wood smoke spiral upward into an azure sky, and the Mississippian knows without having to ask that corn whiskey is fermenting somewhere in these hills, one sip of which you will feel in your toes; it is the equivalent of this region's *vin de pays.* You do not see many African Americans about, making this region unlike all other parts of Mississippi. There are fast-food chains in some of the towns, and junior high school kids, like their counterparts in Trenton or Dubuque or Kansas City, congregate in the new shopping malls to do whatever junior high kids do in the off-hours. But this area is still very much what it has always been. "These hill people are very tough and private," a friend who knows the place has said to me.

Corinth, the tacit capital of the extreme northeast, is an old, settled town, scene of the bloodiest Civil War battle fought in Mississippi. During its occupation by both armies, some three hundred thousand men in all, a system of fortifications was built around the town, and these earthworks remain the best preserved in the nation. The beautiful national cemetery contains the graves of fifty-seven hundred soldiers from fifteen states. Lining Corinth's languid streets are a number of antebellum and Victorian houses, and situated about the courthouse square are many business establishments rich in history and character. The town today is the industrial hub of the Tennessee River Hills, but local historians remind us that from

the 1940s to the 1960s Corinth had a reputation for being the hideaway for Chicago mobsters and acquired the nickname "Little Chicago."

The battlefield of Shiloh was never far from my thoughts here. It is twenty-two miles north of the Tennessee line, but in spirit it is Mississippi. The horrific 1862 battle taught both sides that the war was going to be tragically bloody and long. The wounded of both armies were loaded onto railroad cars and dispatched into the northeast Mississippi hills. Then the trains stopped in one Mississippi town after another, leaving in each as many of the wounded as the women of the town could take care of, eventually going as far south as McComb. Hundreds of Union and Confederate dead from Shiloh are buried on the campus of the University of Mississippi in Oxford eighty-five miles south.

The highest point in the state is in this neighborhood: Woodall Mountain, a deeply forested ridge which rises to 780 feet, unprepossessing by North Carolina or Colorado standards, perhaps, but formidable enough for Mississippi. One reaches this auspicious crest on a rutted gravel road that rises and twists in great contortions. In William Styron's novel *Sophie's Choice*, Stingo and the doomed Sophie and Nathan Landau chose Woodall Mountain as one of the places they wanted to see on their projected tour of the South, although tragedy managed to intervene. Several miles away is one of the state's notable historic landmarks, the 1854 Federal-style Jacinto Courthouse, imposing and graceful, which appears like a lonesome phantom in its spectral setting of hard hills and trees. On our visit there, several frisky boondocks dogs followed us everywhere, and there are two prominent signs on the rustic dwelling across the road: "Courthouse Caretaker" and "Country Eggs for Sale."

Farther south, the hill village of Tishomingo, even in the modern day, with its ageless envelopment of country seems spawned from the sparse tossing land. This little village has a primitive aura about it. Many of the establishments on Main Street, including the modest public library (an old storefront painted a bright blue), are constructed of the native limestone.

All around us on our drives was the inspiriting foliage of autumn, which arrives earlier here than anywhere else in Mississippi, and unlike elsewhere in the state almost resembles New England in its grandiosity. This mountain tableau is best seen in its most untamed glory in the forested enclave of an old Indian ceremonial ground, now Tishomingo State Park, with its crystal-clear creeks and wild ferns and limestone rock with noticeable depressions in the ledges where the Chickasaws once ground their corn into meal. Spending a Saturday night in one of the stone cabins, with steaks on the grill outside and the cool supple breezes stirring the October leaves, we had the place all to ourselves. This was indeed a very different part of Mississippi, and we could have been in another century altogether were it not for the Ole Miss–LSU football game on our portable radio.

Booneville and Fulton to the south, in Itawamba County (the last "a" pronounced "i" by the natives), are, next to Corinth, the largest towns in these "Mississippi mountains." Of Booneville, which the Mississippi Municipal Association chose as the 1998 "Most Livable City" in the state, one local says, "Nine thousand residents and just about as many fishing holes," and the town also hosts art exhibits and writing conferences sponsored by Northeast Mississippi Community College. The region around Booneville is the world's largest producer of upholstered furniture. Fulton, on the banks of the Tenn-Tom Waterway, has always been noted for its indigenous artists and craftspeople, who in the tradition of lower Appalachian heritage continue to mold authentic pottery, weave baskets, stitch quilts, and tat chairs.

Northeast of Tishomingo, the town of Iuka, located close to the Alabama line, is what our New Orleans cousins would call a lagniappe. After our exploration of the rudimentary earth of this northeast region, I expected Iuka, one of the larger towns around here (about thirty-one hundred souls), to have the same stark country flavor Tishomingo does, but I was wrong. Perhaps Iuka's progress can be attributed to the noted mineral springs just out from town, which was once a health resort. At the 1904 World's Fair in St. Louis, Iuka's mineral water was named the best and purest in America. The site is now a landscaped park with ancient beeches, sweet gums, and oaks and six different springs. History reports that the biggest spring has dried up only two times, the first when Grant's and Sherman's troops drank it dry, and the second when the whole of Tishomingo County had a barbeque here. The downtown parallels the railroad tracks, and the ambiance of it is rather refined, with immaculate shops and establishments selling antiques and green-shuttered, deeply porched antebellum buildings and coffee shops and substantial churches, especially the Methodist church, with its white Gothic spire that can be seen from all over town. As with other small Mississippi towns scattered throughout the state, this one has a bloody lineage—one fierce Civil War battle and several skirmishes within the city limits. In Shady Grove Cemetery, a cool and translucent spot, the Confederate boys lie buried en masse in one long trench. That is Iuka at the beginning of the twenty-first century, another of Mississippi's surprises.

Tupelo, with a population of thirty thousand, is the largest city in northeast Mississippi. The 1938 *WPA Guide* was prescient in describing it as "Mississippi's best example of the 'New South'—industry rising in the midst of agriculture and agricultural customs." Today Tupelo is still one of the most progressive cities of the modern South, and in 1999 it was named by the National Civic League as one of the top ten cities in America for its initiatives in combating school dropout rates and juvenile crime, for its health care programs for the working poor and unemployed, and for its longstanding commitment to superior public school education. Tupelo was the first city in the country to take advantage of the Tennessee Valley Authority, and it has followed a path of enlightened industrial development "without handing over the keys to the city and leaning on local taxpayers," according to the *Wall Street Journal*. In the process it has become "the envy of corporate recruiters across the U.S." Per capita income is the second highest in the state, and the city supports its own symphony orchestra, the nation's largest rural hospital, and Gum Tree Book Store, one of the finest

bookstores in the state. It has eighteen Fortune 500 companies, including Philip Morris, Cooper Tire & Rubber, and Sara Lee, as well as substantial furniture makers and investors from all over the United States and the world.

Public education has been the bedrock of the Tupelo story. Public and private money pours into its schools. School bond issues typically pass with 90 percent approval. In the early 1960s Lee County was the first county in the state to integrate its schools. White flight to segregated private academies has been a fact of life in some areas of Mississippi, but in Tupelo 60 percent of public school students are white (compared to 47 percent in the rest of the state).

The last major engagement of the Civil War in Mississippi, and one of the fiercest, was fought here. But Tupelo is probably best known nationally as the birthplace and boyhood home of Elvis Presley. When you visit Elvis's birthplace in Tupelo, keep in mind that his daddy borrowed $180 to pay for it, and the bank foreclosed on him. And if you wish to buy a guitar, you can go to the old Tupelo Hardware where Elvis bought *his* first one.

The progressive tempo of Tupelo extends to small neighboring cities such as Pontotoc and New Albany (the latter being the birthplace of William Faulkner), both of which are widely noted for their antiques festivals and shopping places.

THE BLACK PRAIRIE

The city of Meridian, its population of 41,036 making it the largest city in east Mississippi (and until 1930 the most populous in the entire state), is geologically not in the Black Prairie but is in many ways the southernmost gateway to that unique suzerainty. We began our excursion through the Prairie in Meridian.

"Meridian, with its depots, storehouses, arsenal, hospitals, offices, hotels . . . no longer exists," reported that willful and temperamental arsonist Sherman to Grant in 1864 after Sherman had finished his business there. For that reason, as is true with Jackson, there are few antebellum buildings. But the town was blessed in having among its citizens one of America's finest modern architects, the late Chris Risher, Sr., and his architectural gems, including the Vise Clinic Building, the Red Hot Truck Stop, Weidmann's Restaurant, and several schools, honor the landscape. The downtown, with spacious thoroughfares that are immaculate and prosperous, is dominated by its most salient piece of architecture, the seventeen-story Threefoot Building, and the historic, newly remodeled Union Station has encouraged similar renovations in the adjacent area. The remarkable Peavey Electronics Corporation, the city's second-largest employer (the first being the U.S. Naval Air Station) celebrates its accomplishments with an impressive museum display of speakers, amplifiers, PA systems, guitars, keyboards, drums, and other equipment used by musicians worldwide.

Out at Highland Park, where we went to see the Jimmie Rodgers Museum, dozens of African American Meridianites and their relatives from up north were having a celebrative reunion and were wearing T-shirts emblazoned with their family names. Not far from the Rodgers Museum we came across a most fortuitous surprise, the Dentzel Carousel, created by Herr Dentzel in Pennsylvania in 1895. It is a turn-of-the-century treasure with twenty-eight meticulously hand-carved horses, lions, reindeer, and other animals, oil paintings adorning the carousel's top crown, and the original carousel pipe music; children from the family reunion were enjoying the ride. We had dinner at Weidmann's, one of Mississippi's fine restaurants, once owned by the late Shorty McWilliams—star halfback at the U.S. Military Academy (in the same backfield with Mississippian Doc Blanchard and Glenn Davis) and later at Mississippi State—and now run by his three ebullient daughters and their husbands. The gallery of sports photographs and memorabilia was a condiment to our private celebration of Shorty Mac.

One footnote for aviators and trivia buffs: two Meridian boys, Al and Fred Key, in 1935 set the world record for sustained endurance in the air—653 hours and 34 minutes, or over 27 days—in the skies over town, and the record still stands. Their plane was

named the "Ole Miss," and the Meridian airport is justly called Key Field.

Except for occasional forays I had never spent much time in the Black Prairie. I was fascinated by it. It begins roughly in Scooba just south of Macon and extends northward eighty-four miles to the Tennessee line. It is about twenty to twenty-five miles wide, a comparatively treeless and flat-to-gently-rolling plateau which takes its name from the dark color of its fertile soil. (On its southward and eastward journey it extends deep into Alabama, where it is called the Black Belt.) There are two towns actually named after the Prairie: Prairie Point in Noxubee County and Prairie in Monroe County. A number of businesses reflect the name, such as Prairie Livestock in West Point. The early brand name for one of the state's prominent industries, Bryan Brothers Foods was the Prairie Belt Brand, with its well-known slogan: "It's Prairie Belt for Me." This was one of the earliest settled regions in Mississippi, with numerous cotton plantations. In its halcyon era the Prairie was a small replica of the Natchez District, with Macon, Aberdeen, and Columbus its most wealthy antebellum centers, and to this day the area exhibits some of the style of the Delta, though not so flamboyantly: "its old tight intermarried towns," Faulkner wrote of it, "and plantation houses columned and porticoed in the traditional Georgian manner of Virginia and Carolina in place of the Spanish and French influence of Natchez."

As one enters the Prairie, the horizons suddenly become as broad and spacious as the Delta. There is not so much cotton anymore, but instead a plentitude of good-looking soybeans, fat cattle, hay, diversified high-tech farming and dairying, and timber. (In Mississippi the richer the land becomes the more poor people you see.) Barns, silos, and a few windmills dot the landscape, and there are substantial wildlife refuges. The Tenn-Tom Waterway slices southward through much of the vicinity on its way to emptying into Mobile Bay. Throughout the state the Prairie region is known for its hunting and for the breeding and training of exceptional bird dogs.

Macon is a somnolent prairie town extending fan-shaped from the banks of the Noxubee River, with large-columned homes affirming its Old South prosperity. Along with Columbus and Aberdeen, it celebrates a yearly spring pilgrimage. The Columbus vicinity is the earliest place mentioned in the historical records of Mississippi; it is surmised that de Soto crossed the Tombigbee here in 1540. Today Columbus is the site of the Mississippi University for Women, the oldest state-supported college for women in the United States, and of the first free public school in the state. It is also home to one of the most impressive secondary education establishments in the South: the Mississippi Governor's School and the Mississippi School for Mathematics and Science, one of the first public, residential high schools for gifted students in the nation. Columbus is a stunningly mellowed and beautiful city; its broad, tree-lined streets accommodate one of the greatest concentrations of nineteenth-century houses in Mississippi, including the one that was Tennessee Williams's birthplace and where he spent his childhood. The Greek Revival columns and Gothic lacework on certain of the mansions are a style unique to Columbus. Jet aircraft fly over these graceful neighborhoods en route to the nearby U.S. Air Force base, and Weyerhauser has two substantial divisions here. What would Tennessee Williams make of the fact that his hometown is now the world's largest supplier of sodium chlorate (used as a bleaching and oxidizing agent and in explosives), not to mention of electric starter motors for small engines? Columbus, along with other Mississippi towns like Meridian, Natchez, and Aberdeen, has also been in the forefront of converting space above old main street businesses into apartments to help insure that downtown remains vital to the local life.

The Golden Triangle is the region formed by the triangle of Columbus, Starkville, and West Point. Starkville, home to Mississippi State University (the state's largest university), is only a stone's throw from the Black Prairie proper. Twenty miles to the northwest, West Point, center of the popular annual Prairie Arts Festival and site of the predominately black Mary

Holmes College, greets you with one of the most roomy and picturesque small downtowns in the state: it offers quaint sidewalks, an expansive city park, antique shops, and the Clay County Courthouse nearby. Not far out in the countryside is Waverly Mansion, with its circular staircases and domed observatory; it is one of the most well-known antebellum buildings in the South. In the summer of 1999, more than a hundred thousand people descended on the West Point area for the Women's U.S. Open Golf Championship, played on one of America's finest courses, appropriately called Old Waverly.

Amory sits on level river terraces near prairies to the west and hills to the east. It is an active Tenn-Tom port city with an unbelievably long main street for a town of seven thousand. In 1887 much of the original community, Cotton Gin Port (settled on the site of an Indian river ford), was physically moved to a location at the new railroad. The annual Railroad Festival is a popular Mississippi celebration, and Amory's public school system is regarded as one of the most distinguished in the state. The middle school, with its programs aimed at the physical, psychological, and social needs of the children, is the only school of this type in the Deep South.

Aberdeen, fifteen miles from Amory, was the highlight of our Prairie peregrination. One of the wealthiest towns in Mississippi's cotton kingdom, it was by 1850 the second-largest city in the state, with the largest port on the Tombigbee, which explains its extraordinary architectural heritage. Along the sedate streets are examples of almost every period and style of southern architecture: antebellum mansions; ornate Victorians with wrap-around porches, mansard-roofed towers, leaded stained glass, and elaborate gingerbread; and 1920s bungalows. The main Victorian boulevard is called "Silk Stocking Avenue." Fifty-five homes appear on its driving tour. The town's second boom, in the late nineteenth century, inspired period shopfronts and landmark buildings in the downtown neighborhood, where entire blocks are sheltered by old-fashioned flat roofs supported by curbside pillars. I could have stayed in Aberdeen for days.

THE HILLS

Between the Black Prairie on the east and the Delta on the west, the Central Hills run slightly west and north, from just below Meridian, all the way to the Tennessee line—a succession of clay hills where soil erosion, which limited the growth of cotton, and the exigencies of the Civil War gave over the land for decades to sharecropping and the wicked credit system from which it did not reasonably recover until well into the twentieth century. The area now has a little cotton, usually scraggly, but mainly soybeans, corn, watermelons and other fruits, cattle, and light industry. One would never be tempted to call this region histrionic. The larger towns, however, though somewhat jejune, are sturdy enough; they include, on a south-to-north axis with certain east-west detours, Quitman, Newton, Forest, Philadelphia, Carthage, Louisville, Ackerman, Eupora, Calhoun City, Water Valley, Bruce, and Ashland. Black citizens make up only 35 percent of the population; Calhoun County, for instance, once called itself "the purest strain of Anglo-Saxon in the World." Many of these counties are legally "dry," including a number where you cannot buy even beer. A typical sight at county lines separating beer from non-beer provinces is a mammoth beer joint such as the one only a stone's throw south of Neshoba into Lauderdale.

"The somnolent hills and indolent population of East Mississippi" is how a local writer once described the texture of these locales. The rugged, primitive hills sometimes stretch to surprising heights (for Mississippi), then reach down into low-lying valleys and bottomlands, and the splendid pines and hardwoods in both the hills and the hollows lend a fine beauty to the landscape. Along circuitous two-lane roads I saw ruined shacks with rusty tin roofs under the shade of tall sheltering trees, small empty towns drowsy in a summer's sun, parched corn growing right up to the main streets, country baseball fields with chicken-wire backstops, log trucks of all sizes and descriptions, service stations that sell fried chicken, gnarled old men whittling under pecan trees, abandoned cars on dusty front lawns, loblolly pines lining the road as far as the

eye can see, the tiny lost hardscrabble hamlets, the small farms, distant ridges, and pasturelands all set in the stunningly red soil. Whenever I drive through such remote terrain I am reminded of what some elderly Mississippians contend to this day—that the most basic and dramatic happening in the state in the whole twentieth century was the introduction of electricity and running water to such poor rural areas.

Louisville is a hill-and-prairie town of farms and lumbering with an impressive mix of antebellum, Victorian, and early-twentieth-century homes; Ackerman, an old sawmill and courthouse town stretched out along the railroad tracks; Eupora, a rugged vista of wide streets and rough exteriors once noted for feuds and killings rivaling those of Sullivan's Hollow, where the late-night boys hang out in T-shirts in front of service stations near the highway junctions; Walthall, a minuscule county seat, where the courthouse of Webster County appears without warning in the middle of a field next to a half-collapsed house with a precarious tin roof; Bellefontaine, a crossroads village once noted for its noisome saloons, and which the natives pronounce, of course, Bell Fountaine; and Calhoun City, a hamlet with a large central square and sign of welcome: "The City Waiting for Tomorrow."

The Loess Hills (loess, les, lus: "a buff to grey windblown deposit of fine-grained, calcareous silt or clay") physically occupy just about all of the Old Natchez District and then continue north all the way to Memphis. The principal towns here are Vicksburg, Jackson and the nearby towns of Ridgeland, Madison, Pearl, and Brandon, Canton, Durant, Lexington, Winona, Kosciusko, Grenada, Water Valley, Batesville, Oxford, Sardis, Senatobia, Holly Springs, and Whitehaven. All except Water Valley, Oxford, and Holly Springs lie on or near the great south-north artery of Interstate 55, which crosses the heart of the state from the Louisiana line at Osyka to Memphis.

I have always admired Vicksburg's long steep thoroughfares, lofty bluffs, and its eternal dead: the cemetery where the Union boys are buried is the second-largest national cemetery, after Arlington. It does not have as many antebellum mansions as Natchez, seventy miles to the south, but the ones that survived the Civil War are impressive. It is a *funky* town with an honest feeling to it. It was the first of Mississippi's larger towns to elect a black mayor. For a long time its citizens held Natchez somewhat in contempt, because Natchez capitulated to the Federals without a fight, while Vicksburg—the Gibraltar of the South—was starved out and shelled for forty-five days. The fall of the town was likely the decisive moment of the Civil War (Lincoln telegraphed Grant: "The Father of Waters flows unvexed to the sea"), although the bloodletting raged on for another year and nine months. Because Vicksburg surrendered on July 4, that holiday was not observed in the whole surrounding region until World War I.

In *Life on the Mississippi*, Mark Twain recorded the recollections of a man who invited a friend to visit his cave for some prime whiskey after the night's bombardment. The two were heartily shaking hands when suddenly a shell descended, taking the friend's arm off and leaving it dangling in the man's hand. "And do you know," he told Twain, "the thing that is going to stick the longest in my memory, and outlast everything else, little and big, I reckon, is the main thought I had then? It was: 'The whiskey is *saved.*'"

In my own growing up, Vicksburg was a hypnotic place, only forty miles southwest of my town; driving with my grandparents among the markers and monuments of the battleground as a small child, I wondered to myself what had *happened* here, and my grandmother was always quick to give me *our* side of things. Later, in high school, we came here with our girlfriends for picnics, and explored the still-scarred ravines and hills, and absorbed the prospect of the river, tawny and omnipotent, far out in the distance. In 1948, we traveled to Vicksburg to welcome the Freedom Train, which was traveling around the nation with the original Declaration of Independence, the Constitution, the Emancipation Proclamation, and other items, and, for the first time that I had seen, black people waiting in line to board were not required to stand in back and let the whites go first, a spectacle that impressed and astonished me.

It was here, in 1894, that a candy merchant named Biedenharn took the fountain drink called Coca-Cola and put it into bottles for the first time and shipped it into other areas, creating a new concept in marketing. "Who knows?" a home expert says. "The Coca-Cola company might not even exist today had it not been for Biedenharn." Dr. Jane Ellen McAllister, the first black woman ever to receive a Ph.D. from Columbia University Teachers College and esteemed professor for many years at Jackson State University, was from Vicksburg, and so is the writer Ellen Gilchrist.

The commanding eminence of downtown Vicksburg today, on a high hill overlooking the river, is the Greek Revival courthouse with its clock tower and Ionic columns, cupolas, and porticoes. It houses a most uncommon museum with items going back to the Indian and French settlements as well as the South's largest collection of Civil War memorabilia. One day I asked Gordon Cotton, the curator, who knows as much about Vicksburg and its environs as anyone around, how on earth the courthouse survived the shellings from the gunboats. "It was easy," he said. "We put the Federal officers we'd captured in the courtroom, then got word about that to the Yankee admiral, Porter." Later that night, Gordon and I were having a drink at the bar in Maxwell's Restaurant, and a tourist from Iowa who had stopped to do a little gambling in one of the new casinos had a question for me. "Say," he asked, "wasn't there some kind of battle here?"

Sixteen miles north of Jackson is the noteworthy town of Canton, which lies between the Big Black and the Pearl rivers. Its old cotton culture and proximity to the Natchez Trace endowed it with a surprising number of mansions set on tree-lined streets, and its Greek Revival courthouse is one of only seven antebellum courthouses left in Mississippi. (The other six are Woodville, Holly Springs, Liberty, Natchez, Raymond, and Carrollton. The former Vicksburg courthouse is also antebellum.) While so many other towns are bulldozing their old buildings for parking lots and fast-food enterprises, this town has zealously preserved its many historical edifices—

hotels, banks, the depot, the jail, schools, the post office, churches, stores, barbershops—a foremost reason why a succession of fine Hollywood movies have been filmed here (including one of my personal favorites, *My Dog Skip*), and in the process brought considerable money into the local economy. There is also a museum of African American history, an annual hot air balloon festival, and two flea markets a year that bring in eighty thousand people from all over the United States. Other Mississippi towns would do well to emulate the example of Canton.

As one continues north on I-55, the town of Carrollton, one of the oldest in north-central Mississippi and home of the writer Elizabeth Spencer, is not far off the path. Carrollton lingers from a more fabled aristocratic cotton past, with a courthouse square pristine from that era. Not far from Carrollton through pine and cedar forests was the palatial mansion Malmaison, the domicile of the legendary Greenwood Leflore, Choctaw chief and later cotton planter. Greenwood, Mississippi, and its county, Leflore, are named after him. He refused to support the Confederacy, and the American flag flew over Malmaison throughout the war.

Kosciusko, south and east of Carrollton, was named for Tadeusz Kosciusko, the Polish general who served in the American Revolution. Situated just off the Natchez Trace, which gave it a cosmopolitan flavor early on, it is a somnolent town of Victorian houses set back from towering magnolias, narrow streets that dead-end at tortuous ravines, and a courthouse square which dominates the tallest hill around. In my high school era, the Kosciusko Whippets were known regionally for their tough athletic teams—a "tough town," we called it, which may explain why it produced both James Meredith and Oprah Winfrey. The town has named a street after Oprah and has grown into an antiques center. Fifty-six miles northwest is Grenada, technically a hill town, although, being on the fringes of the Delta, it bears much of the character and personality of that province. It is the hometown of former governor William Winter and of Jake Gibbs, all-American quarterback for Ole Miss and later catcher with the New York Yankees, one of

the state's most beloved athletes, who on his first Manhattan evening while dining with Mickey Mantle, Yogi Berra, and Whitey Ford at the Fifty-One Club ordered from the dessert waiter "apple pie a la mode, and put some ice cream on it."

I lived for ten years in Oxford, fifty miles northeast of Grenada, as writer-in-residence at the University of Mississippi. One night when I was dining with Miz Louise, William Faulkner's sister-in-law, she told me some local stories, then said, "Oxford's an interesting town." I found myself replying, "I agree, Louise. I think somebody ought to write about it."

Oxford is profoundly shaped by the Faulknerian corpus and by the presence of the University of Mississippi. It is in every aspect a college town, with one of the loveliest campuses in America, and a well-functioning courthouse square which with its shiny boutiques and art galleries and gourmet restaurants has grown quite fancy since Faulkner's day. Enrollment in the university and the population of the town are almost equal, roughly ten thousand each, and the campus and courthouse square are only a few minutes' walk from each other; perhaps all universities should be in small towns. The houses have names like Shadow Lawn, Memory House, and Rowan Oak, which was Faulkner's.

When he was alive the town did not know what to make of Faulkner. Even when he was in his prime, laboring on his most powerful novels, he was known here as "Count No 'Count." He loved Mississippi, but Mississippi did not return his love. For his liberal views on race and his explicit books, the state's leading newspaper columnist in the 1950s judged him a member of "the Garbage Can School of Literature." Today he is a principal industry of the town, with pilgrims paying homage from all over the world, though fortunately Oxford has not succumbed to commercial Faulkner mania the way Hannibal, Missouri, for instance, has done in regard to Mark Twain. In September 1998, Oxford celebrated the centennial of the bard's birth with well-attended ceremonies on the square and the unveiling of a statue of him, created by William Beckwith, sitting for posterity on a bench as he often did in this neighborhood, in a tweed jacket and smoking a pipe. All Faulkners living in Oxford and elsewhere, with the exception of one distant cousin, boycotted the event because they deemed the statue an invasion of privacy. But during the ceremony Shelby Foote remarked that Faulkner belonged to the world.

The countryside's rough red earth, the creeks and swamps and abandoned wooden houses, farmers ambling along the roads, dark snake-infested kudzu vines, country dogs barking in the distance, the fields of soybeans and unseemly cotton, the humble graveyards and derelict general stores are the most eloquent Faulknerian monuments, however. Shown these sights in the area around Oxford, a French intellectual in attendance at the annual Faulkner conference declared to her guide, "I love this decadence! You must preserve your *decadence*!"

Oxford was also the hometown of Stark Young, 1881–1963, author of the Civil War epic *So Red the Rose* and national literary critic, and is now where the contemporary writers Barry Hannah and Larry Brown reside.

Holly Springs, north of Oxford beyond the Tallahatchie River, which with the Yalobusha forms the Yazoo north of Greenwood, is one of the most exceptional towns in Mississippi. It, too, harbors a palpable air of decadence. Marshall County, of which it is the county seat, provides an unerring example of how the land itself has molded its people. Neither a Delta county nor a Black Prairie one, Marshall County possesses a wide corridor of rich loess soil; it is an incredibly fertile vicinity, which produced a cotton culture and a slave economy overseen by dispossessed well-born second sons who immigrated here from Virginia and the Carolinas in the 1830s. Without this rich loess outcropping there would not be a 70 percent black population and a black-majority civic government, nor, for that matter, the numerous colonnaded antebellum homes, sixty-one in all, Greek Revival and Georgian Revival and Deep South replicas of the grandiose Tidewater style, lining the lanes off the courthouse square like sentinels. More than a few of them are rather forlorn now—"their faded grandeur," to quote the *WPA Guide*, "eloquent ex-

pression of a culture that sprang into being, flowered, and died within a generation."

During the Civil War, Holly Springs experienced more than sixty raids by both armies, which added to the schizoid nature of the town. In Earl van Dorn's Confederate raid of 1862, which likely postponed the fall of Vicksburg by a year or more, the invaders destroyed Grant's stores, made off with his army's money, commandeered his headquarters, and almost captured his wife.

Holly Springs was the hometown of a beguiling literary figure, Sherwood Bonner (1849–1883), who, as a young woman, moved to New England after the Civil War and became the personal secretary and close friend of Henry Wadsworth Longfellow. He encouraged her in her own writing, and critics acknowledge that her stories and tales helped move American fiction from saccharine romance toward realism and naturalism.

It is a town that will not let go of you. Like many in the Delta, it is a drinking town, a town of partyings in genteel houses. On my first visit there years ago, I was a guest in the home of a scion of that gentility, lineal descendant of one of the first two U.S. senators from the state, a graduate of Harvard Law with the most unadulterated nineteenth-century southern accent I have ever heard, who confessed to me he took his Buick on the *Queen Elizabeth* for a tour of Europe not long after World War II. Why did he take his car? I asked. "Because I wanted to have the only vehicle in all of Europe with a Mississippi license plate," he replied. Later, before we went on a private excursion to the unforgettable Holly Springs cemetery (in which he himself, God bless him, now rests), he fixed two very tall and powerful gin-and-tonics for us to take along.

A few years back I took Jeffrey Selznick to Holly Springs. (Jeffrey is the son of David O. Selznick, who produced the movie *Gone with the Wind*.) After a while Jeffrey said, "I sure wish my father had known about *this* town." A recent establishment in Holly Springs, set up in an antebellum house, is called Graceland Too; its proprietors are a father and son, both Elvis impersonators. This nexus exhibits Elvis memorabilia and paraphernalia, including the petals from the first flowers on Elvis's grave, and keeps the iconology alive by monitoring on a twenty-four-hour basis all television programs about Elvis to ascertain their accuracy. The owners were genial enough when David Rae dropped in on them, but required that cash be exchanged for any photographs taken, which suggests something, I suppose, about the Tupelo boy's offshoot financial progeny.

On the outskirts of town is Rust College, an all-black liberal arts school founded by the Methodist Episcopal Church in 1868. It has exchange students from all over the world. One Sunday afternoon I happened into a barbeque place near the college, to be greeted by a stunning sight: some three or four dozen young people in native African dress, speaking in exotic languages while eating with considerable gusto steaming platefuls of Mississippi barbeque and hushpuppies.

THE DELTA

This may be the most unusual of the Mississippi regions. If, through some egregious misjudgment in ecological planning, eons hence the entire globe is made into a parking lot, the Delta will be the last to be paved over. Although not so much as it once was, Memphis remains in many ways the unofficial capital of the Delta. Greenville writer David Cohn said, "Culturally, Memphis is to the Delta what Paris is to Toulouse." This is where the banks grew rich by loaning money at bloated rates to Delta planters, where thousands of impoverished Delta blacks migrated, and where Delta wives came to shop on cotton credit.

But the heart of the Delta, its primordial interior, is south of Memphis. It is the most fertile land in the world, richer than the Nile Valley, so fecund that, long before the working of cotton plantations by African slaves, the native-born Indians had formed a complex civilization derived from agriculture. It is wholly flat—not a hill from Yazoo City to Memphis. It once was the very floor of the sea. The historian James C. Cobb calls it "the most southern place on earth," the novel-

ist Richard Ford, "the South's South." "The planter here has evolved an active yet irresistible way of life," the 1938 *WPA Guide* reported. "The variable factors are high water and the price of cotton; the constant is the Negro."

More than 80 percent of the state's cotton and soybeans and 95 percent of its rice are grown in the Delta. Many outlanders confuse it with the classic delta at the mouth of the Mississippi built up over the ages by silt transported by the river to the reaches south of New Orleans. But this one is different. It is the Yazoo-Mississippi Delta, a vague deltoid triangle between those two rivers, some two hundred miles north to south and on average sixty-five miles in width. Once it was an impenetrable forest, "a jungle equal to any in Africa" as a nineteenth-century traveler described it, swarming with bears, panthers, alligators, giant mosquitoes and spiders, blue-backed scorpions, rattlesnakes and cottonmouths, and swarms of little gnats that would hound men to crazy distraction.

The Delta to me is Old Testament in its intensities. It was settled late, so that, except for a few big plantations and river towns, even by the 1890s it was mostly undeveloped. Today the shadowy preserve of the Delta National Forest between Holly Bluff and Rolling Fork provides some notion of what the Delta was like before it was cleared. Whites and blacks entered the area at the same time. "This land is first and last [the black man's] handiwork," one historian has written. "It was he who brought order out of primeval wilderness, felling the trees, digging the ditches, and draining the swamps. . . . He built the schools, the courthouses, the jails, the factories, and the warehouses. Everything in the Delta sprang from the sweat and brawn of the Negro."

The sweeping migration of the black people north began in the second decade of the twentieth century and continued unabated with the mechanization of cotton planting in the 1950s, to the extent that, according to the *Encyclopedia of Southern Culture*, for many years almost as many black Chicagoans had been born in Mississippi as in Illinois. The Delta is big houses and abandoned shacks, endless vistas of cot-

ton, soybeans, rice, and wheat, white cotton bolls that fall from trucks during the picking season and line the highways, daredevil crop dusters buzzing overhead, catfish ponds, half-empty hamlets where black men, women, and children sit on the stoops of forlorn dwellings. It is "as if an ancient civilization had died out," the easterner Peter Applebome wrote, "leaving behind only a desultory colony of black survivors and ramshackle houses and ghost towns baking under the Mississippi sun." Cotton growing still meant money for the plantation owners until the 1980s, when many lost land. Today, much of the Delta is held in absentee ownership.

Some of the Delta's big towns look a little frayed at the edges, too. Many of the country people have migrated to them, and fast-food establishments and shopping malls are the first thing you see on your approach. Greenville, traditionally considered the cultural capital of the Delta, is a remarkable river town which has over the years produced an august array of artists and writers, including William Alexander Percy, Shelby Foote, David Cohn, Walker Percy, Ellen Douglas, Charles Bell, Beverly Lowry, Hodding Carter, Jr., Hodding Carter III, Franke and Bern Keating, and the historians David Sansing and Ray Skates, a stunning roster for a town its size. The public library on Main Street is named after the town's patron saint, William Alexander Percy (1885–1942), who attended Sewanee and Harvard and was a soldier, planter, lawyer, scholar, poet, and memoirist, author of the autobiography *Lanterns on the Levee*, and who adopted his young cousins Walker Percy and his brothers after their parents had died. The contemporary writer Beverly Lowry has written of growing up in Greenville: "William Alexander Percy was our greatest hero. From the time I was in elementary school I always knew it was not only respectable to be a writer, but honorable, desirable. The literary tradition in Greenville is strong. Who the next writer would be was always pondered. Teachers were on the lookout."

Greenville likewise quarters my favorite restaurant in the world, Doe's Eat Place, in a decrepit shack where you can dine in the kitchen itself on one-and-a-half-

pound T-bones prepared with steak suet, on tamales and french fries, and where people at adjoining tables finish your sentences for you. (My spirit was sundered, a stake in my deepest heart, when I learned in 1999 that Doe's was moving in toto to one of the new casinos.) In Greenville the domiciles on Washington Street are as graceful as they ever were, but not far away on the water are the casinos.

Cleveland, thirty miles or so northeast, is the site of a fine regional school, Delta State University, with its much admired program in the arts and its athletic teams sometimes called "the Fighting Okra," where in 1947 Dean Acheson, speaking before the Delta Council, first unveiled the Marshall Plan. Clarksdale, farther north, the hometown of the immortal quarterback Charlie Conerly and a place where Tennessee Williams once lived, is home to the Delta Blues Museum. John Lee Hooker and Sam Cooke were born here, Robert Johnson made his pact with the Devil just up the road from here, and W. C. Handy lived here before moving on to Memphis. Wade Walton, the late blues-singing barber, had his barbershop here, and he sometimes played a song between haircuts. Early "Soul Man" Wright spun blues and gospel for decades at WROX radio, which has been here since the 1940s.

Clarksdale and Coahoma County were highlighted in the national media when President Clinton visited there in July 1999 with a group of business and political leaders studying the possibility of economic improvement for such impoverished areas. The city has a new high school, and Coahoma Community College is working with NASA to develop high-tech programs. The vicinity's rich blues tradition is being used to encourage tourism. But the county has lost one-fourth of its population since 1970, is a leader in teenage pregnancy rates, and is among the worst in percentage of high school graduates (54 percent)—a prototypical modern Delta city of extreme wealth but also extreme poverty, which is as pronounced as in any region in America, with 37 percent of its people and more than half of its children living below the poverty line.

Greenwood, which is the hometown of, among others, Carrie Nye, the reputable Shakespearean actress, and Byron De La Beckwith, the assassin of Medgar Evers, calls itself the Cotton Capital of the World and is judged by many who know about such things to be the most Delta of all the Delta towns, an assessment which suggests flamboyance and eccentricity. The towering concrete neo-Gothic courthouse, right on the Yazoo River and a stone's throw from Cotton Row with its old cotton trading establishments—the second largest cotton exchange in the United States—still dominates the downtown, and Grand Boulevard, with its prosperous houses belonging to planters and professionals, remains typical of the wealthy thoroughfare of a medium-sized Mississippi city. Thirty miles west in Sunflower County, Indianola, hometown of blues singer B. B. King and food critic Craig Claiborne, is unexpectedly neat and spruced up compared to my boyhood memories of it, with a prosperous main street that has not capitulated to the Wal-Mart. (I recently gave a talk at the public high school, where the student body is 100 percent black and the alma mater is sung to the tune of "Danny Boy.")

The Delta has forever been noted for its improvidence, its hospitality, its garrulousness, its profligacy, and its partying. It is a church-going and whiskey-drinking society, and this has not changed. The journalist Bern Keating cites parties in Greenville thrown together on the slightest pretext: a too-much-rain party, or a drought party, or a thank-heavens-it's-Thursday party. In the 1950s we Delta kids acquired our taste for such partying early on, mainly to the accompaniment of a peregrinating black band out of Vicksburg called the Red Tops, who during the daytime worked as clerks, postmen, and manual laborers. On my later travels around America whenever I have chanced to run into someone my age and from my native soil, the person has invariably asked, "Did you dance to the Red Tops?"

The Red Tops dances at the Yazoo City Country Club were attended by other high school and college kids from all over the Delta. In the flush of creamy Mississippi adolescence, we and our double-named Delta belles forged the ineluctable bonds of "going

steady." The band played on college campuses and at city auditoriums and nightclubs and became synonymous with indigenous establishments of the era like Ruby's Night Spot and Lillo's Supper Club in Leland, the Wagon Wheel in Jackson, Mink's in Greenville, and the Hippodrome in Memphis. They also performed frequently at black colleges and high schools, where local white youngsters often disregarded the racial taboos and attended—the first faint beginnings, this might be judged, of integration in the great and sovereign state of Mississippi. But the Delta itself was their real and sustaining hegemony, and white high schoolers their most faithful constituents. They were our heroes, and we knew them each by name.

We danced the Memphis shuffle indiscriminately to both the swift and the languid tunes. The Red Tops never failed to bring the house down with their rousing performance of "Darkness on the Delta," because the Delta itself was right outside, its great alluvial flatness, its summer symphony of cicadas, its resonant echoes—the eternal, beguiling, tragic Delta, although I guess we took it more or less for granted then:

When it's darkness on the Del-ta,
That's the time my heart is light,
When it's darkness on the Del-ta,
Let me linger in the shel-ter of the night. . . .

In that era of rigid racial segregation and the tightening of tensions after *Brown v. Board of Education*, the Red Tops were celebrities among Mississippi's young whites, who treated them with undeviating deference and respect. We actually established an organized Red Tops fan club and dressed in uniforms like the band's. We drove from one Delta town to another on weekends for the dances. Did we discern any paradox, or irony, in this back then? Of course we didn't.

The celebrative tradition continues to be embraced by all ethnicities in the Delta, and likely always will. On a recent Saturday night of the full moon I was drawn to a white honky-tonk near a parking lot filled to capacity with dusty pickup trucks. Inside, dozens of couples in all modes of dress gyrated on the dance floor to Willie Nelson tunes, and the unprepossessing interior echoed with wild greetings and indigenous hosannas; there was a pride in this place that I knew in my ancestral soul, a pride not to be unduly tampered with. The black roadhouses and taverns—"juke joints"—which come and go, dotting the Delta, are integral to the region's hard-drinking lineage. They have been memorably photographed by Birney Imes: Monkey's Place and the Pink Pony in Merigold, Riverside Lounge in Shaw, Leland Juke in Leland, the Busy Bee in Hollandale, the Playboy Club No. 2 in Louise, the Uptight in Moorhead, the Royal Crown in Boyle, Emma Byrd's Place in Marcella, the Magic Star in Falcon.

The reunions of black families which take place across the Delta in the summers are in the tradition also, with those Mississippians who have migrated to Chicago or Detroit or Gary or St. Louis returning home with their progeny to see the relatives who have remained. Often they take over entire motels. Once I found myself the only white person beside the swimming pool of a Ramada Inn in Greenwood. Those who claim that the American use of language and way of talking have become bland and homogeneous because of mass television culture should have been listening with me that day.

You must really get out into the byways of the Delta, into its countryside and remnant towns, to capture the true contrasts with modern America and with other parts of Mississippi itself. Here are just a few of them:

Tiny Itta Bena, out from Greenwood, is the hometown of the writer Lewis Nordan and also the location of the predominately black Mississippi Valley State University, where Jerry Rice played football for the Delta Devils, the football stadium rising right out of the cotton fields. In the all-black hamlet of Falcon, on a bitter winter's day there was wood smoke from the lean-to houses and no one was out and about, except for a dozen or so kids shooting baskets, wearing socks on their hands against the winter cold. Down on the main street of Alligator—hometown of the

star National Football League linebacker Tony Bennett, whose nickname, naturally, is "Gator"—almost all the storefronts were boarded up; had everyone migrated to Greenville or Cleveland or Indianola? Out from town the cotton stubble lay gray and frozen, and I knew that in the springtime these fields would be worked by enormous new tractors with air conditioners and stereos in their cabins. I made a side tour to Drew, hometown of the illustrious and gentlemanly quarterback Archie Manning, to visit a former student of mine at Ole Miss who had been named runner-up to Miss America in Atlantic City, but she had been out in the swamp most of the night killing bullfrogs with a .22 pistol for a frog-fry, her mother told me, and had remained at her girlfriend's house in the country. When I left her place I drove past big white ranch-style houses surrounded by pecans and magnolias and featuring croquet lawns, tennis courts, and swimming pools, with Mercedes and pickup trucks under the porticos.

In Belzoni, "Catfish Capital of the World," as the billboard declares, they were having the annual Catfish Festival. But there has been a new twist in recent years. The black citizens had decided to have their own festival, and rather than catfish they were frying *buffalo* fish. I wandered the streets of the town so familiar to me from having gone to Red Tops dances there and playing sports against the Belzoni High School Warriors. The Jewish and Lebanese mercantile stores were the same as ever. The building that once housed the Tru-Value Furniture store was unoccupied. In my youth it was the store of the father of Larry Gordon, now a Hollywood producer. The Gordons were Jewish, but one day when he was little Larry persuaded a young Protestant friend to take him to the revival at the Baptist church. The friend responded to the revivalist's call to come to the altar and be "saved," and when he did Larry Gordon followed him down and was saved, too.

In some parts of the middle Delta, if you are in a wandering mood as I usually am when I'm there, you cross the Tallahatchie River several times. A number of these bridges lay claim to being the one that Billie Joe McAllister jumped off in Bobbie Gentry's haunting popular hit of the 1960s.

Highway 32 connects Highway 49 and the Delta town of Shelby and cuts straight through the heart of Parchman, the notorious state penitentiary where until fairly recent times the worst aspects of slavery survived, making the prison synonymous with cruelty. (Today most of Parchman's cotton land is leased to farmers, and many of its inmates participate in external rehabilitation programs.) There are checkpoints with armed female guards monitoring those who are coming in and leaving. A friend and I drove somberly past Death Row and the other locked installations until we reached the outgoing security gate. The guards stopped us and opened the trunk of our car to look inside; it took us a few miles to conclude that they had been making sure we were not harboring any escapees.

Much farther south in the Delta there is an abandoned high school gymnasium in the Yazoo River village of Satartia. I played high school basketball games in this gym years ago. A Mississippi version of the gym in the film *Hoosiers*, it is now dark and bereft. With public school integration this high school became all-black, and a black kid named Rod Barnes played some of his school basketball here. In 1998, at age thirty-two, Barnes became head basketball coach for the Ole Miss Rebels.

There are stretches of the Delta as isolated and primitive as you will find anywhere in the United States. Lula, in the deepest soul of the flatland, hometown of Thomas Harris, author of *Silence of the Lambs* and *Hannibal*, is a very long way from Madison Avenue and 42nd Street, but it's not far from the remote and beautiful Moon Lake, prominent in Tennessee Williams's work. Uncle Henry's Place, the old restaurant-dance hall and gambling casino which Williams wrote about, is still there, shrouded in crepe myrtles and magnolias on the banks of the lake and evoking the playwright's doomed characters Blanche DuBois, Papa Gonzales, and Amanda Wingfield. Jonestown has sizeable potholes in its main street and the most impoverished black quarters I have ever seen in

this state; here in front of the diminutive wood-frame town hall I encountered a man with his yellow dog and asked him if Mr. John Wing, whom I had heard about here and there, was still mayor of the town; he casually withdrew a wallet holding an official badge with the inscription "Mayor of Jonestown" and said, "I beat the Chinaman two years ago." North and west, lying in the shadow of the Mississippi River levee with a fine view of the river from the top, Friars Point has the feel of a ghost town, although thirteen hundred souls still live there, and history records it as the oldest steamboat town on the river, established in the 1830s. This strange little hamlet has the most eclectic museum I have ever visited, with a rusty World War II tank on its front lawn.

I have always loved the Delta in the rain. On one particularly fine and rainy day I drove through Issaquena County down Highway 61 between Rolling Fork and Vicksburg. Somewhere in here is the last remnant of the primordial Delta forests that were the setting for the fictional deer camp of Faulkner's "Delta Autumn," one of the finest stories in the language. In all of Issaquena County, there is not a single school, hospital, railroad, or traffic light. There is, however, the unforgettable Onward General Store, roughly the site of Teddy Roosevelt's bear hunt in 1902, during which he refused to shoot a young bear—hence the genesis of the teddy bear. Not much has changed since Roosevelt was here. The quiescent main street of Mayersville, county seat of Issaquena, comes to an abrupt end at the Mississippi River levee itself. For several years it has had a black mayor, Unita Blackwell, well known in state and national circles and a world traveler. Today she remembers standing by Highway 61 near Mayersville as a child, her grandmother waving down a Greyhound to take them north: "And that highway still looks pretty much the same. It was such a thrill because that bus just came out of nowhere, and when you got on it you knew you were going someplace. But now when I go someplace far away, and I'm headed back, I see that road and it looks like home."

I conclude the Delta section with Yazoo City, my

hometown. Providence had placed us here, half on the hills, half on the great Delta, but in quintessential élan we were really flatland people: roughly half of us Aryan and half African, with an additional leavening of Italian, Jewish, Lebanese, and Chinese. The town is still called "the Gateway to the Delta." I grew up on its first street, and others who called that small neighborhood home include Mike Espy, the first black congressman from Mississippi since Reconstruction and later U.S. Secretary of Agriculture (Mike's grandfather, T. J. Huddleston, owner of a funeral home, was the first black man I ever saw driving a Cadillac); Haley Barbour, national chairman of the Republican Party; Zig Ziglar, best-selling inspirationalist; and Willie Brown, member of the NFL Hall of Fame and the greatest defensive back in the history of football. The Yazoo Motel and Stub's Restaurant, which used to greet one at the intersection of Highway 49E and 49W, have vanished from the landscape, replaced by a gargantuan Kmart. Fast-food franchises line the highways on the edge of the old town, and affluent subdivisions are tucked here and there. The streets in the black section are all paved now, and the town has a black mayor. The historic home of the Oakes family, free blacks who moved to Yazoo in the 1850s, has been restored and made into a museum of black history and a cultural center. With a few exceptions, Yazoo looks remarkably the same to me as it did in 1948. The old residential areas, with their secretive and vagrant alleys behind the main thoroughfares, are still there. Main Street, my Main Street, has altered scarcely at all: only the names on the stores are different.

Just north of town, the high terraced loess hill on which rests the marble-faced headquarters of the Mississippi Chemical Corporation provides the most majestic and intimate vista I have ever seen of the Delta: the cypress trees in the mossy swampland, the cotton fields, the vast alluvia sweeping to the farthest reaches of the copious horizons. Not very long ago during a Sunday afternoon's drive I took Eudora Welty up there. "That's it," she said, as she gazed downward. "That's the Delta."

THE WAY WE ARE

And through all this, one loves this place as I have, the perceptions of the venerable continuities of time—the births and deaths, natural and violent, the forgotten tragedies and triumphs, the sadnesses and joys of man's existence in one small stretch of the planet.

—*Introduction,* YAZOO: ITS LEGENDS AND LEGACIES

MISSISSIPPI IS SET APART BY ITS

people. Here we are—2.7 million people, and most of us want to know as much as possible about the rest of us. We want to know about your parents and grandparents and children and grandchildren—where they come from, where they live now, and what they are doing there. Surely all Mississippians have asked or been asked, when meeting someone from another town in the state, "Do you know X? Where are you from [meaning not where do you live, but where did you grow up]? Are you related to Y?" What Mississippian has not been many miles from the state and met someone who says, "I knew someone from Mississippi once; I'm sure you wouldn't know him"? The outlander is totally surprised when you *do* know the person, but you consider it completely natural. And what Mississippian, when far away, has not been gratified to discover someone who grew up in Mississippi or has relatives here? When I was living in New York City, I would often take a taxicab from the Upper West Side to my office. An elderly, affectionate black cab driver who had grown up in Vicksburg usually tried, after his nocturnal toils, to take his last fare in the mornings around Broadway and the Nineties, and he would look for me waiting on a corner for a cab and drive me downtown to work, talking all the while of home. He and I had it—the Mississippi connection.

The Chapel Hill historian John Shelton Reed was writing about the broader South when he observed, "Where the economic and political story has been one of conflict and separation, the tale of the cultural South . . . is one of blending, sharing, mutual influence, continuing unity and distinctiveness." This, I believe, has been especially true of Mississippi.

Mississippi is an amalgam of diverse racial and ethnic groups, and all are shaped by these nuances of the native culture. Implicit in the reality of the state, of course, is the omniscient white-black connection. Mississippi's two great blood sources were Great Britain and West Africa. (An English visitor to my hometown of Yazoo City once perused the local telephone directory and declared that the surnames in it were the same as in the London one.) Over many years white European Protestants and their black contemporaries have produced distinct but kindred cultures, and they are profoundly intertwined, each borrowing from the other, shaping one another's language, folklore, art, values, and tastes in complex and elusive yet also palpable and day-to-day ways. No one comprehended this more forcefully than W. J. Cash, who wrote in *The Mind of the South*, "Negro entered into white man as profoundly as white man entered into Negro—subtly influencing every gesture, every word, every emotion and idea, every attitude." Race has been a burden, yet also an exhilaration. For thirty years now the state's integrated public schools have enhanced this cultural interaction among the young, a robust interrelationship that augurs well for the society if it continues. A common scene around the state is young whites and blacks who work alongside each other in office or factory complexes taking their lunch breaks together in buoyant fellowship and swapping sandwiches and desserts from their lunch pails or brown bags. You do not see much of this camaraderie, however, after the sun goes down. Besides the workplace, the state's most integrated segments are most of the public schools, sports, and the Democratic Party.

The state's smaller ethnic groups, historically rooted and unique, reflect in varying ways their ancestry and heritage, but are in temper and habitude more American and southern and Mississippian than separatist. Mississippi's mix includes Native American Indians, Jews, Italians, Lebanese, Chinese, Greeks, Poles, Slavs, Vietnamese, and Hispanics; add to that a growing community of largely affluent immigrants from the subcontinent of India, who dwell principally in the Jackson vicinity. I witnessed a happy moment a few years ago when a naturalization ceremony was held in the Oxford courtroom of the late U.S. district judge William Keady, and several dozen people from a number of countries around the world were given their citizenship papers; these rituals take place twice a year in federal courts around the state.

One of the most remarkable juxtapositions in modern Mississippi is found in the red hills of Neshoba County, on the Choctaw reservation just outside Philadelphia. The Choctaws are the only Native American tribe that has remained distinctive in the state. Most of their ancestors were forced to leave their homeland to trek westward along the infamous "trail of tears" to Oklahoma in the 1830s, and those who remained wandered homeless for years through the swamplands of east-central Mississippi until the government relegated them to a few square miles of impoverished soil in Neshoba County. They are a proud people and despite the hardships have been successful in retaining their traditional culture—their language "euphonious and epigrammatic," as one expert described it, "elemental like the sounds of the forest," schools (their sports teams are the Choctaw Central High Warriors, of course), craftsmanship, stickball, and songs, dances, and arts, including basket making, which involves the use of swamp cane gathered from the banks of the Yockanookany River. One of the most memorable sporting events I ever witnessed was the reservation's Choctaw Bowl several years ago—Union High School Yellowjackets vs. Philadelphia High School Tornadoes—where the five thousand or so spectators were roughly one-third white, one-third black, and one-third Indian. The people on the reservation lived in poverty and terrible neglect for long years, until the Lyndon Johnson programs of the 1960s began fostering improvements.

Today, under the guidance of the colorful and influential chief, Philip Martin, a sharp and aggressive leader who speaks with a pronounced Mississippi accent, the reservation is home to the lavish Silver Star Casino, with a world-class spa, gourmet restaurants, and a fabulous golf course to which golfers fly in from all over and on which, I am told, the chief personally demanded that more azaleas be planted than are on the famous Masters course in Augusta. I drove over there one recent Saturday afternoon to be greeted by an arresting spectacle: the casino area (the size of several football fields) crowded to capacity with people of all races, physiognomies, and ages, and the occasional Choctaw man or woman running the blackjack and crap tables and roulettes. The Silver Star arrived on the scene in 1994, and today benefits every Choctaw man, woman, and child.

The Jews of Mississippi can trace their roots here as far back as the early years of statehood. They entered Mississippi in the nineteenth century, mainly through New Orleans, in three waves: Spanish-Sephardic Jews from the Iberian Peninsula, German Jews fleeing persecution in Germany, and Jews from Eastern Europe likewise seeking religious and economic freedom. At first most of them made their living peddling merchandise from town to town or as owners of small stores. Wherever they went they soon established thriving businesses. Originally populating mainly the river towns of Natchez, Port Gibson, Vicksburg, and Greenville, they gradually moved elsewhere in the state as the railroads replaced river traffic. Meridian, for instance, near the eastern edge of the state, developed a sizeable Jewish community, and Paula Ackerman of that city was the first woman in the United States to become a rabbi.

The substantial Jewish cemeteries in the state are singular reminders of their culture and history in Mississippi. "Jewish Hill" in the old Natchez cemetery overlooks the river. The one in Vicksburg is located near the main entrance to the battlefield and was part of the battleground during the siege. (Many Mississippi Jews served in the Confederacy during that war.) I was surprised by how large the Jewish cemetery in Greenville was when I first visited it.

There are smaller ones in other parts of Mississippi, such as the one in the heart of Jackson on North State Street; many are enclaves within town cemeteries, as in Yazoo City where the Main Street merchants and their families I once knew are buried. Strolling these burial grounds and reading the inscriptions on the stones citing the birthplaces in Alsace-Lorraine and Prussia and Poland is a journey through time.

The Jewish people of Mississippi have been noted for their philanthropic activities in the advancement of the arts, education, and architecture. They have traditionally been an integral part of the social, political, and cultural lives of their communities. To be both a Jew and a Mississippian, my Jewish friends have told me, is to be aware of a subtle dichotomy between a deep involvement in one's own history and homeland and the southerner's dedication to place, to land, and to that particular complicated past. In his *The Provincials: A Personal History of the Jews in the South*, Eli N. Evans reports that most Jews in the South, including Mississippi, "live in a relaxed atmosphere without fear for their safety or worry over their future," and that "there are far more threats and incidents directed against Jewish institutions in the major cities of the North, where most Jews live, than in the South." Speaking historically, he writes, "Not only is the intensity of religious prejudice against Jews probably lessened because of the presence of the Negro as the 'lightning rod for prejudice,' but the poor white senses an economic competitiveness that he does not feel with the Jew."

When many Mississippi Jews became involved in the civil rights struggles of the 1960s, however, they drew the wrath of the Ku Klux Klan. This culminated in the bombing of the Jackson temple in 1967, of Rabbi Perry Nussbaum's home later that year, and of the synagogue in Meridian in 1968. These and earlier crimes against blacks, especially the triple murders in Neshoba County, which included two Jewish men, led to vastly enlarged federal law enforcement activity in the state; the FBI targeted the Klan through infiltration and surveillance and for all effective purposes broke its back. After the bombing of

the synagogue in Jackson, a number of Jewish business-men in that city began meeting for lunch every Friday at the Golden Dragon Chinese restaurant to discuss the public issues and problems of those volatile times. Though some are elderly now, they continue to have these lunches. They call themselves "the Kosher Nostra."

I remember from my own growing up in Yazoo City one of my father's best friends, Harry Applebaum, with whom he often played dominoes in Fire Station Number Two. Back in 1904 when Mr. Applebaum and his father were living in Vicksburg, they heard about the fire that had just burned down Yazoo; loading all their merchandise on a barge, they went there and became permanent members of the community. Mr. Applebaum later was mayor of Yazoo City for many years—he often personally directed traffic on Main Street on Saturday nights—and subsequently was elected to the state legislature. In his later days he lamented, as did many small-town Mississippi Jews, that their children were drifting away—to other religions, to the big cities of the South.

It was a steady diminishment. In the 1930s the Jewish population in Mississippi was about five thousand. Today it stands at about two thousand. Of the fourteen temples and synagogues in the state, a few have become historic shrines, such as the one in Port Gibson which now has two members. The other synagogues range from Beth Israel in Jackson with two hundred thirteen members to Temple Beth El in Lexington with seven. B'nai Israel in Natchez, the oldest in the state, has twenty-three members. Once a month the congregation flies in a student rabbi from Ohio to conduct the service.

Today one of the most intriguing places in Mississippi is the Museum of the Southern Jewish Experience in Utica, a 1998 recipient of one of the Mississippi Arts Commission's Governor's Awards for Excellence in the Arts. Founded in 1989 on the grounds of a summer camp for Jewish children directed by Macy B. Hart, originally of Winona, the museum exhibits art, photographs, and artifacts and engages in cultural history tours, the restoration of synagogues, and the preservation of cemeteries. This privately funded museum brings to life the struggles and triumphs of the

European Jews who sought freedom here. Its exhibit *Alsace to America* chronicled the Jewish settlements along the Mississippi River from New Orleans to Memphis.

There are more Chinese-Americans in Mississippi now than in any other southern state. At one time there were around four thousand, mostly living in the Delta. Now there are about twenty-seven hundred. They first arrived without resources in the 1870s directly from China. As with their later importation of Italian peasants, Delta planters used Chinese labor as a threat to blacks that they would be replaced. Those were the Reconstruction years, and freed slaves were proving troublesome to white planters. "Emancipation has spoiled the Negro," the Vicksburg *Times* editorialized, "and carried him away from fields of agriculture. Our prosperity depends entirely upon the recovery of lost ground, and we therefore say let the Coolies come, and we will take the chance of Christianizing them."

The stratagem was ineffective. The Chinese did not take to sharecropping and saw little future in it. They began to move off the plantations and to open small grocery and supply stores, catering to black customers all over the Delta. They treated their clientele better than the white owners did, but were careful in avoiding social identification with the blacks. It was in the towns of Cleveland, Greenville, Greenwood, Clarksdale, Hollandale, and Vicksburg that they first began to rise above their plantation status. Many of their social and economic activities were centered in Bolivar and Sunflower counties because of the influence of the Chinese Baptist Church, to which they were converting. Other waves of immigration continued, and lasted as late as the 1920s and 1930s. Unlike earlier newcomers, a few of the later ones arrived, often from California or Chicago or elsewhere, in possession of a little capital with which to set up a small business, but most had a kinsman or friend already living in the Delta who gave them work.

Older Chinese have spoken with bitterness of the way they were treated. The white society largely classified them as nonwhite, and their children were relegated to separate schools until the mid-1940s, so that for some years in certain places in the Delta

there were three sets of public schools—white, black, and Chinese. (The first year that Chinese attended Cleveland High School, one Chinese student was valedictorian and another was a basketball star.) The Chinese existed in the middle of a highly polarized segregated society. Sung Gay Chow, who was born in China in 1947 but moved with his family to the Delta a year later, graduated from Mississippi State University, and got a Ph.D. in English at the University of Alabama, wrote of this: "My generation learned early how fixed the racial and social boundaries were. We soon understood that there were rules—most of them unwritten—that required everyone to toe the line. The Chinese in Mississippi have always been situated between a white majority and a black minority. We were neither a part of the white community nor a part of the black one. It was as if we occupied a narrow strip of ground between two high fences, one with white people on the other side and one with black people on the other side."

Little surprise, then, that the Mississippi Chinese have preserved an ethnic identity through intimate family and business associations. Every year they celebrate the rituals of the Chinese New Year in private observances, with feasting and exchanging of gifts. The descendants of the early immigrants continue to live mainly in ten counties: Bolivar, Coahoma, Humphreys, Issaquena, Leflore, Quitman, Sharkey, Sunflower, Tunica, and Washington. Many of their stores still have a high ratio of black customers. Some have opened larger stores in the white neighborhoods. As their economic conditions steadily improved and in the civil rights temper of the 1960s, they began to participate more in the Mississippi society of civic organizations, churches, and charities. John Wing of Jonestown became the first Chinese mayor in the United States. In my boyhood we often drove sixteen miles to the hamlet of Louise to see movies in the theater owned by Lee Hong and played high school basketball against a couple of his sons on the Louise team. Many of the younger generation are college educated and have become engineers, computer programmers, and pharmacists. They speak in an authentic Mississippi accent. For all the problems concerning ethnic differences and assimila-

tion the state's Chinese have faced, Sung Gay Chow has observed that, despite the emphasis on family ties and older values, the Chinese have a culture not unlike the rest of Mississippi's: "It is a sense of place—and that place being Mississippi—which reinforces our cultural values and ideals. And while the Mississippi Chinese seem to be disowned or dislocated, we are certainly not detached. We have roots embedded in this place as well."

The Italian community of the state had its genesis in the early 1900s when planters in the Delta imported Italian peasants in cattle cars and put them to work as laborers and sharecroppers. This campaign, as with the Chinese, did not prove very successful. The yellow fever epidemic of 1905 hampered recruitment in Italy, and the immigrants who arrived here were not familiar with cotton farming and found the work abusive and degrading. They began growing their own vegetables and refused to allow the planters to sell the crops for them, choosing to do so themselves for better profits.

It was hard going for them at first, however. Again, as with the Chinese, they were deliberately treated as an inferior minority, and many Mississippi politicians included in their platforms the segregation of Italians along with blacks. For a time their children were excluded from white schools, and the planters discriminated against Italian families by charging them inflated prices at the plantation commissaries and higher ginning fees than blacks paid. The Italians' protest against this treatment led to investigations by the U.S. Department of Justice in the early years of the twentieth century. Eventually the plantation owners conceded that their experiment was a failure and that they could not treat the Italians as they did the black laborers.

The newcomers' sense of group identity and independence exhibited itself when they began to own their own farms and businesses. An energetic Italian community established itself in Natchez, likely because of the old and honored Catholic church there, and also in Vicksburg, where its members prospered in the vegetable and fruit business. Today's descendants of earlier Italian immigrants, living principally in Bolivar County—an area always noted for its vig-

orous Catholic mission—and in Greenville, Vicksburg, and on the Gulf Coast, are respected members of their communities who at the same time seek to retain many of their cultural traditions.

Mississippi's Lebanese entered the state, mostly in the early 1900s, in much the same way the Jews had, as peddlers and small-scale tradesmen. And the same pattern was followed: entry through New Orleans, up to Natchez and Vicksburg and Greenville, establishing of trading posts in the river towns, and a gradual move inland to other areas of commerce centered around the railroad. A significant number of Lebanese settled in Jackson, as well as in smaller towns in the Delta like Yazoo City, Greenwood, Clarksdale, and Cleveland. They usually joined the Catholic churches in these places, although one of the reasons Vicksburg retained such an active Lebanese community was the presence of the Antioch Orthodox Church there.

In my growing-up years they were known as "Syrians," and in Yazoo City and other localities many of them became successful business owners and civic leaders. They were fine people, with strong family ties. Mr. Dan Nicholas owned the Cadillac agency and the best restaurant in town, Danrie's, which offered Lebanese specialties, especially my favorite, kibbee. Their names were also Solomon, Alias, Ellis, Joseph, Abraham, Weber, Coco, Jesse. The older men were excellent athletic coaches. Sam Nicholas and Sammy Moses, who owned the beer and tobacco distributorship, coached our championship youth baseball teams. The younger ones, as was true of many Italian kids throughout the Delta, were gifted athletes. Sammy Moses's son Gerry, who was the batboy on our teams, was for ten years a catcher in the major leagues, with the Boston Red Sox and later with the New York Yankees and the Detroit Tigers. Bobby Jabour of Vicksburg was a star quarterback for the Ole Miss Rebels. Lebanese descendants are still prominent in Yazoo and other places; some have gone on to prominence in the professions. Danrie's restaurant no longer exists, but you can still buy kibbee every day in Yazoo City at Deacon Pattenotte's Grocery, and Deacon isn't even Lebanese.

Recently a group of Jacksonians were touring Greece when they were approached by a local Greek man. "Where in the U.S. do you live?" he asked. "The South," they answered. "Where in the South?" "Mississippi." "Where in Mississippi?" "Jackson." "Well, do you live east or west of the football stadium?" It turned out that the man had relatives in Jackson and had lived there for a while and worked in a Greek restaurant. He was starving for news from Mississippi.

A well-known advertisement for Dennery's restaurant says, "Greeks make the best restauranteurs." It must be true, because Jackson's oldest and some of its finest eating establishments were all founded and continue to be run by Greeks or their descendants: Primos, Dennery's, Crechale's, the Mayflower, the Elite, Bill's Greek Tavern, Nick's. Many of the best hours of my life have been spent at these restaurants.

Among the state's smaller ethnic groups are the Poles and Slavs on the Gulf Coast. Many of them arrived to clear the Delta forests and became lumbermen in the early 1900s, and there is a sizeable number now in the fishing industry on the coast. In Biloxi the Slavic Benevolent Association holds a large celebration every Christmas Eve.

One of the latest significant immigrant populations to arrive in Mississippi is the Vietnamese. About five thousand live here now, also mostly on the coast, principally in Biloxi, having come here as refugees after the fall of South Vietnam in 1975. The first of them came as early as 1977; they encouraged many of their compatriots who had fished in the waters off Vietnam to follow them to the Mississippi Gulf Coast to work in the fishing industry. Difficulties erupted as a result of conflict with the Yugoslavs, who had been there for some time. The result was what has been called the "shrimp war." These newest immigrants retain close ethnic associations. They meet annually at their temple at the beginning of the lunar New Year to celebrate Tet, which is also a Buddhist religious holiday, and Vietnamese national independence day, with prayers, gifts, and games. Today several Vietnamese restaurants and groceries can be found in the area and a Vietnamese newspaper is published.

Mississippi also has a substantial Eastern Indian com-

munity living in the state, some two thousand in all, mainly concentrated in Jackson. Many of the first to arrive here in the 1960s were doctors and teachers. Over the years the community became more diversified and today includes engineers, lawyers, and many small-business owners. The growth of the telecommunications industry in Mississippi has led to an increased number of computer engineers and programmers working in the state. There are two divisions of MCI WorldCom in which Indians constitute the majority. Jai Bhagat, formerly of SkyTel, was instrumental in building that company.

The children of the first-generation Indians have been remarkable in their ability to adapt. They have moved between the traditional Indian world and Mississippi with little dissonance. Marriages between second-generation Indians and Americans have become more and more common, with some Indian parents accepting this gracefully and others bowing reluctantly to the inevitable. A stunningly high percentage of the second generation are superior students in the Jackson schools, and go on to college and then to graduate and professional schools. The two brilliant and gentlemanly sons of the Indian family I know best, for instance, both graduated with honors from Davidson, one going on to medical school at Vanderbilt and the other to law school at Tulane; the doctor is now doing advanced medical research at Johns Hopkins, while the other is an environmental lawyer in Washington, D.C.

The Indian community of Jackson is large enough to support a temple with a full-time priest under the auspices of the Hindu Temple Society of Mississippi. There are worship services in the temple, and members gather there to celebrate Hindu festivals and holy days.

In my conversations with Indians here and there in Jackson, I am told that, while Mississippians are generally quite hospitable to them, some have difficulty distinguishing between what one of my savvy and entertaining Indian friends calls the "feather" and "dot" varieties, referring to the traditional headdress of Native Americans and to the dots on the foreheads of Indian women. A "dot" Indian doctor tells of being in an elevator at the University of Mississippi Medical Center when the only other person there smiled in acknowledgment and began speaking in a language the doctor did not understand. When she asked him what language he was speaking, he said, "Choctaw." Once in the early 1970s an Indian man I know took a lamp to a welding shop in Jackson. The welder commented that the man's "folks" were creating a lot of trouble in the northern part of the country. This was during the unrest in Bangladesh in northeast India. My friend was impressed by how well informed the welder was. As the conversation progressed, he realized that the welder was referring to the troubles at Wounded Knee.

On an evening not long ago at the Southern Cultural Heritage Complex in Vicksburg celebrating the cultural diversity of Mississippi and featuring Vicksburg's Lebanese community, the main lecturer, cultural historian Stephen Young, declared, "What we have found is that every group, regardless of its origin, values the same basic things: family and community, religion and education, cuisine and the arts. There are differences in the way people approach these fundamentals, of course, but these differences should not be seen as threatening. As Queenie Nossour of Vicksburg once said of Lebanese cooking, 'If it ain't seasoned, it ain't worth much.' We like to emphasize how wonderfully spicy Mississippi has been and continues to be."

Whatever the ethnic group, the church or temple is still the center of life for many in Mississippi. Church structures the social schedules of countless families, and church activities are quintessential to life in the small towns. "What church do you belong to?" has long been one of the first questions Mississippians ask of newcomers to their community—it is a way of finding out who they are. The writer and man of the world Gore Vidal, who has cousins in Houston, Mississippi, in Chickasaw County, spent a week there one recent summer and told me that local entertainment consisted of practically nothing besides Little League baseball games and church activities. A northern admirer was visiting Eudora Welty in Jackson one

morning a few years ago and asked, "Why are so many people going to church?" Eudora replied, "Well, it's Sunday."

There are five thousand churches in Mississippi, roughly one for every five hundred people, and the social life surrounding these institutions is an inevitable reflection of the outlook and ethos of the denominations. In 1990 there were 1,720,521 Christians in the state, which amounted to 94.2 percent of the population, a percentage meaning that Mississippi ranked third among all the states in that regard. Those of the Jewish faith made up 0.6 of 1 percent, agnostics 0.5 of 1 percent, and "none" 2.8 percent, which gave the state a ranking of forty-seventh in that category.

Flannery O'Connor identified the American South as "Christ-haunted." The religious life of Mississippi, as well as of the rest of the South, is emphatically dominated by evangelical Protestant fundamentalism, which makes it unique not only in the United States but in the world. *The Encyclopedia of Southern Culture* was assessing the entire South, but it could just as well have been Mississippi in particular, when it reported: "From Presbyterian to Pentecostal, from Campbellite to Holiness, in black churches and white . . . four common convictions distinguish serious religion in the eyes of the rank-and-file religions: (1) the Bible as the sole reference point; (2) direct and intimate access to God; (3) Christian morality defined in the terms of individualist and personal ethics; (4) informal, spontaneous patterns of worship."

It is not fortuitous, then, that Baptist Church socials, for example, feature iced tea and fruit punch and cookies, while the Episcopalians (whose influence is larger than their numbers) may serve cheese and wine, and perhaps on occasion something a little more robust. One of my most lucid recollections from childhood is the moment when I observed from a distance the ground-breaking ceremonies for a new Catholic convent in my hometown and saw Father Hunter, one, drinking a beer and, two, shaking hands with a black man. It was the first time this Methodist boy had ever seen a man of the cloth with

a beer and the first time I had ever seen *any* white person shake hands with a Negro. The little white country churches are well known for their reunions and picnics on the grounds, while in the black churches the Sunday preaching, singing, and socializing go on for hours. If you drive through the rural Delta on a Sabbath, for instance, you will see a common sight: gathered around the little wooden churches with their pointed windows and small towers or in a grove of trees abutting the church graveyard will be dozens of people of all ages dressed in their Sunday best, talking in animated élan during a recess in the worship. Another truth of Mississippi religious life is that with rare exceptions there is very little racial integration in the state's churches, although today not much effort is being made officially or informally to achieve or discourage it as there was in the 1960s and 1970s.

There is also a passionate religiosity to the culture of sports in the state of Mississippi, whether you are talking football or fishing—but especially football. A popular sports radio show heard all over the state prefaces each day's program with a countdown, viz.: "Only 158 days til the football season." Marino Casem, for many years the coach at Alcorn State and known as the "godfather" of SWAC, may have put it best: "In New England, college football is a cultural exercise. On the West Coast, it is a tourist attraction. In the Midwest, it is cannibalism. But in the Deep South, it is religion, and Saturday is the Holy Day."

It is the commingling of this revivalistic fervor and the bone-crushing physicality of the game that appeals so to the Mississippi psyche. If one really wishes to be both indigenous and historical, he might find the genesis to all this in the ancient game of the Mississippi Choctaws called *ishtohbohl*, which had profound religious significance and was accompanied by many rituals. It was a violent contest, without any rules to speak of, between the young males of entire villages, the object being to carry or throw a ball, using sticks, between two goal posts. I gather from the primitive paintings I have seen of *ishtohbohl* that it was less a game than warfare—one game did in fact

actually end in war—and this ceremonial spirit carries over to the modern Mississippi day.

To a lesser extent in other team sports, but especially in football, there are collective ritualistic aspects that enhance the group gregariousness of Mississippians, their predilection for vivid congregating, a sine qua non of their personalities. The women all dress up for these ball games. (When Ole Miss was playing Notre Dame on a frigid midwestern afternoon a few years back at the hallowed stadium that Knute Rockne built in South Bend, my companion, Glen "Squirrel" Griffing, the storied Rebel quarterback in the glory years, declared, "The only women wearing fur coats are from Mississippi.") The tailgating before the games is imperative to the football culture. In the Grove at Ole Miss you will see silver candelabra on tables covered in linen and flower arrangements in football helmets. The tailgating fans before Jackson State games are effervescent and friendly, and when David Rae was shooting photographs he had to stop every few yards or so to accept fried chicken, so that when he finally reached the stadium he was too engorged to walk very fast. Approaching the Alcorn State campus before a game on the winding road from the Windsor Ruins, you are greeted on all sides by the spiraling smoke from the barbeque cookers.

The most sweeping change in Mississippi athletics over the last three decades has to do with its effect on racial desegregation. The state's three largest universities, all predominately white, have football teams that, since 1969, have gone from being all white to majority black. (In 1962 the coaches of the all-white Mississippi State University basketball team, led by the legendary Bailey Howell, had to sneak the team out of Mississippi in the dark of night to avoid an official state injunction against their playing an all-black team, Loyola, in the NCAA tournament in Chicago.) At first the "white" schools were reluctant to recruit any black athletes who bordered on the flamboyant. In 1971, for instance, the University of Southern Mississippi did not recruit Walter Payton from nearby Columbia because of the manner in which he celebrated his long touchdown runs. "We don't want no smart-ass n—s on this team," one coach suppos-

edly said, referring to perhaps the greatest football player who ever lived.

Black athletes, however, swiftly made their presence felt. "Wee Willie" Heidelburg, all 140 pounds of him, scored two touchdowns and carried the day in Southern Mississippi's monumental upset of Ole Miss and the great Archie Manning in 1970 when the Rebels were ranked number four in the land. Legend has it that Heidelburg was the only black person in Oxford's Hemingway Stadium that day other than the Ole Miss groundskeeper. What a difference twenty-nine years—and people like Willie Heidelburg—have made.

Rick Cleveland, one of the South's best sportswriters, tells me of his own experience as a white ballplayer in Hattiesburg. "I was a senior in high school in 1969–70 and saw integration firsthand. I have no doubt that black athletes did more than anyone (including U.S. marshals) to pave the way for the relatively smooth integration of Mississippi schools. In the case of my own Hattiesburg High, we had basketball's Short brothers, Eugene and Purvis, who led dear old HHS to three state championships. In just three years' time, we went from having no black schoolmates to actually having black heroes. In retrospect, it was truly an amazing transformation, although I'm not sure we even realized it at the time. I discussed with one of Purvis Short's teammates at a reunion recently about what those teams meant in the overall scheme of things. Greg Conner, a black guard who later played at Jackson State said, 'We weren't thinking about any of that. We were just trying to win games.'"

In 1972, ten years after the Meredith crisis at Ole Miss, "Gentle" Ben Williams of Yazoo, the school's most beloved football player, was overwhelmingly voted Colonel Rebel, the university's most prestigious honor, by the 99-percent-white student body. There are similar stories in small towns across the state. The playing fields and basketball courts were the first places where young black and young white Mississippians learned that they could work and play together and be all the better for it. In 1982, when I was doing a book on the exceptional black running

back Marcus Dupree at Philadelphia High in Neshoba County, I kept noticing a white substitute player who always had a glass of water waiting for Marcus when he came off the field, and helped him with his tearaway jerseys. I found out the white boy was Cecil Price, Jr., son of the deputy sheriff who had been sent to prison for conspiracy in the Ku Klux Klan plot that resulted in the murder of three civil rights workers twenty years before. In my travels to high school games around the state then and later, I witnessed the interracial crowds in the grandstands, local whites and blacks exchanging comments and high fives.

I remain astonished at how my home state, so small and poor, continues to produce so many great athletes, especially in football. In the 1990s, studies showed that Mississippi had per capita by far the most players in the National Football League of any state. The NFL's all-time leading rusher (Walter Payton of Jackson State), pass receiver (Jerry Rice of Mississippi Valley State), and scorer (Rice again) hail from small-town Mississippi. So does the three-time NFL Most Valuable Player Brett Favre of Southern Mississippi, who is on course to become the NFL's all-time leading passer. The state has six in the NFL Hall of Fame: Lance Alworth, Lem Barney, Willie Brown, Frank "Bruiser" Kinard, Walter Payton, and Billy Shaw. Eleven Mississippians are in the College Hall of Fame: Lance Alworth, Charlie Conerly, Charlie Flowers, Jake Gibbs, Edwin "Goat" Hale, Parker Hall, Frank "Bruiser" Kinard, Archie Manning, Jackie Parker, Barney Poole, and Walter Payton. Ray Guy, who performed for Southern Mississippi and the Oakland Raiders, is widely regarded as the game's greatest punter; Willie Brown of Yazoo City, Grambling, and Oakland as one of the finest defensive backs ever; and Frank "Bruiser" Kinard of Pelahatchie, Ole Miss, and the Brooklyn Dodgers (NFL), as one of the best linemen in history. There are so many outstanding football players from the state that you can hardly drive through a small town without remembering an impressive name. In the tiny southwest Mississippi town of Homochitto (a suburb of Gloster), three of our state's most storied football

players came from the same family—Buster, Barney, and Ray Poole. All three were Ole Miss stars; all played in the NFL; and all are in the Mississippi Sports Hall of Fame. And it happened despite the fact that in the early 1930s neither Homochitto nor Gloster had a football team—or, in fact, a twelfth grade. When brawny Buster, the oldest, enrolled in the Natchez senior class, the football coach quickly signed him up for the squad. Not long thereafter, Buster apprised his brothers, "Boys, I have found us a game to play!"

The importance small-town Mississippi places on football has much to do with the quality of its athletes. Unless you have attended a Mendenhall-Magee game, or Starkville-Tupelo, or Grenada-Kosciusko, or Forest-Newton, or Pearl-Brandon, or Senatobia–South Panola, you cannot fathom this local zeal. "The Super Bowl is a production," Rick Cleveland observes. "Mendenhall-Magee is for real. I've covered probably fifteen or sixteen Super Bowls and not one has approached the intensity and emotion of a Mendenhall-Magee game."

That passion for football is what allows such a small state to produce enough talent to be the base for six Division I college programs, including three Division I-A teams, which all played in bowls in 1998–99. Imagine what kind of team Mississippi would field if we had a university system like the one in Arkansas, where all the top athletes wind up at one school. Mississippi would compete every year for the national championship. We would have to double-deck the sixty-thousand-seat Memorial Stadium in Jackson to hold all the fans. I would call the team the Rebellious Golden Tiger Dawgs.

It is always intriguing to observe the Saturday crowd spectacles at Oxford, Starkville, and Hattiesburg compared with those at the black schools, Jackson State, Alcorn, and Mississippi Valley. The passion and commonality are there in all these places, but the aura has considerably more animation and flair at the latter three, and the black fans are even more garrulous than the white ones, if you can believe it; even the epithets are more flavorsome. I have never seen a more thrilling sports milieu than at the famous

Alcorn–Mississippi Valley game in Jackson in 1984, when the Delta Devils had Jerry Rice and never used a huddle. Some seventy-five thousand people watched, the largest single crowd ever to gather in one place in the history of the state.

My wife and I drove down the Natchez Trace to Alcorn several times during the 1994 season to watch the fabled Braves quarterback Steve "Air II" McNair, candidate for the Heisman Trophy. He was a poor black kid from a small Mississippi town; he and his brothers used a cow pasture for a football field. The stadium, which seats twenty-two thousand, is called Spinks Stadium after the first black person ever to play in the National Football League (Jack Spinks in 1952), and, like the bucolic campus itself, seems carved from the very earth. We were there the day Steve broke the all-time NCAA total career offensive record for all college divisions. After he passed that auspicious milestone, he called time out, trotted to the sidelines, and presented his mother with the football. The moment was nothing if not ecclesiastical; the band broke into a hymn, and there was not a dry eye around. When Steve later signed with the Houston Oilers (now the Tennessee Titans) for $28 million, the first thing he did was build his mamma a new house.

While football remains the favorite sports pastime of Mississippi, and the most communal, basketball has become by far the main attraction of the inner cities, especially in Jackson, where the all-black public high school teams are on a level with some colleges. In the winter Jackson gymnasia are packed, and emotions run every bit as high as they do at football games in the rural areas. Jackson has become a hotbed for recruiters from across the country.

Another formidable change in the state's athletics over the past three decades has been the emergence of college baseball as a big-time sport. An Ole Miss–Mississippi State baseball series in 1999 drew sixteen thousand spectators to the new stadium in Oxford. Ten years ago, the Ole Miss baseball facility consisted of old wooden bleachers with hazardous splinters and no public restroom facilities. In 1999 Mississippi State, Ole Miss, and Southern Mississippi

all reached the NCAA tournament. Mississippi State's Ron Polk is the man singularly responsible for baseball's rise in popularity. He showed college administrators that baseball could actually make money. State was the first school in Mississippi to build a sizeable modern stadium, and the games there are noted for the uninhibited left field lounge, an outdoor area behind the outfield fence where fans from all over Mississippi gather to cook barbeque, eat, drink, talk, and shout disparaging remarks at the enemy left fielders; this venue is baseball's answer to football tailgating.

Over the decades the state has produced a respectable array of major league baseball players, but none more heroic than the late James Thomas "Cool Papa" Bell, who was born and raised in Starkville but left as a teenager for St. Louis in 1921, because there was no black school in the entirety of Oktibbeha County. He played for years in the Negro League, and he is the only Mississippian in the Hall of Fame in Cooperstown. He owns the reputation as the fastest man ever to play baseball. His roommate Satchel Paige said Cool Papa was so fast he could turn the switch on the bedside lamp and be in bed and fast asleep before the light went out; he once outran the 1936 Olympic gold medalist Jesse Owens in a 100-meter exhibition match. In 1999 the Starkville Race Relations Team named a street after him and unveiled a historical plaque before a large interracial crowd that included the honoree's Starkville and St. Louis relatives. Buck O'Neil, the aging former Negro League star who played with Cool Papa, surveyed the celebrative assemblage and said, "I live in Kansas City, where everybody is on everybody else's back. I'm proud of Mississippi!" He added, "There always were more good people than bad people in the South."

Ron Borne, the Ole Miss professor and vice-chancellor for research, has as an amateur baseball historian researched Mississippians in the major leagues and found that more than 125 have reached "the big show" over the years, an extraordinary record for such an underpopulated state. The two Mississippians who had the longest major league

careers were both pitchers: Guy "The Mississippi Mudcat" Bush of Aberdeen and Claude Passeau of Waynesboro, who had 176 and 162 career wins respectively. Historically the St. Louis Cardinals and the Detroit Tigers have had the most players from Mississippi. Sammy Vick of Batesville, who played for the New York Yankees and the Boston Red Sox, was the only man ever to pinch-hit for Babe Ruth. Here is Professor Borne's all-time Mississippi Major League All Star team: George "Boomer" Scott of Greenville, first base; Buddy Myer of Ellisville, second base; Don Blasingame of Corinth, shortstop; Bill Melton of Gulfport, third base; Harry "The Hat" Walker of Pascagoula, Gerald "Gee" Waller of Gulfport, and Sam Leslie of Moss Point, outfield; Jake Gibbs of Grenada, catcher; Sport McAllister of Austin, utility; Gerry Moses of Yazoo City, designated hitter; Boo Ferris of Shaw, best right-handed pitcher; "Vinegar Bend" Mizell of Leakesville, best left-handed pitcher; Marshall Bridges of Jackson, best relief pitcher; Guy Bush of Aberdeen, best all-around pitcher (despite giving up Babe Ruth's last two home runs); and Harry Craft of Ellisville, manager. Dizzy Dean, Donnie Kissinger, Will Clark, and Rafael Palmeiro did not make this honor roll because they did not fit the criterion of having been born in Mississippi.

In other sports, Calvin Smith of Bolton was from 1983 to 1988 the fastest man on earth, having possessed the world 100-meter record of 9.93 until it was finally broken by Carl Lewis. Archie Moore of Benoit held the world light-heavyweight boxing title from 1952 to 1960. Tennis has been on the rise in the state, and the Mississippi State and Ole Miss teams are often nationally ranked. Women's college basketball has become highly competitive in the last twenty years. And Mississippi now has three of the finest golf courses in the country: Annandale (designed by Jack Nicklaus), Dancing Rabbit Creek on the Choctaw reservation in Neshoba County, and Old Waverly in West Point, where a hundred thousand people came for the U.S. Women's Open in the summer of 1999.

Soccer has become quite a phenomenon in the state. In 1992 Belhaven College in Jackson won the National Association of Intercollegiate Athletics Championship. And the popularity of soccer in the schools rivals that of Little League baseball in certain vicinities. Orley Hood of the Jackson *Clarion-Ledger*, one of the most widely read columnists in Mississippi and a former sportswriter, has observed this development because his two young sons are star players. "Just twenty years ago we were adamantly opposed to soccer," Orley tells me, "the theory being: first soccer, then the politburo. We had enough sports. And if the Soviets and the Germans, the two scourges of the twentieth century, were united in their support of the game, then we were honor-bound to line up on the other side. Who needed kickball? But soccer has gotten to be like religion—a little here and a little there and pretty soon you wake up one day and you've tithed away the family fortune." The soccer life starts with the kids playing "under-6" and subsequently "select" and "olympic development"; they participate in club tournaments from Dallas to Atlanta. "It is part of a strange, traveling civilization," Orley judges, "unknown to outsiders."

Who knows what will become of the National Hockey League once Mississippians take to the ice?

The focus for the commanding history of athletics in the state is the Mississippi Sports Hall of Fame in Jackson, a state-of-the-art facility that opened in 1998, one of the finest and most extensive of its kind. Under the direction of Michael Rubenstein, it has become the hub of social and professional activity involving sports in Mississippi. There are thousands of audio- and videotapes and exhibits on hundreds of athletes. If I had to choose one of the most unusual tales of all those documented there, it would be the one told in the voice of Shorty McWilliams of Meridian, the heroic running back for Mississippi State in the 1940s. The State team was warming up before a game at Tiger Stadium, known around the league as Death Valley, in Baton Rouge. McWilliams was catching punts around midfield when he sensed an ominous presence immediately behind his back. Someone had let the LSU mascot, the Bayou Bengal tiger, out of his cage, and Shorty Mac turned around and saw the creature glowering at him from a couple

of feet away. "What did you do?" the interviewer asked. "I wet my pants," Shorty Mac said.

Important cultural condiments are part of the Mississippi football ethos, and these have little to do with creed, race, gender, or even class. Beginning in junior high school and progressing through college, many of the youth of our state are cheerleaders, band members, and baton twirlers. Although I have no raw statistics before me, I have an unerring hunch that Mississippi takes these pursuits more seriously than even our sister states of Alabama, Tennessee, Arkansas, and Louisiana. But you can be serious about something and still have fun, and these zesty callings have been and always will be in the substance and ambiance of Mississippi congregation and diversion. Two of the state's writers, Barry Hannah and Noel Polk, have written vividly of their experiences in high school bands.

Here the kids start taking their trombone or snare drum lessons early, and high school bands are active presences in our communities and will march in any parade anywhere on the merest suggestion. They also give free concerts from time to time, and the most dexterous musicians in their number will often moonlight in dance or jazz ensembles at various spots around the town. Their most significant role remains, nonetheless, their performances at the football games. On cool nocturnal Friday autumns in Mississippi, the broiling summer temperatures felicitously behind us, the most poignant sound wafting across the towns is that of the echoing thuds of the bass drums as young percussionists get in a few practice licks on the way to the playing field or the hefty staccato puffs made by the boys, and sometimes girls, on the unwieldy bass horns draped around their shoulders. In my peregrinations to high school matchups across the state, I for one have learned to judge a school band by how well its trumpets sound the high F in our national anthem. High school band directors have always been respected members of our communities and are major influences on the children and teenagers in their charge. In 1998, for instance, the high school band director in Grenada, David

Daigneault, won a Governor's Award for Excellence in the Arts, having been named in 1997 national high school band director of the year. He oversees the study of fine arts in the Grenada schools and has touched the lives of thousands of Mississippi students.

When college comes around, the few who make the university bands are admired back home, and correctly so, because these bands amount to all-star assemblages of the most adept of the high schoolers. Their role at the football games is second only to the action on the field, and sometimes is actually paramount if the home team is losing badly. They add militancy and fervor to the combat at hand. When the Ole Miss band, for instance, marches at halftime playing "From Dixie with Love," a blend of "Dixie" and "The Battle Hymn of the Republic," it is almost symbolic of modern Mississippi and would bring tears to the eyes of a Massachusetts abolitionist, not to mention contemporary Oregon liberals.

All the state's college bands have their individual flavor and character, but I have to say that the black bands from Jackson State, Alcorn State, and Mississippi Valley are the most talented and beguiling I have ever seen, with their intricate and undulating marching patterns and the sheer power of their orchestrated sounds. When Jackson State's Sonic Boom of the South launches a number, you feel proud to be a human being, and the band's blended consonance is so all-surpassing that it can probably be heard in Gluckstadt ten miles away. The annual JSU homecoming parade, which draws thousands to downtown Jackson every year, showcases the Sonic Boom and other bands from around the state and the nation, not to mention beauty queens of all ages. At the Alcorn games the band's two dozen bass horns keep up a deep steady resonance all during the activity on the gridiron, lending to these golden afternoons the corporeality of a rich symphonic coda. The incredible young women who perform as a dance troupe at Alcorn halftimes—they call themselves the Golden Girls of ASU—wear matching gold-sequinned swimsuit-style outfits, and their dance routines are heart stopping. And who can ever forget the famed

Dixie Darlings of the University of Southern Mississippi or the Hinds High Steppers of Hinds Junior College?

As for cheerleading, it never ceases to titillate me that at the state's high school games the white and black cheerleaders' shouted words and phrases are shaped by the black vernacular, as are their gestures and rhythms, one of my favorite cheers being "Who dat say day beat Yazoo? Who dat? Who dat?" Cheerleaders, too, have always been central to the Mississippi scene. In both high school and college they are often influential members of the student body. "High school football games are great for fathers of teenaged daughters who are cheerleaders," a father of just such a cheerleader in a middle-sized Mississippi town tells me. "Teenaged daughters love to scream. This gets them out of the house to scream, and in a good cause." The two U.S. senators serving the state in the year 1999 were both cheerleaders at Ole Miss—Thad Cochran in the late 1950s and Trent Lott in the early 1960s. Traditionally cheerleaders in Mississippi have been more group oriented and less individualistic than drum majors, drum majorettes, and baton twirlers. Many of them attend an annual cheerleading clinic at Ole Miss in the summer. When I was living in Oxford, I saw spectacles that reminded me of scenes from Fellini movies. Walking through the Grove toward their mass convocations, the young cheerleaders from each school cluster together, wearing their school colors. As they stroll along, they practice their favorite cheers. One time I saw a group of them in matching blue and gold doing their routines while perched on the limb of an elm tree, and another bunch practiced on the roof of a sorority house. I was bombarded from every direction by hundreds upon hundreds of screaming teenagers, strutting to various beats and yelling their cheers in fashionable black cadences.

The following week the high school twirlers would arrive for the Ole Miss baton twirling clinic. The twirlers were more sedate, more personal. Baton twirlers here, I have always been told, are more thoughtful and deliberative than cheerleaders. In Mississippi many of the twirlers' mothers were

twirlers, a circumstance amounting to a family heritage. The mothers get their daughters started at an early age. For various reasons twirlers are not in a group all the time. When they perform on the field, they stand out as individuals, and if they make a mistake everyone notices—when they drop the baton, for instance, or worse, if it lands on their heads, which I myself have witnessed more than a few times. Bands these days do not have as many majorettes as they once did—just one or two featured twirlers in most cases. The trend in recent years has been toward a drum-and-bugle-corps marching style, with twirling flags and rifles, perhaps the result of Pentagon influence.

Here is a fact that not many people know, even in Mississippi. Up until his senior year in the newly integrated Columbia High, when he decided to go out for football, Walter Payton, probably the greatest football player of all time, was the drum major for the high school band.

The beauty queen folkway in our state is not directly associated with the sports locus but does have a tangential link. In both high school and college, homecoming queens are always crowned at halftimes of football games, and more often than not Mississippi's high school beauty queens have been cheerleaders or baton twirlers.

The beauty queen tradition is perhaps hardier in Mississippi than in any of the other states, and granting my obvious bias I know the reason why: although our state may rank near the statistical bottom in innumerable categories, it stands an undisputed first in all of the U.S.A. in the beauty, attractiveness, and grace of its women. This is indeed a multiracial phenomenon. The outlander, who invariably comments on this matter to the natives, need not conduct a demographic probe to ascertain the patent truth. All he has to do is to come down here and look around— on the streets and in schools, churches, colleges, Junior League meetings, ball games, country clubs, shopping malls, restaurants, PTAs, supermarkets, debutante balls, office buildings, cocktail parties, class reunions, funerals, literary conferences, fashion

shows, flea markets, jazz and blues festivals, Bible study groups, volunteer fire department suppers, hot air balloon shows, and, yes, the beauty pageants—wherever one goes to look people over. The state abounds in lovely women and is justly famous for them.

Mississippi does, withal, rank first per capita among the fifty in Miss Americas. It has had four, and also is the leader in the aggregate number of runners-up and alternates. (California is first numerically with six Miss Americas, and Ohio and Pennsylvania tie with five each.) Mississippi likewise leads the nation in total points for all wins, including swimsuit, talent, and Miss Congeniality. (The girl who lived next door to me when I was a little boy in Yazoo City was later runner-up to Miss America.) Lynda Lee Mead and Mary Ann Mobley, who won the Miss America title in consecutive years, 1959 and 1960, were Chi Omega sorority sisters at Ole Miss, and there are men I know who to this day claim to have dated them both, though not at the same time. Mary Ann later acted in Hollywood films and played opposite her friend and fellow Mississippian Elvis Presley in a movie called *Harum Scarum*. Cheryl Prewitt (1980) and Susan Akin (1986) are the state's other two Miss Americas.

What is it, pray, about Mississippi women that makes them look better as a group than women from other places? They dress imaginatively, wear makeup, doll themselves up in a way that many others elsewhere do not, and not only for special occasions. They fix up to go to school, to the grocery store, to catfish joints. A girl in an Ole Miss dormitory might be painting her toenails and then shout to her friends across the hall, "Anybody want to go buy some *shoes*?"

Somehow in this state many girls seem to just grow up wanting to be beautiful and try to make themselves so, even the brainy ones. They see it in their mothers and grandmothers and in other girls. They seem to learn it without even trying. So becoming a beauty queen is a natural progression of things. It is a legacy. However, it must be pointed out that not all or even most Mississippi girls desire to be beauty queens. And the ones who are *not* in the pageants are just as beautiful, if not more so, than the ones who are.

Those who do participate are generally in a great many of them. The young ladies get to know each other from one pageant to another, and despite the competitive nature of these events, develop an existential bond—as in sports, one surmises. (In the 1999 state pageant, however, I heard, two of the contestants actually got into a physical fight when one of them said she had sewed her own evening dress, and the other said she was lying.) The apotheosis of all this is the Miss Mississippi pageant, held annually before sell-out crowds in Vicksburg; young women today train hard for this, and many of them are in it for two, three, or four years trying to get to the Miss America pageant. The 1999 Miss Mississippi, Heather Soriano, was making her fourth try. The question remains as to why the pageant is so popular here and why Mississippi is the only state that still televises its competition. "I think Mississippi gets into the pageant because we've been ranked last in so many things," one of its 1999 organizers conjectured. "It may be because we did so well from early on. Success does breed success."

A former director of the Miss Mississippi contests observes that urban northern girls enter the competition for the scholarship money or to acquire an inside track into show business. "In Mississippi," he says, "it's tradition for the best girls to come out for the pageant. In Mississippi, the best girls just want to be Miss America." Unlike in earlier times, however, when almost all the contestants' stated ambitions were for a nice man, nice family, and nice house, these days they may be planning to go on to medical school or to earn a degree in engineering. There are trainers here who teach girls how to compete (figure improvement, runway walking, talent competition, interviews) and other people who make a living designing and sewing evening gowns specifically for the pageants. In the last fifteen or twenty years of the century a whole network of experts has developed a succinct body of knowledge about what to do and what not to do. In addition, some of the women go

for *Mrs.* America after they get married. Pamela Nail of Brandon was Mrs. America in 1987 and went on to be named Mrs. World.

In the overall picture, there are not as many disparate beauty pageants in Mississippi as there were a generation ago, when the contestants were sponsored by civic groups like the Lions Club and the Jaycees. Local pageants seem not to be in such vogue today as they once were. Not too long ago, however, we had dinner at Hal & Mal's in Jackson with a young Mississippian who had just been crowned Catfish Queen U.S.A. Everyone ordered the fried catfish.

Sitting in a deer stand in a river bottom at sunrise . . . paddling a canoe down a shady stream . . . watching ducks spiral down into a decoy in a Delta slough . . . catching red-belly bream with crickets in a creek. These are familiar experiences to many Mississippians.

Hunting and fishing have always flourished in the state, and so, too, the communal doings which enhance them, often familial in their unfolding: the camaraderie of the deer camps with their fiercesome poker games, an eclectic stew simmering on the fire, some sour mash and beer within convenient reach, the dogs lazing around scratching and waiting for something to eat (the deer camp itself often the original rough cabin of the fathers and grandfathers, with the new mobile home manufactured in Akron and purchased in Memphis or Jackson beside it), a father taking his son on his first hunt, whole families lining a pond with cane poles, sinkers, and big canfuls of worms nearby.

One in five Mississippians fishes, one in ten hunts—250,000 hunters, an arresting statistic in a state with a population of about 2.5 million. Fishing continues to grow as a recreational pursuit, with over half a million people now participating. As with hunting, the love of fishing is often almost ritualistically passed along from one generation to the next. Fishing, hunting, and wildlife-related activities are a $1.9 billion industry annually, including the expensive saltwater fishing on the coast. Mississippi, along with Alabama, Kentucky, and Tennessee, has the high-

est rate of gun ownership anywhere, with three in four citizens owning guns, preponderantly hunting rifles and shotguns, most of these in rural areas. Guns as family heirlooms are often ceremonially passed from fathers to sons.

There are more than 200 types of freshwater fish in the state's innumerable rivers, lakes, and creeks, and the favorites for the fisherman are largemouth bass (the official state fish—Mississippi bass fishermen are so zealous in their calling they are a cult all their own), bream, perch, crappie, bluegill, and catfish. The lucrative farm-grown catfish industry notwithstanding, it is still not uncommon to see adventurous souls working the banks with cane poles for the big cats, and the more intrepid ones continuing the custom of hand grabbing in hot, sluggish rivers, a practice which sometimes has one reaching an arm into a hollow underwater log and pulling mating catfish out by hand; unsporting as this may be, trotlines are also used to hook the cats, but as yet despite the traditional tall Mississippi tales there has been no credible verification of anyone pulling out a catfish big as a grown man as Huck and Jim once did. A hand grabber at the Ross Barnett Reservoir recently did pull out a 102-pound cat, roughly the size of a seventh-grade boy. Various fishing contests and tournaments add to the communal flavor of the state's fishing life. The customary family or community fish fry, replete with the accoutrements, is still very much part of the Mississippi tableau.

An astounding fact is that there are 275,000 registered powered boats in the state, one for about every nine people, and a serious concern among responsible sportsmen is that some of the owners do not know how to operate them properly and that too many of them do it while under the influence of beer or strong spirits. The annual Thunder on Water safe-boating festival at Grenada Lake, reputed to be the third largest sporting event in the state, features boat parades and races, fireworks, blues concerts, and arts and crafts. Canoeing and water-skiing are popular diversions on the state's rivers, lakes, and reservoirs, and even on the Tenn-Tom Waterway. The annual Mississippi Deep Sea Fishing Rodeo, the Gulf Coast's old-

est fishing tournament, was founded by a favorite native son, Guy Billups, Jr., who himself once brought in a 588-pound blackfin tuna, at the time the biggest fish ever caught in Mississippi waters.

For hunting, the preferred migratory birds are ducks, doves, and geese. (Quail hunting is pretty much a thing of the past.) The fabled wolves and cougars of the old forests are no more, and the bear of Faulkner's Ike McCaslin's day are exceedingly rare, the main game being white-tail deer, squirrel, and rabbit. Poor people in rural areas still hunt raccoons and possums (the "o" is expurgated from opossums here out of nothing but rank opprobrium). In a few exotic enclaves fox hunting takes place, and mounted huntsmen actually "follow the hounds." But this is more an equestrian activity than a blood sport. Mississippi is first in the United States in deer population density per square mile, and the terrific increase in recent years has encouraged a noticeable trend: traditionally fathers would have their sons learn the woods by first hunting for squirrels, but more and more now they start with deer. (In 1996 outside Ackerman a buck was downed that had the largest antlers ever recorded in American history.)

There are millennium twists. In 1999 a fishing and computer fanatic named Bob Worsworthy of Brandon established a free Web site with weekly fishing updates, weather forecasts, and maps to forty-two major lakes near eight cities.

The growing cost of hunting and fishing has become prohibitive to many. The state has recognized the economic importance of its natural resources and has worked with landowners to restore habitats, buying and setting aside new lands for public use. This is significant since the cost of land ownership or hunting club membership through leasing of private lands and waters has exceeded the reach of many Mississippians. The Mississippi Department of Wildlife, Fisheries, and Parks is now concentrating on programs that will attract children and women to the outdoors—and there is still plenty of outdoors in Mississippi.

Another decisive aspect of the state's cultural mores, often manifest in day-to-day ways, is its heritage of patriotism—the warrior tradition. Mississippi's official coat of arms is a shield in the colors red, white, and blue, featuring a golden eagle with extended pinions which is holding in one talon a palm branch and in the other a bundle of arrows; below this are two branches of a cotton stalk and a scroll bearing the state's motto—*Virtute et Armis* (By Valor and Arms). The state flag features in one corner a replica of the Confederate battle flag, a continuing target of criticism from some citizens.

One of the many ironies and truths of our history is that in challenging moments Mississippians are intensely American. The Americanization of Mississippi began before the state was even admitted to the union. All through its early history Mississippians were soldiers for nationalist causes, for continental expansion, for laying to rest the specter of European domination. Even the rhetoric of secession was couched in language that was deeply American, having to do with the constitutional ideals of the founders. In his first inaugural address, even if he did not succeed, Lincoln was wise in appealing to "the mystic chords of memory" which might hold the Grand Old Union together. Those chords were strong in Mississippi, but the sound of another distant drummer prevailed, with staggering costs. L. Q. C. Lamar, a Mississippian, was instrumental in the Compromise of 1877, which brought North and South together again after the bloodiest war the republic has ever known.

During the Civil War, Mississippi's percentage of dead was the largest among the states. The University Greys, 103 boys from the state university, constituted the first wave of Pickett's Charge at Gettysburg; every one of them died. In *The Civil War: A Narrative*, Shelby Foote reveals the astounding statistic that in the year 1866, one fifth of the state's revenues went to purchase artificial limbs for returning veterans. At the war memorials on the lawns of the state's courthouses the Confederate dead outnumber the dead of all other wars combined, although in some towns the casualties from World War II run a close second.

In the twentieth century Mississippians have been noted for their devotion to the flag. In World War I,

704 lost their lives; in World War II 4,185; in Korea 409; and in Vietnam 637—a total of 5,935, which gives the state top ranking in war casualties per capita in the nation. In my boyhood in Yazoo City the American Legionnaires, mostly veterans of World War I (my own father among them), were, with their blue-and-yellow envelope caps emblazoned with "Roy Lammons Post No. 7," a familiar presence in the town. They sponsored our championship American Legion boys' baseball teams. They were really not so much farmers and used-car salesmen and bookkeepers and merchants as honorably retired warriors; in their nocturnal off-hours, they congregated up the street from my house at a grocery store owned by one of their number, drinking from a vinegar jar filled with corn whiskey, talking of the Argonne, the Meuse, and Château-Thierry, and singing "Over There" and "It's a Long Way to Tipperary." I know, because I watched them from the back of the meat counter.

During World War II eleven Mississippians died on the first day's fighting alone, all on the USS *Arizona* at Pearl Harbor. More Mississippians than soldiers from any other state won the Congressional Medal of Honor in that war. Jack Lucas, a marine from Hattiesburg, was the youngest man in the twentieth century to be awarded the Medal of Honor, for throwing himself on a grenade to protect others in his unit during the assault on Iwo Jima. The tiny town of D'Lo in Simpson County sent more men to war than any town of comparable size in the country, 150 out of a total population of 400, or 38 percent of the town, many of them volunteers, and for this was featured on the cover of *Life* magazine. The Choctaw reservation in Neshoba County saw 105 of its men go to World War II (and 20 later to Vietnam). Among the many black Mississippians who fought in the war was Medgar Evers of Decatur, who saw combat as an infantry lieutenant and returned home to fight another war for equal justice.

The first black Mississippian to become a general in the U.S. Army was Brigadier General George Baker Price of Laurel, the brother of opera soprano Leontyne Price. America's first black aviator to die in combat was Ensign Jesse L. Brown of Hattiesburg, who was shot down in Korea in 1950 at the age of twenty-four; the USS *Jesse L. Brown*, a navy escort ship, was later named in his honor.

Mississippians were active during the Korean War as well. The Dixie Division of the National Guard, composed of men from Mississippi and two other states, was called up early in the war and became engaged in the bitterest combat. A high school friend and I who played "Taps" on our trumpets at the military funerals of those being returned from Korea to Yazoo witnessed the terrible scenes of grief at the gravesides. The American Legionnaires from World War I constituted the protocol honor guards and fired the volleys.

The most decorated soldier in the entire history of the U.S. Army was a Mississippian, Lawrence "Rabbit" Kennedy of Amory. Lewis H. Wilson of Brandon was a four-star general, commandant of the U.S. Marine Corps in the 1970s, and a member of the Joint Chiefs of Staff. G.V. "Sonny" Montgomery of Meridian was for fourteen years the popular and respected chairman of the U.S. House Committee on Veterans' Affairs, where he was widely known as a consistent advocate of veterans' rights, including health care, long-term care, and pensions. And most recently during the Persian Gulf War, the Mississippi National Guard was activated, just as it had been in Korea a generation before; many young men and women from the state served with accomplishment in the remote sands of the Arabian desert.

All this has contributed to the state's long-standing convention of "getting together"—at American Legion and Veterans of Foreign Wars meetings and socials, more often than not regarded for their partying spirit. Mississippi's veterans are also conspicuous on Memorial Day, with parades honoring the dead of the American wars and the ceremonial placing of flags on the graves of veterans in many far-flung cemeteries of the state. The annual observance of Memorial Day as a holiday, in fact, began in Mississippi in 1866, a year after the Civil War ended, when women who had lost husbands and brothers placed flowers on the graves of both the Union and the

Confederate soldiers buried in the old Friendship Cemetery in Columbus, the first time men from both armies were honored at the same time. This event was the subject of a poem called "The Blue and the Gray" by Francis Miles Finch which subsequently was published in *The Atlantic Monthly*. The ceremonies in Columbus were emulated elsewhere and soon led to our national Memorial Day.

The "fair"—what an explosion of the senses that small word suggests. Fairs of all varieties still satisfy an honorable niche in the state, and in some vicinities, the county fairs of the Mississippi autumn continue to carry on as vigorously as ever, bringing together townspeople and country people and their kids in festive amalgam. For an entire week people take in the 4-H exhibits—vegetables and bottled preserves in all the shades of the rainbow, prize-winning cakes and pies. Tiny children lead enormous mooing livestock around arenas, the aroma of manure over all. The amusement rides, the test-your-skills booths with gaudy trinkets and stuffed animals for the dexterous, the two-headed snake shows, and the bawdy goings-on in the big brown tents that four generations of preachers have been unable to do much about—it all still goes on. There are beauty contests in some places, and car races and tractor pulls, and aspiring country singers. Mississippi's Eudora Welty consummately captured these older county fairs in her story "Petrified Man" and in her photographs.

But there is no county fair in America quite like the Neshoba County Fair, held outside Philadelphia in the hottest and rainiest part of late July and early August. This is the oldest remaining campgrounds fair in the country, dating to 1889. Twelve thousand people go to live there for an entire week, cooking, eating, drinking, and visiting around in some five hundred rustic cabins built by their forebears. The storytelling is, to say it mildly, ongoing, and parties erupt on the momentary whim, and at night there are memorial services for the dead and communal singing. No one gets much sleep. The cabins' occupants are noted for their hospitality. This fervid annual commingling is surrounded on all sides by a carnival midway, a track for harness racing, agricultural exhibits, and platforms for preaching and country music and beauty pageants. At the venerable open-air Founders Pavilion, with sawdust floor and weathered wooden benches, anyone can give a speech who wants to, but people mainly flock from all over the state to listen to and cheer and heckle candidates for political office on two days each year. Traditionally this is where candidates toss their hats in the ring for the first time, and the indigenous rhetoric is penultimate Mississippi.

While the Neshoba fair prides itself on being "the world's biggest family reunion," there are smaller such reunions occurring all the time around the state, though not in such garnished settings. They usually take place in the summer and are annual or ad hoc depending on the family and the circumstances. The families themselves are often elaborate and extended, and the celebrations center as they always have on a plethora of food, drink, and talk. The food listed by the writer Gayle Graham Yates at one such reunion consisted of "fried chicken, ham, meat casseroles, rice dishes, cooked garden vegetables, fresh raw vegetables, potato salad, gelatin salad, seafood salad, homemade rolls and breads, cakes, pies, cookies, jams, preserves, pickles, watermelons, iced tea, and lemonade"—and, again depending on the contingent, sometimes something stouter than the tea and lemonade. If it is "dinner on the grounds" in a churchyard, these offerings extend considerably on temporary tables covered with tablecloths and set on sawhorses. The ambiance is usually amiable and affectionate, but in some such reunions in older times family disputes sometimes broke out over wills and properties, with fistfights lending flair to the genealogical proceedings.

Akin to the fairs and reunions are the unique local festivals of the state, which attract Mississippians for more specific reasons but in a similar gregarious pattern. The National Sweet Potato Festival in Vardaman, besides featuring the crowning of the annual Sweet Potato Queen, has a flea market, eating and cooking competitions, and a contest for the best-washed bushel of sweet potatoes. The World Catfish Festival

in Belzoni has kindred festivities and the crowning of the World Catfish Queen. The Watermelon Festival in Mize designates its Watermelon Queen and has a largest-watermelon contest, a greased-watermelon race, and a seed-spitting match. The Blueberry Jubilee in Poplarville features string band and bluegrass concerts, wagon rides, arts and crafts displays, and blueberry jellies, jams, cakes, and pies. The Tomato Festival in Crystal Springs has a similar motif. The annual Dixie National Rodeo in Jackson, which draws more than fifty thousand people, has a huge rodeo, the largest livestock show east of the Mississippi, and an armadillo race. The Railroad Festival in Amory, with its pageants, parades, exhibits, and golf tournaments, attracts sixty thousand visitors a year. In like temper, but more entrepreneurial, are the First Monday Trade Days in Ripley; one of the liveliest events in all of north Mississippi, they have been held every month beginning on the previous Saturday since the 1890s. Here you can buy or barter anything from dogs to trucks to furniture to shoes, all of it engulfed in the avid idiom. The Gum Tree Festival in Tupelo, held each spring on the lawn of the Lee County Courthouse, features the works of artists and craftsmen, local theater productions, storytelling, music performances, and appearances by writers. The Prairie Arts Festival in West Point, one of the state's largest festivals, showcases painting, pottery, crafts, local cooking, and live entertainment.

In this spirit of congregating, quieter phenomena involving personal understanding and companionship among whites and blacks have been noted here and there. One such organization in Kosciusko is called "The Club" and meets in restaurants for friendly talk and meals: no dues, fees, officers, or projects, and no customer-merchant or employer-employee emphases—just men of all ages and classes shooting the breeze. In Clinton church ministers of different races meet regularly for fellowship and to discuss common concerns. In Jackson the Friendship Ball is sponsored annually by Jackson 2000 to bring black Mississippians and white Mississippians together.

Mississippi's long-established tradition of home cooking is still in the forefront as we enter the twenty-first century. I myself have many memories of the food of my childhood and the rituals of cooking and domestic dining. I remember the covered-dish suppers at the church where a boy could be a paragon of religiosity and sample the venison stews and chicken pies and dozens of casseroles and banana puddings and meringue pies that made the eternal ragings of the Devil himself seem less contemptible. I recall my grandmother's stories of the after-church noontime Sunday dinners (not lunches—*dinners*) in the 1880s at the family house in Raymond when the preacher came. Since she was the youngest of the seventeen children, she sat at the farthest end of the table. "By the time the fried chicken got down to me, all that were left were the necks and the wings," she would tell me, pausing to add, "but they were still mighty good." And the conversations she told me about that took place around that table! One Sunday my great-grandfather, Major Harper, invited the professor from the normal school (teachers' academy). My great-grandfather believed in a proper feast on these Sabbaths—soup to nuts. Near the end of this particular repast he asked the guest at the far end of the table, "Professor, will you pass the nuts?" The professor replied, "I don't know, Major Harper. I haven't graded their examinations yet."

The Mississippi cook today is sometimes the woman, sometimes the man, sometimes both. I am reminded of a lovely young woman from the Delta who serenely marinates and chops and sautes and serves up delightful dishes on perfect china with the correct liquids in the right glasses for a small tribe of guests and makes it seem all effortless. Much of the work is done while her guests are sitting comfortably with her in the kitchen, sour mash in hand, exchanging stories about people long gone or moments from the past.

Taking food is still the primary way in which Mississippians show sympathy for a bereaved family. The axiom here is the smaller the town, the better the funeral food. Jill Conner Browne has written of this Mississippi rite in *The Sweet Potato Queens' Book of*

Love: "For everyone left behind after the untimely passing, there's the unmistakable comfort of funeral food. When there's a death in a town, everybody who has ever known anybody in the family has to take food to the home of the bereaved. It is practically a law." She described one lady in a small Mississippi town who got up every morning of the world and fried a chicken first thing so that, just in case somebody died that day, she could be on the spot with first-class funeral food.

At the best of the private dining experiences will be authentic Mississippi produce, including okra and squash and field peas and corn and greens and butterbeans and cushaws (sometimes known as winter crooknecks), all of which we can grow in the backyard or buy fresh in the spring and summer in places like the Farmers' Market in Jackson, where farm families bring in fruits and vegetables daily. And there will be venison and quail and squirrel and rabbit, oysters and crabs and shrimp just up from the coast, catfish, and watermelons and pecans and blackberries. The stories of homegrown culinary personalities around the state are many: the old man in Canton who walked around the courthouse square selling lemons, pecans, and fruit pies to raise money to rebuild his church which had blown away, the woman in Natchez who prepares her hot pepper jelly in the makeshift kitchen of a carriage house where the breezes from the river cool her off in the summertime, the sportsman from Clinton whose specialty is blackbird and dumplings and who describes fried rattlesnake as "a cross between frogs' legs and fish."

This is a place with a fairly short history of "eating out," but in recent years a number of reasonably good restaurants, and several superb and even fancy ones, have appeared across the state. (Some Mississippians frequent the modern fast-food establishments just as their fellow Americans do everywhere, and there are more buffet places and cafeterias than in most other locales, but what can be written about this?) Now the state's urban areas and college towns have their share of au courant restaurants, much like the ones you find in New York or L.A., featuring entrees with wine sauces, herbs, and portobello mushrooms.

(JoAnne and I recently ate at K.C.'s in Cleveland and found it to be a gourmand's delight.) In Jackson, the Japanese cuisine at Little Tokyo has become fabulously popular, and diners in the capital city can now partake of Thai and Indian food as well.

But most eating out in the state is still done in little hole-in-the-wall establishments serving the same dishes that have been listed on the wall for years—places that are beloved because you can get good, simple food, usually at outrageously inexpensive prices, and also see your friends and neighbors. If you choose not to eat at home, you go somewhere that's just like home, and the tradition of Mississippi cuisine in all its variety lives on in these places.

Catfish restaurants and barbeque joints populate the landscape in every section of the state. The best-loved dinner spots are still serving steaks and chicken and seafood the way they have for years in the same down-home settings; Mississippians have been eating chicken and catfish for two centuries now, and we like them fried. Prohibition has been over in many parts of this state since 1966, but nearly all these home-style restaurants are still "brown bag" establishments: they do not have bars, but customers may bring their own spirits in brown paper bags just as they always did when the state was dry.

I hate to leave out any of our great old dining places, but the ones my friends and I know best are the Mayflower, Crechale's, and the Elite in Jackson, Doe's Eat Place in Greenville, Lusco's in Greenwood, the Revolving Tables in Mendenhall, Lillo's in Leland, Weidmann's in Meridian, Peggy's in Philadelphia, the Hollywood in Robinsonville, Smitty's in Oxford, and the Yocona River Inn in Yocona. You can always count on having terrific food in such places, but these archetypal Mississippi establishments are as much about people as they are about food—there is much boisterous banter and table hopping. Another treasured place is Leatha's Bar-B-Q Inn in the secluded hamlet of Foxworth, a family business with sons, daughters, cousins, and grandchildren all working there, presided over by Leatha Jackson, who began picking cotton at age six and emerged from poverty to produce the best spareribs in Mississippi.

Mississippi was the first state to ratify the prohibition amendment to the Constitution in 1918. Prohibition ended in the United States in 1933, but to this day the state legislature has not formally approved the Eighteenth Amendment repealing prohibition. Never mind. Much has gone on in between.

Despite the bilious customs of the state's populace, it was 1966 before the eighty-two counties were given the chance to vote on whether to make the sale of liquor legal. Today wine, spirits, and beer can be sold in over half the counties, only beer can be purchased in some, and others are still legally powder dry. There are odd local quirks: in Oxford, for instance, a hard-drinking university town, you can buy beer in the stores, but not cold. When I lived there if you paid a certain character in one of the grocery stores a little extra money, he would fetch a plastic garbage bag and some dry ice and have a six-pack cold for you in three and a half minutes. In some localities, liquor stores—called "package stores"—are required to paint over all their windows, presumably so people cannot look inside and get corrupted.

Prohibition was long a clause in the state constitution, but Mississippi was nothing if not a bootlegger society. My father used to say that the only difference between Mississippi and Tennessee was that in Tennessee, which was a wet state, you could not buy booze on Sunday. The legislature passed a 10 percent "black market" tax on all liquor sold. On the Gulf Coast and in river towns you could buy drinks in restaurants and at open bars. My wife and I went into a restaurant in Vicksburg one day years ago after a long drive from Texas and the waitress said, "Welcome to Mississippi. We're a dry state. What can I get you to drink?" The Mississippi bootlegger, who theoretically operated "grocery stores," with ten or twelve cans of sardines and a few boxes of crackers for sale, stayed open at all hours, and would sell to anyone regardless of age or race. Bootleggers would often deliver whatever you wanted to your door. Many sheriffs amassed small fortunes in secret payoffs.

Every so often there would be a referendum allowing voters to express themselves on whether the state should be wet or dry. For weeks before, towns like mine would be filled with feverish campaign activity. Some would quote the old saying "As long as the people of Mississippi can stagger to the polls, they'll vote dry." A handful of people came right out and said that liquor should be made legal so that the bootleggers and the sheriffs would not be able to make all the money. The preachers delivered endless sermons on how to vote, and the churches handed out bumper stickers that said, "For the sake of my family, vote dry." The bootleggers and their families drove around town with these same bumper stickers plastered on their cars. When the time came to vote, the result was a foregone conclusion. Our state legislator from Yazoo City, Harry Applebaum, kept introducing bills in the legislature to legalize liquor and they kept failing, so he began carrying a camera along to various functions around the capital city in order to photograph his fellow legislators pouring drinks for themselves.

Today in many places in the state the former bootleggers own the legal package stores, and older citizens still say they are "going to the bootlegger" when they are en route to a legitimate merchant. Mississippians love their parties, and strong spirit lubricates the coils of sociability, just as it did in the "dry" times. The historical dichotomy is scarcely noticed, except that the liquor entrepreneurs, unlike the bootleggers, do not deliver to your door. Acquaintances of mine in the liquor trade say that the most popular varieties of hard liquor in Mississippi today are, in this order, vodka, scotch, bourbon, and gin. A noticeable development in the last fifteen years or so has been in the consumption of wine. A substantial number of Mississippians have become wine drinkers, and many have come so far as to be considered reasonably discerning connoisseurs. The more prosperous package stores sell wines from the finest vineyards of America and around the world, and the wine lists in the more sophisticated restaurants rival those of their counterparts in nonsouthern metropolises.

Mississippians are involved in a variety of national associations, such as the National Association for the

Advancement of Colored People, the Daughters of the American Revolution, and the Rotary and Lions clubs. Our citizens have organized an astonishing array of some of the nation's more esoteric groups, which have their national headquarters in Mississippi and are sources, too, of meetings and socials and companionship. Most have their own national publications. There are two dozen or more of these Mississippi-based organizations, and I will cite here some that attracted my immediate attention:

• The Palomino Rabbit Co-Breeders Association, located in Ocean Springs, founded in 1953, with two hundred fifty members in seven states, promotes the development of palomino rabbits.

• The Philippine Collector Society, located in Bay St. Louis, founded in 1982, with two hundred members and a staff of three, caters to collectors interested in Philippine coins, tokens, medals, and currency.

• The Old Boys Network Turtle Club, located in Corinth, founded in 1951, with seventy-five hundred members, was organized, in its own words, for "fun-loving folks who are willing to stick their necks out to succeed."

• The Women of the National Agricultural Aviation Association, located in Greenwood, founded in 1976, with one thousand members, is devoted to assisting the National Agricultural Aviation Association with public relations and recreational activities.

• The Descendants of the New Jersey Settlers, located in Natchez, founded in 1940, with five hundred members, is composed of lineal descendants of some people who settled in Natchez between 1772 and 1775. The New Jersey settlers were those who wished to remain loyal to the English crown but did not want to take up arms against their neighbors in New Jersey, so they emigrated to Natchez. Objectives include maintaining the King Cemetery located in front of the Kingston United Methodist Church in Kingston, Mississippi.

• The Coleopterists' Society, located in Natchez, founded in 1969, with six hundred members, consists of professionals and amateurs interested in beetles.

• The multinational Gardner Registry, located in Grenada, founded in 1992, promotes interest in the Gardner automobile, produced in St. Louis between 1920 and 1931.

• The American Checker Federation, located in Petal, founded in 1949, with one thousand members, is composed of master and expert checker players and supporters of the game in the United States and other countries.

Finally, culturally there has been a sea change in the last generation or so in the phenomenon of small-town Mississippi Saturdays, and this saddens me considerably. The home place was pretty much ours until Saturday, when those from the country came to town. The main streets and courthouse squares were centers of bustling activity from Saturday morning to well into the night. In Yazoo one side of Main Street was packed with white people, the other with black, all in town to shop in the stores but mainly to congregate and talk; many townspeople joined in the conviviality, and pint bottles could be seen in more than a few back pockets. All that is gone, replaced by television and fast-food strips and shopping malls. The school kids now hang out in the malls, and so do senior citizens, who sit on the benches there or walk for hours in their Reeboks, chatting as they go—it is the modern-day version of the courthouse square.

The front porch has also pretty much fallen victim to air-conditioning and TV in most Mississippi places, large and small. Not many people sit on front porches anymore and shout greetings to the people walking or driving by. Most houses do not even have front porches, certainly not those in new subdivisions with automatic gates and security guards. But people do still talk, of course. One recent summer twilight I caught sight of my stepson Graham on our back patio talking on a cellular telephone to former governor William Winter, who was also on a cellular phone in his front yard across Purple Crane Creek. As they chatted away, each was looking directly at the other.

OF PARADOX AND PROMISE

*Do not think that even in the poorest commonwealth of the
Great Republic the acquisitive American urges are not still in flourish;
down here the merchants perform their own television commercials, and the
undertakers do also. The merchants sound like undertakers,
and the undertakers sound like merchants.*

—NEW YORK DAYS

THE PHENOMENON OF THE

Mississippi Chemical Corporation fascinates me, and for understandable personal reasons. Its world headquarters are in Yazoo City, my hometown, and it is a homegrown Mississippi enterprise in the best sense. It celebrated its fiftieth anniversary in 1998, having been founded in 1948 as the world's first farmer-owned nitrogen fertilizer plant. Today it is a highly successful publicly traded corporation with installations, partners, and markets around the world. Its inception was in a modest boardroom at the Mississippi Farm Bureau office on Congress Street in Jackson in 1947 when Owen Cooper and a handful of other visionary Mississippians first discussed the possibilities of their chimerical scheme: if Mississippi farmers could not get fertilizer during the drastic shortage after World War II, then, by God, let's build a fertilizer plant for them.

In Yazoo in those times we middle-class kids and planters' sons started driving cars at twelve or thirteen, and I graphically remember cruising in my father's green DeSoto past a cornfield off Highway 49E, where they were slowly and painstakingly putting together the new chemical plant. Railcars from all over the nation were bringing in the basic components. It was a bizarre spectacle, dozens of anonymous men working enigmatically in the muddy field with esoteric pieces of equipment lying about and small tractors scurrying around. The words "nitrogen" and

"ammonia" and "ammonium nitrate" were just then coming into the parlance of the town, and since these were the early years of the horrendous thermonuclear age, my friend "Muttonhead" Shepherd, who was in the DeSoto with me one day, suddenly exclaimed, "My God, do you think they're buildin' an *A-bomb* factory?"

MCC's engineers and scientists began implementing technological advances in making fertilizer. In 1957 in a remote wilderness outside Pascagoula, wild Brahman cows were chasing the MCC people around trucks and trees as construction began on the new Coastal Chemical Company facility, now a major Gulf Coast industry. By 1998 MCC was the greatest potash producer in the United States and had created a partnership with the world's largest supplier of phosphate rock, located in Morocco; the company also has extensive facilities in Trinidad. Today under its CEO, my friend Chuck Dunn, its products are exported all over the world, as far away as China and India, and the company remains the recognized global leader in ammonium nitrate technology, its expertise studied and imitated and its original technology licensed to manufacturers in all corners of the globe. Whenever I am in Yazoo City it does me good to see domestic and foreign visitors who have flocked there to study Mississippi Chemical's techniques. When I was growing up I never once heard Bulgarian spoken there. MCC has always been a civilizing presence in Yazoo City and in the state at large, promoting art and educational and environmental programs and encouraging interracial good will.

It is a real Mississippi story. And there are others throughout the state, which point to our ability to solve our own problems and be the best in the world at what we do. We urgently need more such stories of success so that we can lift ourselves from the bottom rung of America's economic ladder.

Mississippi ranks first among the American states in the percentage of its people living below the poverty level: one citizen in every five. It is fiftieth in per capita income (fifty-first if Washington, D.C., is included) and fiftieth in both median family income and disposable personal income.

Our state ranks last in the country in literacy. Regarding citizens twenty-five years of age and older, it is last in percentage of high school graduates and forty-eighth in persons twenty-five years or older with college degrees (14.7 percent of the population).

One of the signal figures pertaining to a state's effort in the matter of education is that of the enrollment of students from kindergarten through the twelfth grade. The statistics from 1980 to 1995 show a decisive improvement in the percentages of students enrolled, an unequivocal result of the 1982 Education Reform Act under former governor William Winter, but Mississippi still lags behind other states. In 1980 Mississippi was last in the percentage of students enrolled from kindergarten to twelfth grade, with 79.6 percent; in 1995 it had a percentage of 91.8 percent, which placed it ahead of some states in the South.

Equally salient and disturbing figures released in mid-1999 by the tenth annual KIDS COUNT survey compiled by the Baltimore-based Annie E. Casey Foundation showed Mississippi last among the fifty states in child development issues. The ratings were based on figures that measure ten categories such as education, family structure, child death rates, births to teens, poverty, school dropouts, unemployed parents, and lack of health insurance. More than one in every five children in the state were judged "high risk" for developmental problems that could create difficulties in later life, as demonstrated in the percentages of high-school dropouts and teenagers not attending school or working—thirty-fifth and thirty-ninth respectively.

Many of these dilemmas are solvable, according to Jim Bean, former chairman of the state senate committee on public health and welfare. But improvement will come only if the state's leadership shows a dedication not previously seen. "It's going to take a commitment to put children first regardless of whether putting them first would enhance anyone's political future," said Jane Boykin, president of the Mississippi Forum on Children and Families. She

confessed to frustration. "It's the gap that's really starting to bother me," she said. "When we make progress sometimes, work as hard as we can, and make a huge jump percentage-wise, we're lucky if we break fiftieth."

One of the traditional issues facing the Mississippi legislature has been teachers' salaries and expenditures on education. In 1990 the average salary for the state's elementary and secondary schoolteachers was $24,366 (national ranking: forty-eighth). In 1997 the average salary for Mississippi elementary and secondary schoolteachers had risen to $28,062 (national ranking: thirtieth). Despite this improvement, if a Mississippi schoolteacher crossed the state line into Tennessee he or she would automatically make six thousand dollars more a year.

Current total state and local expenditures are $4,118 per elementary and secondary school pupil, making Mississippi fiftieth in the ranking of all states' expenditures per child. The state stands fortieth in expenditures on higher education and fiftieth in faculty salaries in its institutions of higher learning.

We have finally begun to make progress in university library collections. Until recently, a sad fact was that the Louisiana State University library alone contained more volumes than the combined libraries of all eight of Mississippi's publicly supported universities. Redirected priorities and increased library funding have reversed this circumstance. This is a hopeful sign.

With poverty comes an inevitable lack of adequate health care. Mississippi has an overall ranking of forty-ninth among the states in key health-related measurements. Significant in this ranking are such factors as state spending on health, a medically underserved population, and lack of doctors, nurses, and dentists. The state ranks worst in the nation in infant mortality and second in babies born with a low birth weight. Mississippi leads the nation in the number of teenage pregnancies. (It is forty-sixth in number of abortions.)

The dismal quality of too many elementary and secondary schools is obviously a parallel reason for many of the tenacious failures associated with the state. Common sense dictates that until there is wholesale reform in secondary and elementary education the state will remain on the bottom. There patently is room for sweeping renovation in all these areas. What is hampering this improvement?

In February 1999, ten months before Mississippi moved into the new millennium, the state's most widely read newspaper, the Jackson *Clarion-Ledger*, examined the latest poverty figures and, in a lengthy lead editorial under the heading "Last Again?," drew a few conclusions:

Mississippi, like much of the South in the '90s, remains two states: the haves and have-nots. The economy is going great guns for the urban areas, for the educated, for the skilled. For the many rural areas, for the uneducated and for the unskilled, poverty remains just as real and oppressive as the last census report on poverty.

We are a state of new telecommunications facilities in the Jackson area and rusting tractors in the Delta. We are a state with a Las Vegas–type casino complex in Tunica County and dying small towns a few miles down the road.

Mississippi remains capital deficient. And, Mississippi remains human resource–deficient. A large underclass of Mississippians remains stagnated in a cycle of poverty. . . .

There have been significant recent gains for Mississippi, which have been part of a national economic trend. But we still "trend" last economically.

Mississippi must find ways to leapfrog, especially in education and innovative economic development strategies, if it is ever to catch up. Poor economies, whether they are in Mississippi or Bangladesh, lack innovation and flexibility.

Promoting an attitude that Mississippi will never be last again, a Mississippi Miracle, or whatever any political leader wants to call it, is fine for inspiring goals.

But the work on the foundations of economic success are built daily in the decisions that look past politics or profit gains of the moment. Mississippi is doing much better policy-wise, but still has far to go in investing in human capital, in public education and in the social systems necessary for economic opportunity.

Recent economic developments are somewhat reassuring. In October 1994 *U.S. News and World Report* listed Mississippi eighth among the states in both new employment and new business growth and

fourth in income growth. In 1998 Dun and Bradstreet ranked the state first in the nation in the rate at which its entrepreneurs started new businesses and created jobs with those businesses. With nearly four new companies starting up every day in Mississippi in 1998, Yazoo City's Jimmy Heidel, at that time executive director of the Mississippi Department of Economic and Community Development, praised Mississippians "for being industrious, creative, and competitive in exploring new business opportunities." Developments like this can only help an economically beleaguered society. Certain segments are really trying. Although Mississippi has lost more than twenty thousand manufacturing jobs since the North America Free Trade Agreement (NAFTA) was enacted by Congress in 1994, and the state depends on small enterprises to produce 63 percent of its industrial jobs, Mississippi to its everlasting credit has been among a growing number of states which offer vigorous encouragement for "start-up" business enterprises. Around the state at the close of the century, business "start-up" entrepreneurs with support from local governments and the Mississippi Department of Economic and Community Development have been tremendously successful in buttressing businesses largely unnoticed nationally.

Pinnacle Construction, presided over by Donnie Young of Ridgeland, in 1999 was named one of the nation's "Hot 100" fastest-growing new businesses by *Entrepreneur* magazine. Also in 1999 the state was ranked tenth best in the country for survival of small businesses.

The Stennis Space Center in Picayune is helping firms go into high-tech businesses. In Starkville cutting-edge technology enterprises are being developed out of the Golden Triangle with expertise from people at Mississippi State University. (Starkville's Global Aircraft, for instance, completed for NASA in 1999 the successful first phase of a 125-horsepower rotary diesel aircraft engine that will go into mass production in the next few years.) Similarly promising arrangements can be found in Corinth, Columbus, Vicksburg, Clarksdale, Oxford, Grenada, Batesville, and even in rural Kemper County. Jeff Dukes, who

directs these projects for the DECD, says there is considerable return for small investment, reminding us that the state itself only provides $5 million in loan money, with local institutions handling the bulk of the costs.

However, according to data gathered by the North Carolina–based Southern Growth Policy Board in 1999 Mississippi ranked forty-fifth in the nation and thirteenth among fourteen southern states in per capita spending on technological research and development. (Arkansas, twelfth among the southern states in this regard, spent $73 per capita on such programs, while Mississippi and Louisiana dipped as low as $24 and $14 respectively; among other neighboring states Tennessee spent $191 and Alabama $161.) Some local spokesmen pointed out that the state's low ranking is a factor of its types of industry—furniture manufacturing, agriculture, shipbuilding, casinos—but at the same time were quick to say that increasing research is dependent on producing more highly educated students and technicians, which means dramatically increasing math and science education in Mississippi's public schools—something of another vicious circle. A multimillion-dollar program is under way to boost math success in the Delta schools, but the challenges are immense.

One of the most dramatic circumstances in recent Mississippi history, and it augers well for the state in terms of public revenue, has been the highly effective campaign of its resourceful attorney general, Mike Moore of Pascagoula, to hold the tobacco industry financially responsible for the state's public health expenditures necessitated by tobacco use. He won a $4.1 billion settlement in 1997, to be paid over twenty-five years. This inspired similar efforts in other states as well and made Moore an admired figure nationally. (In 1999 the eleven Mississippi law firms involved in the successful battle were awarded $1.4 billion in legal fees and expenses, headed by Richard Scruggs's Pascagoula firm, which received more than $300 million, all these fees being separate from the $4.1 billion settlement itself. "We took an enormous risk and got an unbelievable result for the citizens of Mississippi," Scruggs said.) The Mississippi legislature

has wisely established a trust fund into which the annual payments from the tobacco settlement are placed. The interest from this fund may be spent only on health care matters, according to a coherent plan recommended by health care experts.

The advent of the gambling casinos in 1990, which not a few Mississippians have viewed as bringing decidedly qualified blessings, has clearly been an economic boon, and has elicited much-needed tax growth for the state. (I will discuss the bizarre economic and cultural phenomenon of these casinos later in this section.)

The prospect today for basic social and economic modernization in Mississippi is not without hope, but must be viewed in the broader context of the state's history. As late as the 1930s Mississippi was for all purposes a colonial region. Governor Hugh White's Balance Agriculture with Industry program (commonly known as BAWI), initiated in the late 1930s, succeeded in bringing some industry and a modicum of diversification to a state with an economy based primarily on cotton and timber. It was far from a resounding success. The main problem, however, as Millsaps College historian Robert S. McElvaine explained in his introduction to the fiftieth anniversary reissue of *The WPA Guide to the Magnolia State*, was that the effort to modify the state's economic arrangements six decades ago was done without any relevant effort to reform the social system.

So symbolically and realistically injurious to Mississippi did W. J. Cash consider the state's long-range BAWI program that five of the last eight paragraphs in his classic *The Mind of the South* are devoted to it: the suspension of taxes on absentee Yankee manufacturers for long periods, the handing over without cost of bond-subsidized buildings, machinery, and operating capital, the rock-bottom wages leading to a permanent underclass of workers, and the giving away of wealth with no adequate return, the main benefactors being the merchants and bankers.

In the latter years of the century, increasing world pressures on these penurious factories—"runaway underwear plants from New England," one cynical realist called them—have led the companies to leave places like Mississippi for countries like Mexico where labor is cheaper, precisely what brought them here to begin with. Optimists hope that these will be replaced at a greater rate by more appealing light industries.

One of the lingering pernicious human problems is the absence of broad and effective programs in adult literacy, vocational and technical education, and work-force training. Mississippi has the lowest-skilled work force in the nation. "You can't learn how to be a welder if you can't read the manual," a critic of the state's job-training commitment observes. One Mississippi businessman among many, Charles Holder of HOL-MAC in Bay Springs, a manufacturer of heavy machinery, points to the desperate need for better education and improved training: "There's no question in my mind. This is a very complex situation. We don't have students coming out of the twelfth grade who are really twelfth-grade educated. For those of us in industry, by the time they get remediated, we've still got to train them. It's a very serious pattern for the economy in this state."

In the opinion of progressive business people in the state, long-range economic development must be markedly enlarged; only minimal advances have been made, and Mississippi will not be able to compete without technology. And education is the key to technology.

It bespeaks something of the paradox and promise in our state that seven months before the new millennium a scion of one of the state's oldest and most distinguished and enlightened families, James Barksdale (whose forebear General William Barksdale fell at Gettysburg), having made a considerable fortune as president and CEO of the Internet's Netscape Communications, announced that he would return home and invest a good portion of it in the improvement of education in Mississippi. He intends to put his money into early childhood programs to help white and black public school children, particularly in reading and math, so that they will be able to compete for jobs in a highly technical and international market. "That's why it's so important to build the talent pool in Mississippi," he said, "by creating qualified work-

ers—and that goes back to the need to produce a very good caliber of public-school-trained technicians and workers." The hope is that this vision will come to be shared by much of the state's power structure.

The state has always been noted, of course, for its sparse levels of government spending and taxation and for its regressive tax system. It was Mississippi, in fact, which in 1932 pioneered the sales tax in an effort to save a bankrupt treasury depleted by the depression and Governor Bilbo's fiscal irresponsibility. Poorest of the states that it is, it ranks sixth in the nation in the sales tax rates ($4.02 per $100 of personal income), which are applied indiscriminately to food purchases and diamond rings, and its onerous motor vehicle taxes are the nation's seventh most stringent. Despite all this, Mississippi's last governor of the twentieth century, a Republican and prosperous construction firm owner named Kirk Fordice, unsuccessfully advocated sharp reductions in state income taxes on the wealthy.

In the cause of perspective, it must be said that, since the 1960s, with Lyndon Johnson's War on Poverty and accompanying legislation, the most awesome alteration in Mississippi's economy has come not from industry or technology, not from the gambling casinos or the tobacco settlements, but in direct benefits from the federal government—that traditional anathema to many here—both to the state itself and to its individuals. Since 1960 federal subsidies here have increased by more than 900 percent. By far the most substantial origin of income in the state at the close of the century is federal "transfer payments"—military pensions, welfare, senior citizens' centers, Medicaid, school lunch programs. (A common scene at store checkout counters throughout the state is groceries being paid for with food stamps.) In 1995 the citizens of this state received over $10 billion in federal payments. In contrast, the state's general budget that year was approximately $2.8 billion.

In 1995 only 13.4 percent of all jobs in the state were agricultural; 24 percent were manufacturing; 21.6 percent, service; 21 percent, trade; and 20 percent, governmental.

Because of the monumental decrease in farm workers after World War II, in the early 1960s industrial employment finally equaled agricultural in Mississippi. In 1965, for the first time in the state's history, industrial income exceeded agricultural. The number of farms has been steadily declining as the size of them increases. In 1998 there were 42,000 farms with an average size of 276 acres. The vast majority of the state's agricultural produce is grown on corporate-sized farms. Small farms still exist, but a phenomenon of the latter years of the century is that these farmers frequently work their land only on weekends and at night while earning their living in the nearby towns. But Mississippi in élan and character is still primarily an agricultural society. Its principal agricultural-livestock goods are cotton, soybeans, broilers, and "aquaproducts," meaning fish of all kinds.

In Mississippi the late 1940s were marked by a burgeoning revolution in agriculture, which changed the rudimentary contours of the state just as it did in the larger South. Cotton production, which had involved sharecropping and hoes, now began to make use of tractors with flame burners, cross-plowing, herbicides, and mechanical cotton pickers. The first mechanical picker, made by International Harvester, was tested in 1944 at Hopkins Plantation just south of Clarksdale in the Delta, and eventually led to the most sweeping reversal in the cotton culture since the cotton gin itself. One two-row mechanical picker could replace 140 hand pickers. The familiar vista of hundreds of black people of all ages chopping and picking cotton, dark silhouettes in the sunlight who would pause in their labors and wave at you as you passed in your car, was soon to disappear. The poor, unsung mule (Faulkner judged mules the smartest of all animals), faithful ally that plowed the fields and helped build the levees, is seldom seen anymore.

In 1956 the deadly methyl parathion was introduced to the cotton industry to control the boll weevil, and for years it and DDT would be the mainstays against that wily predator. Mechanization proceeded

apace. In the year 1999 one man driving the largest, fastest mechanical harvester could collect one hundred forty thousand pounds of cotton a day, the equivalent of one hundred bales, a feat that fifty years ago would have required six hundred human beings.

Now cotton is no longer king in the state. Soybeans lack the awe and theatricality of cotton, its historic past of blood and guilt; where else but in the Mississippi Delta would you see the words "God Bless America" hand-painted on a cotton bale? But beginning in 1950 acres planted in soybeans began to outnumber those on which cotton was grown. A diligent individual named Dr. Hartwig at the Stoneville Experiment Station in Leland would lead the world in developing soybean varieties, which he named for Confederate generals—Jackson, Hood, Hill, and, of course, Lee; he also named a newly developed wetland bean Semmes in honor of the Confederate admiral. Cotton, while its acreage is diminished, to this day remains the ranking cash crop. Mississippi is third in the United States in cotton production.

Today the state's farmers employ sophisticated satellite and computer-operated rigs to apply the precise amount of plant food needed on every plot. In the 1980s BASF, the German chemical giant, introduced the plant regulator chemical called PIX that inspires cotton to produce faster and on a shorter stalk; this development would allow farmers to plant later and harvest sooner, before the fickle autumnal rains that once destroyed their crops. Following three successive years of droughts and crop failures, Delta farmers finally acknowledged that they would have to irrigate to produce higher yields. Now the giant irrigation machines resembling long steel dinosaurs hissing mists of water across the ravenous Delta soil have become familiar fixtures.

At long last the agricultural landscape of the state has the affluent look of intelligent diversification. Rice was introduced in the 1960s. Farmers could utilize the heavier clay "buckshot" soils, which hold water required for growing rice (and raising catfish) but are not suitable for growing cotton because of poor drainage. Bolivar County in the Delta is now the second-leading rice-producing county in the nation. The debut of rice has by any measure been a striking addition to the state's agricultural family. ("Now," a waggish Delta fellow I know says, "if we could just figure out how to grow gravy, we'd be tops in the world in raising rice and gravy.")

Mississippi farmers raise wheat, oats, corn, cattle for meat and dairy products, hogs, pigs, and chickens; in 1995 Mississippi was fifth in the country in the production of broilers and sixteenth in eggs. Pecans are a profitable enterprise in several parts of the state, and fruit growing has become a viable calling; blueberries, for instance, are now being marketed by the hundreds of thousands of tons. The native muscadine is being used for wine making at Mississippi State University, the Old South Winery in Natchez, the Gulf Coast Winery in Gulfport, the Aspen Winery in Jackson, and a few other places, as well as for muscadine jellies and jams. And while Belzoni calls itself "The Catfish Capital of the World," the even smaller town of Vardaman refers to itself as "The Sweet Potato Capital of the World," and Mize is known as "The Watermelon Capital of the World."

The real giant among Mississippi agribusinesses is the forestry industry. The far-flung branches of the forestry business, which includes not only timber and paper products but furniture as well, provide jobs for 66,173 Mississippians—fully one-fourth of the state's manufacturing work force—with an annual payroll of $1.6 billion. According to the Mississippi Forestry Association, our state leads the nation in tree planting and harvests $1 billion per month from forests and forest products.

Mississippians in the Piney Woods region and elsewhere have long since learned that lumber is a renewable resource, to be harvested like crops; having begun in the middle 1960s, a technology to make plywood out of young pine trees has grown into a godsend for lumber businesses in the state. Weyerhauser, Georgia-Pacific, International Paper, and other corporate behemoths began reforesting to provide trees for their Mississippi plywood plants and paper mills.

In Mississippi, forest lands cover 11 million acres,

some 62 percent of the state. Sixty-nine percent of our forest lands remain in the hands of private landowners, with 11 percent owned by the federal and state governments and 20 percent by corporate interests.

One of the nation's cutting-edge timber investment and management organizations, the Molpus Woodlands Group, was launched by Mississippi's impressive former secretary of state, Dick Molpus, after he lost a hotly contested bid to unseat Kirk Fordice from the governorship in 1995. "I had to have a job," Molpus explained, "and this is what my family had done since 1905—manage timberlands." Molpus has persuaded investors from around the globe to let him purchase on their behalf six hundred thousand acres of land in Mississippi and other southern states, and, using new forestry management techniques, grow large, mature pines in a manner that protects streams and wildlife, avoids the blighted landscapes of clear-cutting, and produces maximum returns. In the short span of five years, his firm, the only one of its type in the South, is the nation's fifth largest.

In 1989 a massive $350 million paper mill, Newsprint South, which opened near Grenada, drew on modern technology to attract the cash of major American newspapers. One of the most interesting business facilities in the state is Ringier-America, Inc., a mammoth printing complex in Corinth which prints *National Geographic*, as well as *Woman's World*, *Ebony*, and *Jet*.

The much-maligned channel catfish has always had a rather tarnished reputation as a poor man's trash fish, but today in Mississippi the catfish revolution rivals the casino one, while being considerably more venerable and indigenous. The state's catfish industry had its genesis in the 1960s. Since then Mississippi catfish have become the fifth most popular seafood in the United States, trailing only shrimp, salmon, tuna, and Alaska pollock. Two-thirds of the world's production of catfish (raised on what are called catfish "farms") originates in the Mississippi Delta. Mississippi, then, ranks number one in catfish output not only in the nation, but in the world.

Between 1970 and 1993 there was an astounding hundredfold increase in catfish production in the Delta, from 5.7 million to 460 million pounds. Even cerebral gourmands in restaurants on the Upper East Side of Manhattan and the Sunset Strip of Los Angeles have been extolling the piquant delicacies of Delta catfish. The white, clean flesh is high in protein and low in calories, features that make it attractive to a diet-conscious American society. Craig Claiborne, the Mississippian who was food editor of the *New York Times* for many years and the most perspicacious arbiter of cooking and dining in the country, addressed himself to the plethora of catfish recipes everywhere: catfish amandine, catfish souffle, crab-stuffed catfish, Kiev-style catfish. *Southern Living* reports that almost a thousand recipes are entered each year in Mississippi's Farm-Raised Catfish Cooking Contest. Since their inception, which involved the conversion of cotton and soybean fields, catfish ponds have come to cover well over a hundred thousand acres in the state. The live fish are transported straight from the ponds to processing plants, then shipped all over the United States. Support industries include hatcheries, feed mills, and harvesting establishments; the farm value of catfish sold increased from $14 million in 1970 to $275 million in 1996. Some 90 percent of the state's catfish are raised in the Delta, and most of that in two counties alone, Humphreys (Belzoni) and Sunflower (Indianola).

The state's largest industrial employer is Ingalls Shipbuilding on the coast in Pascagoula, a subsidiary of Litton Industries of California. Its employees number over ten thousand. It has an eminent history. In 1940, two years after it was established, Ingalls built the world's first all-welded, dry cargo ship, *The Exchequer*, and that ship is still in use. During World War II it constructed seventy aircraft carriers, troop transports, and cargo ships. In the last quarter of a century, its Pascagoula yards, the nation's most modern, have produced a large share of the U.S. Navy's warships, nuclear submarines, and guided missile cruisers, and continue today to build the navy's finest and most sophisticated ships. In 1995 Ingalls received over $1.25

billion in defense contracts. Also in Pascagoula, Friede Goldman Halter Inc., the state's third-largest employer, utilizes three thousand people to construct giant offshore oil rigs and other marine products.

In northeast Mississippi, the explosive growth of the furniture industry is a national success story. It began in the 1950s when Morris Futorian, a visionary Russian immigrant, moved to New Albany and launched highly successful furniture factories there and in Okolona. His successors, Mickey Holliman and Hassel Franklin, have since built two of America's largest furniture empires. Holliman, with offices in Tupelo and St. Louis, is CEO of Furniture Brands International, which claims the largest share of America's furniture market. Franklin's firm, headquartered in Houston, Mississippi, is America's largest privately owned builder of recliners. Tupelo, long a beacon of economic progress in our state, has grown to be the nation's second-largest furniture market (trailing only High Point, North Carolina), with twenty thousand buyers from around the world arriving twice a year to purchase from dozens of northeast Mississippi furniture makers. Tupelo has recently built 1.2 million square feet of showrooms in hopes of luring furniture buyers to Lee County.

Known for its meat products, Bryan Foods of West Point was founded in 1934 and merged with the Sara Lee Corporation in 1968. John Bryan is CEO of Sara Lee. His younger brother, George, remembers working in his father's modest canning plant during the 1950s, putting the little keys on tops of cans of Vienna sausage—a far cry from his present position as senior vice president of Sara Lee, where he oversees eleven operating companies and eighteen meat-processing facilities in the United States, twenty in Europe, and three in Mexico, producing, among other brands, Bryan Foods, Jimmy Dean, Smoky Hollow, King Cotton, and Hillshire Farm. The current annual sales for the meat division, over which Bryan presides, are $4.6 billion. It was Bryan that financed and oversaw the construction of one of America's finest golf courses, Old Waverly, just outside West Point, which in 1999 hosted the LPGA U.S. Women's Open. On display in the Old Waverly clubhouse is a black pot, which George's grandfather, James, used in the late 1800s when he killed his pigs and sold them at his meat market in West Point.

Although not a leading source of minerals, the state *is* a consequential producer of oil and gas. Oil was first discovered in Mississippi in Yazoo County in 1939, and I remember how the town was almost overnight descended upon by outlanders with unfamiliar license plates from Texas, Oklahoma, Arkansas, Kansas, and other exotic venues; my father for a time worked for the first oil refinery in the state at Tinsley. Mississippi has frequently been ranked among the country's top ten states in oil production, but the catastrophic depression in oil prices in the early 1980s had its effect, and today one can see idle drilling rigs marking the landscape here and there. More than half the state's counties produce either oil or gas, mainly in south Mississippi.

Mississippi's best-known homegrown retailers also made news in the late days of the twentieth century. Twenty years after taking over the venerable Kennington's department store across from the Governor's Mansion on Capitol Street in the 1970s, the Jackson-based McRae's stores became a part of the Proffitt-McRae companies, which made history in 1998 by acquiring the nation's most famous fashion location, Saks Fifth Avenue. I enjoy reminding my old Manhattan friends that the administrative offices for Saks Incorporated are now located in Jackson (on Highway 80, not far from Crechale's restaurant) and directed by two imaginative and aggressive southerners, Brad Martin of Tennessee and Jim Coggin of Jackson.

Mississippi's largest home-owned private business, Jitney Jungle stores and its Holman and McCarty founders, captured headlines in the late 1990s when they sold the grocery chain to northern investors for a reported price of $200 million. They got not only Jitney 14 where Eudora Welty and my grandmother shopped for decades, but also my own nearby Woodland Hills store. Apparently, the new owners are not as savvy as were their Mississippi predecessors who

managed Jitneys for generations: they were forced to file for bankruptcy in 1999. The same situation has occurred with Bill's Dollar Stores, whose bright logos grace storefronts in rural downtowns across the Deep South. Bill Walker of Columbia, who pioneered the concept of dollar stores in small southern towns, sold the chain, which still bears his name, to New York investors, and in a few years they, too, were in the bankruptcy courts. It appears that Mississippi boys know a thing or two about buying low and selling high.

In this quintessentially laid-back state, it is satisfying to acknowledge certain technological truths, such as that the first astronaut to head NASA is Richard H. Truly from the little town of Fayette and that Joe Price of Meridian is chief of the Science and Technology Division of the Library of Congress.

In 1998 it became international news when a Mississippi company, WorldCom, swallowed the telecommunications giant MCI to become the second-largest long distance telephone company in the nation, with world headquarters in Clinton. The man who succeeded in engineering this remarkable coup was Bernie Ebbers, a Canadian who had come here as a student to play basketball for Mississippi College in the early 1960s. Now media pundits have said that Ebbers could rival old John Rockefeller as a dynasty builder and that Bill Gates should thank his lucky stars Bernie chose telecommunications, not software. In 1999 Forbes reported that Ebbers nearly doubled his wealth in the previous year to $1.3 billion, which some old-timers say makes him Mississippi's first billionaire. He is now president and CEO of MCI WorldCom, and a deal maker extraordinaire. At the close of 1999 Ebbers and MCI WorldCom were in the process of acquiring the nation's third-largest telecommunications company—Sprint—in what would be the biggest acquisition ever, worth $130 billion.

MCI WorldCom also acquired Jackson's SkyTel, founded by the legendary Corinth native John Palmer, in 1999, in a deal valued at $1.3 billion. Mississippi's telecommunications comet is flying high, and Ebbers says he is here to stay. He is expected to bring more excitement to Mississippi with the debut of his Jackson Bandits professional hockey team.

What would longtime agriculture commissioner Jim Buck Ross think about ice hockey in his rodeo coliseum?

The telecommunications industry is apparently growing faster outside the United States than in this country, and experts say MCI WorldCom is now in a position to corner that international growth. That is one reason the Mississippi behemoth will likely expand faster than the industry as a whole. In 1998 MCI WorldCom had global revenues of more than $30 billion in sixty-five countries.

Another jewel in Mississippi's technological crown is Delta and Pine Land Company, with world headquarters in tiny Scott, just north of Greenville on Highway 1 and site of the 1927 Mississippi River levee collapse that resulted in the flooding of the entire Delta. Under the farsighted leadership of Brooklyn-born Roger Malkin, Delta and Pine Land has grown to be the world's largest breeder, producer, and marketer of cottonseed, with operations in Arizona, Argentina, Australia, Brazil, China, Greece, Mexico, the Netherlands, Paraguay, South Africa, Spain, and Turkey. Investors on the New York Stock Exchange cotton to Delta and Pine Land stock because it is the world's first firm to master the profitable art of genetically engineering cottonseed to produce higher yields and have resistance to boll worms and herbicides. Delta Pine was founded in 1911 by the Manchester, England, Spinners and Doublers, who coveted a source of fine Mississippi cotton for their British mills. For decades the British-owned Delta operation experimented with improved varieties of cotton and sold seed as a sideline business. Two decades ago, the astute Malkin, who saw the lucrative possibilities for high-tech breeding of cotton and soybean seeds, persuaded the Brits to sell him their business, and now the Delta-based firm is a giant in world seed technology.

Once Mississippi's cotton is harvested, another homegrown firm, StaplCotton of Greenwood, steps in to market that cotton to mills around the world. Headed by Woods Eastland, son of Mississippi's famous Senator James O. Eastland, StaplCotton is the world's oldest and among the three largest cotton marketers in the world.

Just around the corner from StaplCotton's world headquarters in Greenwood's historic cotton district are the handsome showrooms and headquarters for Viking Range Corporation, creators of the world's finest gas ranges for the home kitchen. Gourmet cooks and discriminating chefs around the world sing the praises of the sleek and pricy Viking commercial-type cooking equipment, all manufactured in Greenwood by innovative CEO Fred Carl. Some years ago, Carl, a Greenwood building contractor, got so frustrated trying to locate a stove to his liking that he decided to build it himself. Now he manufactures a complete line of professional-quality kitchen appliances.

In other technological advances, the John C. Stennis Space Center in Hancock County, sprawled over two hundred square acres of land, employs 3,575 people, 42 percent of them scientists and advanced engineers. Rocket and space-shuttle engines are developed and tested there. The U.S. Naval Research Laboratory is also quartered in this complex, including the Naval Oceanographic Command with its numerous laboratories for acoustic and oceanographic computation and analysis. The prodigious antennas dotting the landscape receive oceanographic and meteorological satellite data. All this constitutes yet another of Mississippi's surprises—such complicated and esoteric paraphernalia situated just outside the once-somnolent settlement of Picayune (named after a pioneering female journalist from the vicinity who became editor of the *New Orleans Picayune*). Years ago, before the lumber crash, the lumber mill owned by L. O. Crosby, whose descendants are today among the state's leading philanthropists, employed just about everybody in town, the main noise coming not from rocket engines but from the sawmill whistle.

Farther north in Vicksburg is the largest U.S. Army Corps of Engineers research, testing, and development installation, the Waterways Experiment Station, which houses the biggest hydrology and hydraulics laboratory in the world. In the academic milieu, the Jamie Whitten National Center for Physical Acoustics is located on the campus of the University of Mississippi. In this renowned research facility, scientists and students explore the physics of acoustics—sound and sound waves. If you are fascinated by the concepts of sonoluminescence, resonant ultrasound spectroscopy, outdoor sound, nonlinear acoustics, land mine detection, and agroacoustics, the Ole Miss center is *the* place for you.

The National Science Foundation Engineering Research Center for Computational Field Simulation, considered the most impressive of its kind, is located at Mississippi State University in Starkville. The center's vision, in its own words, "is to enable for U.S. industry and government agencies superior capabilities for computational field simulations of large-scale geometrically complex physical field problems through domain-specified integrated simulation environments for rapid analysis and design, facilitating a shift from physical prototyping towards computational simulation prototyping." I'm just an old Mississippi boy, and that's good enough for me.

Despite its lackluster reputation in modern-day health care, Mississippi has many bright spots in medicine today and can also claim a proud past in that field. I call on the *Encyclopaedia Britannica*: "Historically, the state has been in the vanguard of public health services. The causes of pellagra were discovered in 1915 through experiments at the state penal farm. A model mosquito-control program eradicated yellow fever, and the state tuberculosis sanitarium became recognized nationally. Pioneer work has continued in Mississippi in the education of blind and deaf children."

To me the two foremost Mississippi men for all seasons are Dr. Arthur C. Guyton and Dr. James D. Hardy, both of whom are associated with one of the state's most admirable institutions, the University of Mississippi Medical Center in Jackson, which was founded in 1955, a huge cosmos of hospitals, schools, laboratories, libraries, and health services. These men are celebrated around the world for their imaginative and innovative work, which brings honor to our state. Dr. Guyton is generally acknowledged to be the world's finest physiologist. His *Textbook of Medical Physiology*, first published in 1956, is the most widely

used medical study tool anywhere; it is read by medical students all over the globe. Several of his discoveries have reversed previously held scientific beliefs. He was also an inspiring teacher; former students who worked under him in Mississippi are now in charge of medical and physiology complexes around the United States and in many foreign countries, including Switzerland, the Netherlands, Japan, and Egypt, and his computer techniques regarding bodily functions have revolutionized medicine. His research on heart and blood vessel function has been crucial to that field; not stopping there, he has invented a walking brace, a medical hoist, and a motorized wheelchair. All ten of his children are medical doctors.

Dr. Hardy and his Jackson medical unit performed the world's first heart and lung transplants and the first kidney autotransplant. In the midst of this daring work he also served as president of the American College of Surgeons, wrote textbooks, and continued in teaching, research, and administration. The legacies of both Guyton and Hardy are still powerful presences at the University Medical Center.

It should be noted that a respected national medical referral service, Woodward/White, Inc., in 1999 named nearly five hundred Mississippi physicians as being among the country's finest doctors, twice as many as our population would suggest. One hundred sixty-five of these doctors were from the University Medical Center alone. Most of the Mississippi doctors were from the Jackson area, but rural neighborhoods like Winona, Hazlehurst, and Amory were also represented.

In this exploration of some of the contemporary economic, technical, educational, and political structures of the state, I have reserved a special place for one of its most vivid and in many circles volatile developments—the advent of the gambling casinos. Many conversations in Mississippi these days inevitably turn to these arrivistes.

Despite the biblical injunctions, Mississippians have always been gamblers, gamblers against the eternal elements, against the dire ephemera of life itself. Years ago there were hidden-away illicit spots for gambling. William Faulkner took note of "the discreet and innocent-looking places clustered a few miles away just below the Mississippi state line" where blackjack and dice and roulette were available. What, I wonder, would Mr. Bill make of today's circumstances?

Legislation allowing casinos was passed in 1990, but it was close (by two votes in the state senate), and permits gambling establishments to be located only on certain bodies of water—the Gulf of Mexico and along the Mississippi River. Federal law permits gambling on Indian reservations in those states where gambling is sanctioned. Now, a decade later, Mississippi is the second-biggest gaming state in the country, trailing only Nevada, and gambling (or "gaming," as it is euphemistically called) constitutes a major new tax base and source of construction growth; the state levies an 8 percent tax on gaming revenues, and the local municipalities in the nine gambling counties tax at 4 percent. In 1998 state government received $250 million in casino taxes and the localities $65 million, and those figures are steadily rising. The tax monies from casinos, which flow into the state's general fund, amount to almost 10 percent of the state's budget. Though, as with the tobacco money, there is no plan specifying exactly how these monies must be used, they have funded, among other things, the construction of highways, university buildings, and mental health facilities, as well as teacher pay increases.

The casinos directly employ over thirty-three thousand people with an annual payroll of half a billion dollars. Since 1992 they have spread like kudzu on the Gulf Coast, in Natchez, Vicksburg, Greenville, and Tunica County, and on the Choctaw reservation in Neshoba County. The inevitable proliferation of housing, hotels, grocery stores, restaurants, and other service businesses has created thriving boomtowns, like Horn Lake and Southaven, reminiscent of the lumber baron's days in the Piney Woods. The survival of these places depends on the continuation of the gambling lifestyle.

But ambivalent feelings exist among certain politicians, business leaders, and others for religious or

moral reasons. Baptists call it "the sin industry," maintaining that it preys on the weakness of others. Nearly everyone has a story about friends or acquaintances getting mired in such deep financial trouble that they lost everything and had to seek psychotherapy. The state helps fund the nonprofit Mississippi Council on Compulsive Gambling, which in 1998 divulged that some 88,700 Mississippians may have addictive gambling behavior. One of the big problems apparently is that such obsessive souls engage in what is called "chasing," which means that when they lose a lot of money they decide to bet more to make up for it.

The question, too, is raised regarding the value of tax benefits set against local sense of place and identity, the worry that a once-lovely and sultry seductress like the Gulf Coast, for instance, has become an appendage of Vegas and the casino economy. You see pulpwooders, poultry workers with nets on their hair, housemaids, and laborers galvanized by the sight of other people winning all around and attracted by the giving away of new cars and houses. (The nation's most illustrious entertainers also come in to perform regularly in Mississippi's casinos.) In America's most impoverished state the spectacle of poor people leaving these establishments with empty pockets and dazed looks on their faces does not especially warm the heart.

But of one thing we can rest assured: with nearly a billion dollars in wages and taxes entering the state economy every year, as a legislative lobbyist says, "Demon gamblin' ain't ever gonna go away. You can bet on it." The gambling business is certain to gain more political influence as time passes, although, as one strongly pro-casino legislator sanguinely assures us, it will never be as influential as the farm bureau and the Baptist Church.

Tunica County, with its ten casinos, has more hotel rooms than Memphis. (Special buses come speeding down old Highway 61 from that impervious city.) Traditionally this Delta county has been one of the poorest in America. Once I was a passenger in a small private plane that flew over the gambling casinos. It was a terrific spectacle, as if a whole glitzy new city had sprung full-blown overnight from the swamps and oxbows.

The commercial part of Tunica, once so shabby and forlorn, is exceedingly clean and spruced up, with colorful banners on all the lampposts welcoming visitors. North of town to the west of Highway 61, the expansive approach on new thoroughfares toward Casino Strip offers what must be one of the most unusual tableaus in all of modern America. As the casinos rise in the distance, the flat Delta land is everywhere profuse in cotton, which reaches to the very parking lots of the gaming palaces. Glittering new motels emerge here and there from the verdant cotton, along with flashing neon signs reading "Be the First Millionaire in the Millennium" and "Vegas Excitement—Southern Charm" and a little modern mall with a pawnshop displaying a banner that says "Instant Cash," while out in the alluvial fields stand tiny black churches from another era altogether, a shabby tenant shack here and there, an abandoned tin cotton gin covered in weeds and the encroaching kudzu, and road signs proclaiming deer crossings and tractor crossings. Vehicles with out-of-state plates speed past, and, in the shadow of the river levee, just beyond one prodigious casino in the design of a medieval castle with ersatz turrets and a moat, lies a golf course. Although the notorious "Sugar Ditch" slums in the town of Tunica have been torn down, a sprawling impoverished black neighborhood yet remains—row upon row of sagging shacks with a persistent aura of poverty in proximity to the slots and roulettes.

Of the Gulf Coast's twelve casinos, nine are in Biloxi. The newest, called Beau Rivage, opened in 1999 at the cost of over $650 million, including $3.5 million on landscaping alone. It is the largest hotel in the South, and that includes the ones in Atlanta and the New Orleans Hilton. It has 1,780 custom guest rooms with marble baths, 66 suites, 12 restaurants, a marina for yachts and sports-fishing boats, a 30,000-square-foot convention center, a grand ballroom and outdoor pavilion, a special Mediterranean-style gambling area, shops, and a spa. "Mississippi has made some progress in becoming a destination market,"

one gaming analyst said, "and the opening of Beau Rivage will sort of keep things moving in that direction." Television commercials were aired all over the state before the grand opening. After counting off the casino's palatial attractions, a woman's sultry voice concluded, "We still love the smell of magnolias."

The Mississippi River towns of Natchez, Vicksburg, and Greenville also have gambling casinos, and one of the most lavish, the Silver Star Casino, is located far inland in Neshoba County. It and the adjacent Dancing Rabbit Creek Golf Club are owned and operated by the Mississippi Band of the Choctaw Indians.

Mississippi was the first state in the union to establish a junior college system, in 1928, and claims its system is a national model. These two-year institutions are now called community colleges, and there are fifteen of them in the state today operating thirty-three centers. Their enrollment is eighty-one thousand, with 43 percent in academic courses, 19 percent in vo-tech programs, and 38 percent in continuing education. More racially integrated than our senior colleges and most of our high schools, they are as much a fixture on the educational scene here as perhaps in any other state in the nation. Hinds Community College in Raymond, for instance, had an enrollment of about thirteen thousand in 1996, making it larger than any of the state's universities except Mississippi State and the University of Southern Mississippi.

The College Blue Book lists thirty-five accredited colleges and universities in the state. Mississippi is ranked eighteenth nationally in the number of public institutions of higher education and twenty-sixth in the number of private ones. In 1998 the state's expenditures for higher education was $94 million, which gives it a national ranking of fortieth.

Many truly fine teachers work in these schools, believing passionately in the value of teaching young people. They are certainly not in it for the money. Mississippi is ranked fiftieth in the United States in faculty salaries at such institutions, and, without any

meaningful commitment from state government, will remain in that situation.

There are eight state-supported universities, listed here in order of date of establishment: the University of Mississippi (Ole Miss), Mississippi State University, Alcorn State University, Mississippi University for Women, University of Southern Mississippi, Delta State University, Jackson State University, and Mississippi Valley State University, all overseen by a twelve-member board appointed by the governor. My neighbor in Yazoo City, Dr. Robert Harrison, who in my boyhood days was the only referee at the football games played by the black high school (called Yazoo High Number Two), would become in the mid-seventies the first black appointed (by the governor at that time, Bill Waller) to the state board and later was voted its chairman.

Our state's largest university is Mississippi State University, with 16,076 students. Its Starkville campus quarters the distinguished Stennis Center for Public Affairs, and its schools in architecture, engineering, forestry, and veterinary medicine are among the finest in the South; so are its championship baseball teams. Mississippi University for Women, with its stunningly lovely campus in Columbus, opened in 1884 and was the first state-supported university for women in the United States; today 18 percent of its students are men. As a student Eudora Welty was the cartoonist for the paper and fire marshall of Hastings Hall. One night she sneaked away to go downtown and won a Charleston contest at the Princess Theater. The University of Southern Mississippi, which was founded as Mississippi Normal School in 1910 to prepare teachers for the state's school systems, has made remarkable strides in recent decades. Still the state's largest educator of teachers, USM is also home of the Shelby Thames Polymer Science Research Center, which links cutting-edge research on plastics to practical business applications. USM's Center for Writers is one of the nation's best for fiction and poetry, and its College of Arts is one of only a dozen in the nation accredited in art, dance, theater, and music. The Hattiesburg campus is also home to the Lena de

Grummond Collection of children's literature, the world's largest. Jackson State University sponsors excellent lectures, readings, and symposia on the black experience, and is the home of an institute for the study of black history and culture. With an imposing campus, an enrollment of 6,354, and a location in the heart of Mississippi's largest city and seat of government, JSU could, with adequate finances and imaginative governmental planning, become the state's first truly urban university. Its new president, Dr. Ronald Mason, Jr., was tapped to lead JSU because of his success in heading the Tulane-Xavier Center for the Urban Community in New Orleans.

Ole Miss, the state's capstone university, may be associated with death and suffering and blood, the fire and the sword, more than almost any other American campus. During the Civil War, when every single student there went off to combat, the school closed down and became a hospital for both sides. Hundreds of northern and southern boys died on the campus, their corpses stacked like cordwood, buried now in unmarked graves in a quiet campus glade. In 1962 President Kennedy dispatched almost thirty thousand federal troops to put down the bloody riots accompanying admission of the first black student, James Meredith, at which time two people were killed and scores injured; some called it the last battle of the Civil War. In 1982 the university observed the twentieth anniversary of the confrontation; the keynote address before the interracial audience was given by James Meredith. In 1998, 20 percent of the Ole Miss freshman class was black, as was the editor of the school paper. Ole Miss today has salutary leadership and a civilizing attitude about racial concerns and affairs of state, but, as is so with Mississippi's other universities, remains deadlocked by stingy appropriations and relies more than ever on the mercy of the private largesse.

Clustered in and around Jackson are the handsome and restful campuses of four smaller private colleges that enhance life in the capital city vicinity. Millsaps College, affiliated with the Methodist Church, was the first educational institution in the state to voluntarily lift its racial barriers—"the bravest little college in America," Hodding Carter, Jr., once called it—and at present is the only institution of higher learning in Mississippi with a Phi Beta Kappa chapter. Tougaloo College, set on a placid campus with immense trees draped in Spanish moss, is a respected historically black school that was in the center of the civil rights ferment in the late 1950s and 1960s. Tougaloo educates many of Mississippi's black "power brokers"; its sister institution is Brown University in Rhode Island. Belhaven College, of Presbyterian lineage and until 1954 a school for women, is situated in Jackson's historic Belhaven neighborhood. Mississippi College, located twenty miles west in Clinton, is operated by the Southern Baptists and is the largest of the four Jackson-area colleges. Its predecessor, Hamstead Academy, was chartered by the legislature in 1826, making it one of the earliest of the state's first institution of higher learning. (A few years later, Clintonians urged the legislature to abandon Jackson and make Clinton the state capital. A bitter fight on the floor culminated in a tie, thereby ending Clinton's aspirations; Judge Isaac Caldwell, a trustee of the college, was so chagrined that he challenged the Raymond legislator who had cast the tying vote to a pistol duel near the campus.)

About twenty miles southeast of Jackson is one of the most distinctive learning facilities in the nation, the Piney Woods Country Life School, a venerable private boarding institution (elementary through high school) surrounded by whispery pine forests and noted for educating black boys and girls from all over the United States who have no money or family—just a lot of potential. Its programs stress educating "the head, the heart, and the hand." Piney Woods is famous for its musical groups that travel around the nation. Whites and blacks in Mississippi and elsewhere have donated their time and money to the school and helped establish the largest endowment for any black high school in the country. Oprah Winfrey is a staunch supporter.

In 1952 frantic efforts were initiated to upgrade the state's desperately inferior black schools in a cam-

paign to stave off integration, a futile attempt to retain the "separate but equal" pretense. For a decade after the Supreme Court's 1954 ruling in *Brown v. Board of Education* had outlawed segregation in the public schools, the all-powerful Citizens' Council, an unofficial arm of state government, urged massive resistance, instigating the carrying out of violence, burnings, and murder by the more volatile segments of society. The state legislature passed over forty laws, resolutions, and amendments to preserve school segregation. In 1956, incredibly, the state legislature made abolition of all public schools a county option, and the state's voters approved this in a referendum. When full integration became a reality in 1970, in certain areas numerous white students fled for hastily created private academies. Funding and support for public education plummeted in many parts of the state.

After a long time, the state gradually began to concern itself with its grievous school situation. The Education Reform Act of 1982 provided for compulsory attendance laws for students between the ages of six and fourteen, the testing of high school students for competency, and early childhood programs, and in the last eighteen years there has been a decrease in the dropout rate and a noticeable, if modest, advance in test scores. But enlightened leaders in the field of education concede that there is still a very long way to go. "The years have mounted," one of their number recently said to me. "Here we are trying to enter the new century with precious little to give our kids. 'As ye sow,' the Bible says, 'so shall ye reap.'"

Up until the 1970s the state had never had many private schools, and only a few church-based ones, mainly Catholic. Some of those that came along in reaction to desegregation grew to resemble small affluent colleges with excellent teachers and formidable facilities, while many others are tiny woebegone establishments of religious fundamentalism, bone-bare and xenophobic to the core, which causes one to wonder what kind of education their students get. The result today is that there are pockets in the state, such as Jackson and the Delta, where the public schools are predominately black.

As the 1999 state elections were approaching, Lloyd Gray, editor of the *Northeast Mississippi Daily Journal* in Tupelo, a city with one of the finest public school systems in the South, drew attention to a basic reality, which he called "the unacknowledged elephant in the living room, a core truth so politically sensitive that it is rare to hear any politician mention it":

The poorest-performing school districts in Mississippi are almost all in areas of high poverty. Almost all of these locales have experienced diminished community support for public education because of segregated private schools established in the 1970s so whites wouldn't have to go to school with blacks.

There the elephant sits. Communities where most children, white and black, are in public schools have better schools. In communities with lots of poor children, and where educational attention is significantly divided between public and private schools, performance is not generally good.

Throughout the summer of 1999, Lt. Gov. Ronnie Musgrove pledged that, if elected governor, he would lead the state in strengthening and enhancing public education and bringing teacher pay scales up to the southeastern average. His task—and ours—is as immense and important as recovering from the Civil War. Mississippians are still skirmishing over the Confederate flag some 135 years after the Confederacy surrendered. I pray we will not be so long in attaining the excellence in public education that the new century demands and that our children so desperately need.

In Mississippi, a citizen does not have to register as a member of a political party to vote. In the declining years of the century, only half of those eligible were voting. Mississippi in the contemporary political day is a staunchly conservative state. Both its U.S. senators and two of its five congressmen are Republican. The senior senator, Thad Cochran, is a moderate from the community of Byram, an intellectual who switched from the Democratic to the Republican Party in 1972 and who draws many Democratic votes. Trent

Lott, majority leader of the Senate and therefore one of the most powerful politicians in America, is a firebrand conservative from the Gulf Coast; veteran observers report that the nearest thing in 1999 to a state political machine in the old tradition of Bilbo or of James Eastland–Paul Johnson is the GOP machine headed by Lott. For the last eight years of the twentieth century, Mississippi's governor was also a Republican, the first since Reconstruction. [Democrat Ronnie Musgrove was inaugurated as governor on January 11, 2000. His election had been so close that for the first time in history the governor was selected by the state house of representatives: eighty-six for Musgrove and thirty-six for his opponent, Democrat-turned-Republican Mike Parker, who fought on until the last roll call.]

Mississippi's political structure in the concluding four decades of the century must surely be seen through the prism of race, which has shaped everything, but I suppose that could be said of the state's entire history. Until the flourishing of the civil rights movement in the 1960s Mississippi operated under a stringent racial code that regulated even the most mundane aspects of life. Fundamentalist religious denominations in the state, as Mississippian Curtis Wilkie of the *Boston Globe* wrote, "dictated behavior regarding not only worship but two giant totem poles that would eventually fall: segregation and prohibition." For blacks, Mississippi was essentially a police state, which used every method to keep them down. ("A servant of servants shall you be unto his brethren.") Blacks could not vote, could not use the same restrooms and water fountains whites did, could not stay in hotels and motels or go into restaurants used by whites; black men and women were addressed as "boy" and "girl." Those who protested the system were beaten, fired, driven away, or murdered, and this situation persisted well into the 1960s. Conditions in the black schools were horrible, those in rural and small-town areas resembling the one Medgar Evers attended, a hundred or so students and two teachers crowded into one room with a potbellied wood stove and a leaky roof and no decent textbooks. Buses were often not available, and students went to

school only from mid-October to mid-February, with the schools closing down for the rest of the year so the young people could join their elders in the fields.

The stance of most whites had historically been one in which it was tacitly assumed that blacks "knew their place" and were content with it. In the *WPA Guide to the Magnolia State* (1938), for example, blacks were depicted as "a genial mass. . . . The Mississippi folk Negro seems carefree and shrewd and does not bother himself with the problems the white man has to solve." He will leave "the so-called Negro question . . . for the white man to cope with." The years after World War II brought about a growing revolution in race relations in Mississippi, imperceptible at first, then mounting in intensity. "This broad-based social movement," Maryemma Graham has noted, "did not initiate the discussion of racism and segregation in the state. It did, however, greatly accelerate a process of confrontation and transformation." In the years following, on into the 1970s, turbulence and the yearning for quiet battled for Mississippi's very soul.

Lyndon Johnson's Civil Rights Act was passed in 1964 and the Voting Rights Act a year later, and these were to have watershed effects in Mississippi. In the wake of this legislation and its enforcement by federal judges, the discriminatory voting laws enacted by the Mississippi legislature were nullified. In 1965 alone voter registration rose from less than 5 percent of eligible black citizens to more than 60 percent. In the ensuing four years the number of black voters went from twenty-six thousand to two hundred sixty thousand, and would increase even more in the immediate future. In 1967 Robert Clark, from Ebenezer in Holmes County, became the first black person elected to the state legislature since Reconstruction. (The first time he was allowed to vote, Clark would recall, "I voted for myself.") Just before signing the Voting Rights Act, President Johnson looked at his chief of staff, Bill Moyers (my old and honored classmate and friend in college), and said, "This will turn the South over to the Republicans in your lifetime."

In the decades of the 1970s and 1980s a succession

of enlightened Democratic governors—including William L. Waller, William F. Winter, and Ray Mabus—helped lead the state out of its unquenchable past into a modern era of racial harmony and cooperation.

Among these progressive governors, William Winter (1980–84), my neighbor and friend across Purple Crane Creek in Jackson, quietly inspired countless young white Mississippians to perceive the state's imperishable destiny. Every time I see Winter walking his schnauzer named Fritz on Crane Boulevard or playing with his grandchildren on the front lawn, I am reminded of the deep impact he had on our state, and still has. He worked hard to bring an end to racial division and encouraged a new Mississippi civilization by having the state's writers and artists of all races give readings and performances at the Governor's Mansion; Leontyne Price rattled the old building's chandeliers with her rendition of "God Bless America." He traveled the state extensively on behalf of the 1982 Education Reform Act, and in the late nineties journeyed around the nation as a member of the President's Advisory Board on Race. He is a good man to have living across the creek.

A younger generation of whites began to accept integration, in part out of revulsion toward everything the white extremists had once stood for. One of these younger white men was an assistant district attorney in Jackson named Bobby DeLaughter. "The growth I've experienced," he would say, "is symbolic of the growth people of my age have had." In 1994 DeLaughter successfully prosecuted Byron De La Beckwith in Jackson for the murder of Medgar Evers thirty-one years before, and this inspired the holding of another trial four years later in which Sam Bowers, once Imperial Wizard of the Ku Klux Klan, was convicted of the murder of black activist Vernon Dahmer in Hattiesburg in 1966.

In many ways the old conservative Democratic constituency of two generations ago is the undergirding of today's Republican dominance in Mississippi, although it is more urbane and business oriented; these well-to-do businesspeople and professionals have often been joined by poorer whites

whose grandparents had been almost monolithically pro-FDR. This has held true for most of the South. Before the Republicans lost ground in the 1998 elections, the GOP—once the party of Lincoln, Grant, and Sherman—had governors in Alabama, Arkansas, Louisiana, Tennessee, South Carolina, Texas, and Mississippi. "With a couple of exceptions," Curtis Wilkie observed, "these Republican governors were knights of the Christian right, throwbacks to the earlier generation of ultra-conservative Democratic governors." Prominent among these was Mississippi's Kirk Fordice, perhaps the state's most regressive governor of the twentieth century, including Vardaman, Bilbo, and Barnett, all of whom harbored incipient populist impulses.

Conversely, by 1990 blacks made up one-third of the state's registered voters, and there were over six hundred black elected officials, more than in any other state. Blacks hold political, if not economic, control in many of Mississippi's cities, towns, and counties. By 1997 forty-five blacks were serving in the Mississippi legislature, which gave it number-one ranking in this regard in the nation. (One interesting aside is that this state legislature ranked fiftieth in elective turnover.) The accumulated impact of LBJ's civil rights and socioeconomic programs and affirmative action—before it was pretty effectively closed down— helped create an emphatically larger black bourgeoisie in the state, evident mainly in the bigger cities and particularly in Jackson. An all-out effort to enhance the business and economic advances of the state's black people not only amounts to simple justice but can only benefit the broader society.

At the hub of all this stands Jackson, political, cultural, financial epicenter of Mississippi. It is a pretty good old town, despite its problems, and that is why I live here, after my years of wandering, with my wife and three cats. I like it here because of my memories, because of the languid pace, and because people are nice.

Jackson became the seat of government in 1822, five years after Mississippi entered statehood. It is one of four state capitals named after presidents (the oth-

ers being Madison, Wisconsin; Jefferson City, Missouri; and Lincoln, Nebraska), although Andrew Jackson's name was chosen in recognition of his military generalship before he acceded to the White House. Like Washington, D.C., Jackson was a planned city. The authorities wanted it to be on a navigable river (the Pearl) and as close to the state's geographical center as possible. It missed that designation by forty-eight miles—the literal centerpoint is outside Carthage in Leake County—but the plans went apace. In 1821 a man named Abraham DeFrance, superintendent of public buildings in the District of Columbia, was selected to lay out the city based on a design made by Thomas Jefferson some years previously—a checkerboard pattern, building squares alternating with parks. Bern Keating is an authority on these original plans. "Though most of the parks have vanished," he writes, "ghosts of the open spaces still remain; Jackson's downtown is not squeezed quite so painfully into a few towering skyscrapers and narrow traffic-infested streets surrounded by a vast low-lying city of ample spaces as are some other metropolitan centers."

Many natives do not know that at various times Washington, Natchez, Columbia, Columbus, Enterprise, Macon, Meridian, and Monticello acted as the state capital. It changed several times during the Civil War. Sherman burned Jackson in 1863 as part of the continuing, and frustrating, campaign to take Vicksburg forty miles west. In fact he burned it *three* times; every time he passed through he burned it again. That is why there are not many antebellum homes here and also why no streets are named after Sherman; the town's nickname was "Chimneyville."

The city of Jackson has two hundred thousand souls—the metropolitan area totals four hundred twenty-five thousand—no behemoth by northern measure but big enough for Mississippi, and its eminence in the state is illustrated by the fact that the *second* largest city, Biloxi, has only forty-six thousand. Its promoters in buoyant solicitude chose to present Jackson in the waning years of the century as the Bold New City. I prefer to call it the Old Bold, for my aspect of it, in truth, exists in another time, my

childhood years, when it was nothing if not a somnolent state capital town, drowsy in those wartime summers. Even Meridian had more people. I came down from Yazoo on the Greyhound known as the "Delta Local" to visit my grandparents and greataunts, and I am glad that the old art deco bus station was rescued from the blasters and preserved as his office by the eminent local architect Robert Parker Adams.

Even members of the younger generation always refer to "the Old Capitol" and "the New Capitol." The latter was finished in 1903, gracefully refurbished in the early 1980s, and to me is one of the most architecturally pleasing of American state capitols. Here on the broad front steps President Theodore Roosevelt kissed my infant mother on the cheek when he visited Jackson. Eudora Welty always associated the New Capitol with learning Latin: "It took Latin to thrust me into bona fide alliance with words in their true meanings. Learning Latin fed my love of words upon words, words in continuation and modifications and the beautiful, sober accretion of a sentence. I could see the achieved sentences finally standing there as real, intact, and built to stay as the Mississippi State Capitol at the top of my street, where I could walk through it on my way to school and hear underfoot the echo of its marble floor, and over me the bell of its rotunda."

On the building's ground floor is the Hall of Governors. My friend the writer George Plimpton's great-grandfather, General Adelbert P. Ames of Maine, was the appointed and then elected Republican Reconstructionist governor of the state after the Civil War (he was impeached in 1876), Satan incarnate as our teachers taught us in junior high (the last survivor of all the Federal and Confederate generals, he died in 1933 at age ninety-seven), and when Plimpton strolled through the hall one day on a trip from New York he could not find his great-grandfather's portrait. With the help of a janitor he located the portrait of Ames hidden away on the wall behind a stairwell. Today it is back in the main hall, easily recognizable because Ames is the only one dressed in blue.

At the apex of Capitol Street, the Old Capitol, with

its portico and towering rotunda, was the site of impassioned speeches by Andrew Jackson, Henry Clay, and Jefferson Davis. And in the same building where secession was approved in 1860 there now stands a prominent and permanent exhibit on the civil rights movement.

The south edge of downtown, a cultural nexus, contains the impressive Mississippi Museum of Art, the first statewide fine arts museum, opened in 1978 along with the Russell C. Davis Planetarium, a favorite place for children to visit. The adjacent auditorium was renamed Thalia Mara Hall in 1994 after the enterprising local ballet connoisseur responsible for bringing the quadrennial International Ballet Competition to Jackson. In this neighborhood in recent years hundreds of thousands of visitors from around the United States and the world came to see the extraordinary international exhibits *The Palaces of Versailles* and *The Wonders of St. Petersburg*, projects spearheaded by Jack Kyle, from Belzoni, Mississippi.

Capitol Street, the main thoroughfare, has become an amalgam of older high-rises, crumbling storefronts, and immense parking lots, but its middle blocks retain an enduring grace: the magnificent Governor's Mansion, the second-oldest continuously occupied governor's residence in the country and across from it, the Lamar Life Building, built in 1925 largely through the efforts of Eudora Welty's father, who was Lamar Life president. It was the town's first skyscraper, ten stories high, and topped with clock towers. A little north and east of the abiding Mayflower Cafe, one of the oldest of the many excellent restaurants in Jackson, is Farish Street, once the vivacious and flavorsome thoroughfare for blacks, dotted with boarded-up storefronts and juke joints, and now undergoing a restoration.

There is a dark side to this city. In the closing years of the century Jackson set frightening records for homicides and violent, mindless crimes—mostly black against black, and more often than not pertaining to drugs, although armed robberies in predominately white neighborhoods have become increasingly common (in national rankings Mississippi is forty-eighth among the states in police officers per capita, forty-eighth in police protection expenditures, and forty-ninth in correctional expenditures). Someone has observed that in Mississippi it is easier to get a gun than a driver's license. All this has resulted in the flight of blacks and whites alike to affluent suburbias in adjoining counties, and Jackson now has a majority black population.

The suburbs of Jackson have excellent schools and open spaces and are not far removed from real rural countryside. One family I know in Brandon discovered a deer in their kitchen not long ago. But these areas are not immune from mayhem. In 1997 in the town of Pearl, twenty miles east, a high school student opened fire on his schoolmates and teachers, killing two and wounding seven. It was one in a succession of bloody school massacres ignited by young white boys across America, all of them occurring in suburbs.

In 1997 Jackson elected its first black mayor, Harvey Johnson, Jr., a noted city planner whose victory from a field of five came with sizeable white support and didn't require a runoff. In his inaugural address before a large interracial audience at city hall, Johnson spoke of the legacy of Mississippi's Medgar Evers and of the other "long-distance runners, the brave souls who spilled their blood for equality under the law. Lord, just think how far we've come. I don't ever want to go back."

THE CREATIVE SPIRIT

There was something in the very atmosphere of a small town in the Deep South, something spooked-up and romantic, which did extravagant things to the imagination of its bright and resourceful boys.

—NORTH TOWARD HOME

IN MY NEW YORK DAYS I HAD A

somewhat cranky and conservative movie maker friend who was an exile from Louisiana. We were having a conversation shortly after I had published a piece in my magazine, *Harper's*, about the changes I had observed in Mississippi. My flamboyant and irascible companion, who had spent considerable time in Mississippi over the years drinking mint juleps with the cousins of Sartorises and Compsons and de Spains and who was quite conversant with southern literature, looked at me and began shaking his head. "You're crazy," he finally said, repeating it louder next time. "Crazy!" We were having a drink in the Empire Chinese bar on Madison Avenue, our magazine hangout, and even the Chinese waiters, who by then were accustomed to strange outbursts from my steady clientele of writers and poets and all varieties of human fauna, turned their heads to listen. Mr. Suey Hom, the owner, came over and said, "Come on, let me buy you another drink, hah?"

"But this man *is* crazy," my friend persisted.

"Why is he crazy?"

"Because he's a writer, but he wants to change Mississippi. Can you imagine? There he is with the most messed-up state in the union, the most fertile ground in America for a writer. The place of his own forebears. The most beautiful land in the whole damned country. The most

individualistic people in the hemisphere. Cruelties right out of the Old Testament. Relationships that would make Freud give up before he started. Emotions run wild. Romanticism gone amuck. Decadence and decay. Miscegenation that's the envy of Brazil. Charm. Openness. The courage of noble fools. So much hospitality you have to beg them to stop. And he wants to *change* it. Why, if I was a writer I'd use all the influence I had with the politicians and get them to put up big green signs at every point of entry into Mississippi, all along the borders, saying, 'Posted. No trespassing.'"

I will have to admit that a dark and secret part of me was touched by this, and, since my Louisiana friend had worked himself into a high fever, I told him so.

After almost twenty years of living in New York, in 1980 I returned to Mississippi. Many northeasterners of my acquaintance found it hard to understand why I would give up that glittering apex to dwell in what they saw as an isolated, insular place. "Well, it's home," I told them. "I've got to go."

Not long ago, I was at a dinner party on Nantucket attended by a dozen or so well-known writers, artists, art collectors, industrial tycoons, and television personalities, and the host, with absolute earnestness, asked my wife, JoAnne, and me if it were possible to assemble such a creative and stimulating group back home in Mississippi. "Yes, I believe we can," I said, and chuckled politely.

Mississippi is blessed with a dazzling number of brilliant and creative souls who have distinguished themselves and their state nationally and internationally in a multitude of callings. In the fields of music and literature, is there another state that even comes close? In the visual and performing arts, Mississippians are achieving popular and critical acclaim. This creative impulse rests not only with those who are themselves artists or musicians; it thrives within the hundreds of others—teachers, entrepreneurs, librarians, civic leaders, art patrons, museum curators, bookstore owners, parents, homemakers—who draw upon

their own imaginations to enrich the lives of those who live here.

All creativity is discovery; creating is discovering something you did not know before which has sprung from the things you know very well. Mississippi is one big laboratory for breeding and cultivating the creative spirit; I could have been describing it when I wrote the following in my first book, *North Toward Home*: "There was something in the very atmosphere of a small town in the Deep South, something spooked-up and romantic, which did extravagant things to the imagination of its bright and resourceful boys. It had something to do with long and heavy afternoons with nothing doing, and with rich slow evenings when the crickets and the frogs scratched their legs and made delta music, with plain boredom, perhaps with an inherited tradition of contriving elaborate plots or one-shot practical jokes. I believe this hidden influence had something to do with the Southern sense of fancy; when one grew up in a place where more specific exercises in intellection—like reading books—were not accepted, one had better work his imagination out on *something*, and the less austere, the better."

I have been struck time and again by how profoundly our literature, music, and visual arts grow directly out of land and the sense of place—the *mark* of the land, sometimes not so much the land as subject matter but the way it is chosen to be presented in all its directness, the love of narrative, the memory of people and places and terrains of the heart. One sees this at some times directly and at other times through a vivid concreteness and emphasis on detail, as in the stories we love to tell.

We are talkers. We talk about ourselves, each other, our ancestors, events, the funny and quirky and bizarre things people do—true stories, more or less, and the richer and more plentiful the detail, the better. Small wonder then that Mississippi artists find ways to tell their stories in writing, in music, on canvas, and on the stage. Like storytelling, art of whatever form plays a *communal* role: it draws people together, helps them understand themselves and their common humanity. In the creativity of Mississippi-

ans, everything that *is* Mississippi unfolds and is there for all to see.

No art form is more communal than music. Let us start there, then, and with music of high culture, which means Leontyne Price, regarded the world over as one of the greatest artists of our time. The internationally beloved soprano has performed to rave reviews all over the world. Before her retirement in 1985 she had played the female lead in *Porgy and Bess*, Cio-Cio San in *Madame Butterfly*, the title role in Strauss's *Ariadne auf Naxos*, and many, many others. In 1961 she became the first black singer to open the season at the Metropolitan Opera House as Minnie in Puccini's *La Fanciulla del West*. She once received a forty-two-minute ovation for *Aida*. She has received three Emmy awards and eighteen Grammys.

Down here we all affectionately call her Leontyne. She is one of us. She was born in 1927 to a black midwife in Laurel who held the record for having delivered more babies than anyone else in the history of Jones County. With the help of the Chisholm family of Laurel she studied at Julliard in New York. Over the years she often returned to her hometown, and she gave one of the first nonsegregated recitals there. In *I Dream a World* she wrote, "From Mississippi to the Met. That's the pinnacle. . . . I wasn't uncomfortable singing at the inaugural ceremony for my friend William Winter, the governor of Mississippi, because I thought I belonged there. It was as much my capital as his."

Elvis! He is a towering figure in popular culture. Although he has lain in his Graceland tomb for more than twenty years, his legacy, the shadow he still casts today, is gargantuan. Born in 1935 in Tupelo, he grew up in a minuscule house on the wrong side of town and emerged from that poverty to become the most famous Mississippian of all time and one of the world's wealthiest entertainers. With his haunting voice, he sold more records than any other singer in history. He was a revolutionary; he brought in the era of rock 'n' roll.

I never met Elvis, which I much regret. We were almost precisely the same age; we grew up not many miles apart. I know many people who knew him, and a number of my friends still talk about going to his early performances in the Delta and elsewhere. He played on the back of feed trucks and in tiny gyms in little Mississippi towns, with tickets going for about fifty cents. An affecting photograph taken of him in New York City just before his fame descended shows him alone, playing a piano and singing a hymn to himself.

Like Leontyne, Elvis never forgot the Mississippi he came from. At the peak of his celebrity he returned to Tupelo often to give concerts at the Fair and Dairy Show and to visit his relatives, and he donated a small fortune to build a park in his old impoverished neighborhood. Though Elvis was clearly possessed of a great creative spirit, his music showed a variety of influences: black gospel and white gospel, country, the blues. "The colored folk been singin' it and playin' it just the way I'm doin' now, man," Elvis once said, "for more years than I know."

When you picture *the Delta*—the devouring land, the sultry little black churches and juke joints, the remaining shotgun shacks, the very weather itself—you think *blues*: it is one of Mississippi's most extraordinary and far-reaching inheritances, and is closely linked in matters of the soul and spirit and remembrance with the state's literature. "To the black people of the Delta," Alan Lomax wrote in the dedication of his classic *The Land Where the Blues Began*, "who created a Mississippi of song that now flows through the music of the whole world." In the late nineteenth century, as most of the land was being cleared for use, newly freed blacks moved into the Delta in large numbers, expecting equal rights and opportunities. That was not to be; as William Ferris wrote, "They put their hand to the plow, to the railroad hammer, to the lines of the mule team and, in effect, built the South—for subsistence wages. Faulkner's decadent planter class knew how to exploit them and, when they felt it necessary, resorted to the most savage exemplary violence to keep these vigorous and ambitious people in line."

Living a hard, marginal existence, these dispossessed workers often moved from one plantation or

job to another. The blues, mournful and lusty, arose as an escape from their intolerable conditions, an expression both of hopelessness and isolation and terror and of a hard-earned ability, in the words of a later white Mississippi writer, "not merely [to] endure but [to] prevail." The first blues musicians carried their guitars from plantation to plantation to perform their crescendos of African irony and sorrow. They played at parties and juke joints and earned tips at railroad stations, on store porches and sidewalks. They sang about everything—"trains, steamboats, steam whistles, sledge hammers, fast women, mean bosses, stubborn mules," wrote W. C. Handy, the Memphis band leader who had "discovered" the blues in 1903 in Tutwiler. Citing the blues as the vigorous symbol of "an independent and irrepressible culture," Alan Lomax would write that the experience of the Mississippi black people who created the blues in the postslavery years was in some ways more bitter than slavery itself.

The roll call of famous bluesmen who followed is extraordinary: the nearly mythical Robert Johnson of Hazlehurst and Tunica; Muddy Waters of Rolling Fork; Charley Patton of Edwards, Little Milton and Hound Dog Taylor of Greenville; Mississippi John Hurt of Avalon; Son House of Lyon; Bill Broonzy of Scott; Jimmy Reed and James "Son" Thomas of Leland; B. B. King of Indianola; Otis Spann of Belzoni; Howlin' Wolf, John Lee Hooker, and Ike Turner of Clarksdale; Jack Owens and Skip James of Bentonia; Willie Dixon of Vicksburg; David "Honeyboy" Edwards of Greenwood; Clarence "Gatemouth" Brown of Yazoo City; Sonny Boy Williamson of Tutwiler; Bo Diddley of McComb (whose translucent influence was to be in R&B); and countless more. (When the Beatles came to the United States in the early sixties, a newspaperman asked them what they most wanted to see in America. "Muddy Waters and Bo Diddley," they replied. "Where's that?" the culturally deprived reporter asked. The Beatles retorted, "You Americans don't seem to know your most famous citizens."

Robert Johnson, born in 1911, is probably the most mysterious and legendary of them all, a bold, shadowy figure whose memory suffuses the enduring genre. He was both a magnificent musician and a vi-

sionary poet, and the blues recordings that survive from his short life are American classics. He had a fatalistic, supernatural view of human existence and believed that as a bluesman he was taking the side of "the devil's music" against gospel, "God's music." In a juke joint near Clarksdale he made his notorious pact with Satan, selling his soul to be the best bluesman who ever lived. No matter where he dwelled he was always returning to the Delta—and in 1938, in a Greenwood juke joint, when he was only in his twenties, a jealous woman put some poison in his coffee.

The national music companies began responding to the popularity of the blues musicians. The first of the bluesmen to be recorded and to achieve national renown was Charley Patton in the 1920s. Muddy Waters, who died in 1983, was born McKinley Morganfield in 1915 on a plantation near Rolling Fork; he moved to Clarksdale and eventually followed the familiar path to Chicago where as performer and band leader he became a leader in revolutionizing the new urban style of blues. Many of his finest compositions emanated from the Mississipi blues of his youth.

B. B. King, the nation's best-known and most popular blues singer today, was born in 1925 near Itta Bena and later moved to a plantation just south of Indianola. He worked in the Delta fields for a dollar a day. In 1946, King, like so many other black entertainers before and after him, migrated to Memphis. There, and later in Chicago, he began to pioneer the use of jazz and spirituals in the blues he played on his electric guitar. King has achieved international acclaim with his vigorous and innovative style and his original compositions. He has won many Grammys, including a Lifetime Achievement Award in 1987. As with most of his fellow Mississippi artists, he has retained his love of home, returning every summer to give concerts in Indianola and at the annual Medgar Evers Mississippi Homecoming and to play various Mississippi clubs that were on his early circuit.

I knew two of the old bluesmen, James "Son" Thomas and Jack Owens, both now dead. They were among the last of the state's indigenous country bluesmen, staying in the state their whole lives and playing the old-style rural blues. Both were from Ya-

zoo County, but I did not know about them when I was growing up there. Born in 1926 near Eden, Thomas moved to Leland as a teenager and played the juke joints of the Delta, subsequently performing all over the United States and the world. Once during a gig at Ole Miss, he spent the night at my house, where we got into a long talk about supernatural matters. "I don't believe in ghosts," he said, "but they're there." Jack Owens lived his whole life on a scraggly farm outside Bentonia. I sat with him on his front porch one day as he told stories while drinking gin mixed with Kool-Aid and showed me the .22 pistol he carried around in his boot. He died in 1997 at the age of 90; he had been a youngster during the first days of the blues. Today blues fans and would-be blues musicians get together in Bentonia at the Blue Front Cafe and talk about Owens and others and on occasion hear live blues.

If Mississippi is the land that gave birth to the blues, the state has also been midwife and nurse to what the rest of the world thinks of as American music. Jazz, ragtime, rhythm and blues, soul, rock 'n' roll, rockabilly, and hip-hop can all trace their lineage to the Mississippi Delta blues. Even country music is a kissing cousin of the blues. In blending the Mississippi blues with the popular country music of the era and his trademark "blue yodel," Jimmie Rodgers, the acknowledged father of country music in the United States, shaped the music industry. He was born in Meridian in 1897. He started out as an itinerant railroad brakeman, absorbing rowdy country music and blues ballads from his fellow railroad workers. He reached national popularity after 1927, and, during his short-lived career (he died of tuberculosis in 1933), composed such standards as "Mule Skinner Blues," "Travelin' Blues," and "Any Old Time," as well as popularizing the use of the steel guitar in country music. His work influenced many future country music stars and also had an impact on blues, jazz, and rock 'n' roll. A festival held every year in his honor in Meridian is sponsored by the Jimmie Rodgers Museum, which is appropriately quartered in an old railroad depot at Highland Park.

Mississippians who became notable country music performers in subsequent years include Charlie Pride, Conway Twitty, Tammy Wynette, and, still more recently, LeAnn Rimes and Faith Hill.

"The spiritual music of the day and the worldly music of the juke joints are not that far apart," the black Mississippi poet Sterling Plumpp has observed. The state has always been a leader in gospel music. The Staples Singers of Indianola were among the earliest and most revered of the black gospel ensembles, as were the Blackwood Brothers of Ackerman among the white groups. White gospel is vigorous in substance and message; many of its singers have moved from the old quartet style and now use instrumental support and numerous singers. As with the blues, black gospel relies on African folk cadences and popular musical styles. All this still thrives in Mississippi. Even the annual Confederate Pageant, part of the Natchez Pilgrimage, features evening performances by gospel vocalists. The Mississippi Mass Choir, composed of talented gospel singers from all over the state, has become an American institution, with an album that reached number one on the Billboard gospel charts.

Mississippi's musical tradition has also been enriched by the internationally celebrated work of Jimmy Buffett of Pascagoula, Mose Allison of Tippo, Milt Hinton of Vicksburg, Cassandra Wilson of Jackson, and Dorothy Moore of Florence. Among the state's classical composers was William Grant Still (1895–1978), who was born on a Woodville plantation; his *Afro-American Symphony* was the first symphonic work by an African American performed in the United States. Lehman Engel (1910–1982) of Jackson had a long and productive career during which he composed the music for seven Martha Graham ballets and two symphonies. He also served as conductor for a number of Broadway musical hits and worked with Leonard Bernstein, Aaron Copland, John Gielgud, and Mary Martin, among many others.

Jerry Clower of Liberty, who died in 1999, was a recording star of a different type. His storytelling was in the lineal ancestry of Mississippi writing. He entertained national audiences with his outlandish tales about growing up poor in Amite County (his county was so poor, he said, that most people could not even afford to sin), was given the title Country Comedian

of the Year twelve times by *Music City News*, and recorded more than thirty best-selling albums.

Not until the early 1900s did Mississippi begin to nurture a vibrant calling in the visual arts. Because of its proximity to New Orleans, with that city's exuberant visual arts heritage, the Gulf Coast was the first section of the state to become known for its homegrown artists, notably Walter Anderson of Ocean Springs and George E. Ohr of Biloxi. Since then other areas have produced a profusion of painters and sculptors.

Walter Anderson (1903–1965) is perhaps the most internationally recognized of the state's artists. He did prolific and brilliant work from the 1930s until the mid-1960s but was largely unknown until after his death. Having studied at the Pennsylvania Academy of the Fine Arts and traveled abroad, Anderson returned to Ocean Springs, where, during the Depression, he created a spectacular WPA mural in the local high school as well as singular works of pottery for a business owned by his brother. A fragile and tormented visionary genius, he spent the next few years in and out of mental hospitals.

In his latter years Anderson became a recluse, spending much of his time in solitude on Horn Island, the barrier island just offshore, where he kept a mesmerizing diary and did hundreds of naturalistic paintings of the animals and plants of the Gulf Coast. In the 1950s he began painting a mural on the walls of his Ocean Springs cottage. His murals, stunning in their richness and panorama, give viewers an intimate glimpse of his view of the wholeness of nature. They are on display at the Walter Anderson Museum in Ocean Springs adjacent to the Ocean Springs Community Center, where Anderson painted his largest murals. One can also see his work in several handsome books and in exhibitions, which are the result of attentive care by the artist's daughter, Mary Anderson Pickard.

Theora Hamblett of Oxford, who was born in 1895 and died in 1977, moved to that university town from the rural countryside of Lafayette County and supported herself as a seamstress and proprietor of a boarding house for Ole Miss students. She taught herself to paint. In hundreds of works, her lively images elicit scenes of the north Mississippi countryside: workers in wagons going to the cotton gin, children dancing around a cottonwood tree. The subjects of her most unusual canvases, those with biblical and religious themes, came to her in dreams and visions. Working with a bold and solitary dedication, Hamblett painted in small, vivid brush strokes, her work resembling that of a skilled embroiderer, and she became one of the South's most significant artists.

The last two decades have marked the most exciting period of all in Mississippi painting—many accomplished artists throughout the state, greater diversity, Mississippi-born artists living elsewhere but drawing more and more on Mississippi themes. My friend Bill Dunlap is the contemporary artist I know best. He is one of America's finest painters, maintaining studios in both McLean, Virginia, and New York City. I was gratified to narrate an excellent documentary, *William Dunlap and the American Landscape*, which premiered on PBS in 1985. One of his most ambitious works, *Panorama of the American Landscape*, was exhibited in the Corcoran Gallery of Art in Washington, D.C. Talking in swift, staccato cadences, Bill is full of flamboyant Mississippi stories; he talks fast, but he thinks deep. He has not forgotten his home soil either, and returns often to paint his intrepid Mississippi landscapes and to encourage the younger artists among us. Both personally and in his accomplished calling, Bill epitomizes for me the Mississippi creative spirit at its best.

I am enthralled also by the vibrant, adventurous paintings made by the Jackson artist Lynn Green Root, who illustrated two of my books. Lynn herself is as colorful and spirited as her work, and both bring me great pleasure.

One of the first artists to use clay as his principal medium was George E. Ohr (1857–1918), who worked in Biloxi. His pots were eccentric, abstract, and brilliant, but people did not know what to make of them, or for that matter of the man himself, whom some considered quite mad; photographs of him with his wild hair, scraggly beard, two-foot-long mustache,

and beady eyes make me think of a cross between John Brown and Charles Manson. In 1967, an art dealer discovered thousands of Ohr's pieces in a warehouse, and these days a couple of his pots will go in auction establishments for considerably more money than the artist made in his whole lifetime. The George E. Ohr Arts and Cultural Center in downtown Biloxi houses a permanent collection of this esoteric genius's work.

Creative ceramics, indeed, is a Mississippi landmark. Walter Anderson's superlative figures were created in the bucolic environs of Shearwater Pottery overlooking the gulf in Ocean Springs, and that inheritance continues in the work of Anderson's nephew Jim and other family progeny. In the Delta hamlet of Merigold in Bolivar County can be found the exceptional pottery of Pup and Lee McCarty, coveted by collectors in Mississippi and around the country. In his gallery and studio situated in verdant terrain outside Brandon, Emmett Collier creates and sells his variegated work, sustained by his vivacious consort, Jani Mae.

Mississippi has always been known for accomplished individuals who work magic with cane and cloth and wood. The Delta cotton-and-catfish town of Belzoni has given us not only bluesmen, athletes, and Hollywood producers but also one of the country's finest artists in the traditional folk art of needlework, the late Ethel Wright Mohamed. In her late fifties, after the death of her husband in 1965, Mrs. Mohamed began embroidering her famous stitchery pictures noted for their intricately colorful primitive images recalled from her own past, experiences from her family's life in Mississippi. Her work hangs in permanent collections throughout the United States, including in the Smithsonian. Mississippi Choctaw basketmaker Eleanor Ferris of Conchatta is today the foremost representative of the tribe's long and illustrious tradition of producing swamp cane baskets. Highly prized among connoisseurs, her work has drawn on the Choctaws' ancient folk art form, and her craftsmanship is of the highest order.

The late Pecolia Warner of Yazoo City, a well-known quilter, revealed the West African roots of her work with her bold colors and designs. Her travels took her all over the country, but she said she liked her home state the most because "here in Mississippi you can sit out on your porch at night and cool off." In his rustic barn near Vaughan in Yazoo County, Greg Harkins fashions sturdy and handsome oak rocking chairs using techniques acquired from venerable Mississippi craftsmen; these rockers will last forever, and his clients have included four American presidents. Fletcher Cox of Tougaloo, along with his wife, Carol, makes furniture and smaller objects in a contemporary style of woodworking; his work has been nationally recognized, and a piece of his was selected for the White House Collection of American Crafts. The Coxes gave my wife an exquisite pencil holder made of wisteria, lovely in design and proportion, pointing out that this native plant, while beautiful and fragrant, is also reputed to have poisonous fruit.

Mississippian William Eggleston is an internationally recognized photographer. His were the first color photographs to be exhibited in the Museum of Modern Art in New York; he had a one-man show there in 1976. The Japanese camera industry has named him the outstanding color photographer in the world. His depictions of rural southern countrysides are often surprising, always lyrical yet starkly real, rich and dense and almost palpable in their clarity.

Photographs by Birney Imes have been widely exhibited in his native state, as well as at the Art Institute of Chicago, the Museum of Modern Art in New York, and in Paris. His pictures have been collected in the volumes *Juke Joint* and *Whispering Pines*. Other award-winning Mississippi photographers include Maude Schuyler Clay, Robert Townsend Jones, Rita DeWitt, Allen Frame, Tom Rankin, Milly Moorhead, Marion Brown, and Franke and Bern Keating.

Throughout the state in recent years, especially in Jackson and on the coast, there has been a proliferation of private galleries and art dealers. Lesley Silver may be the state's ranking patron of local and regional art. A good friend of my family, she is a repository of Mississippi stories and Jewish history, and her Attic Gallery in Vicksburg is a treasure trove full of

joys and surprises: carvings, paintings, jewelry, pottery, blown glass, enigmatic figurines, a variety of folk art objects.

Up in north Mississippi, right on the courthouse square in Oxford, is the Southside Gallery, owned by Milly Moorhead, who, along with her former husband, Rod, was once a student in my writing class at Ole Miss. They paint, write, sculpt, and photograph, and show good taste in what is displayed in the honored structure that was once Shine Morgan's Furniture Store: fine and folk art of all descriptions, uncannily individualistic, including the works of MacArthur Chisholm of Yalobusha County, who fashions religious crosses and birdhouses from bottle-caps, and Burgess Dulaney, who is a sorcerer with pure Itawamba County mud.

A little beyond the hamlet called Bovina a few miles east of Vicksburg is an ancient red crossroads grocery store, now the home of Earl's Art Shop, which someone once described as the visual equivalent of the Delta blues. The proprietor is an African American man named Earl Simmons. Earl and his habitat, which is constructed of leftover lumber and other scrap material, have unequivocating origins in Mississippi's intricate and colorful folk culture going as far back as the slavery era. Earl's place leaps out at you with raw, honest character. I once bought an exceptional item there, now on display in the den of my house—a big wooden truck carrying lumber. "I want that lumber truck," I said to Earl. "It's not a lumber truck," he declared. "It's a *pulpwood* truck."

First-rate art galleries in the Jackson area are operated by my friends James Patterson and Larry Mc-Cool, James's (Gallery 119) in the city's downtown and Larry's (Madison Gallery) in Madison.

Readers who would like an excellent overview of the visual arts in the state should consult *Art in Mississippi, 1720–1980* by Patti Carr Black.

Perhaps the most luminous jewel in the crown of the state's performing arts is the International Ballet Competition, a premiere event in the dance world, which every four years since 1979 has come to Jackson. The annual competition rotates among Moscow;

Helsinki; Varna, Bulgaria; and Jackson. As part of the festivities the most illustrious names in dance arrive here to be judges and to teach at the ballet school that accompanies the contests. The 1979 performances marked the first time that the international competition had come to the Americas. "Reporters, photographers, television cameramen, dance critics, and celebrities of the dance world crowded the town," Bern Keating, who was there, wrote. "Television commentators and anchormen on the national networks openly struggled with their disbelief that they were reporting that world-class cultural happening from Jackson, Mississippi. But they indisputably were, and they wanted to know why."

The reason is the remarkable Thalia Mara, who attained a global reputation as a ballerina and later as a teacher and author of textbooks for children and ballet instructors. She picked Jackson as a place to live because she felt she could make a difference, and indeed she has. The International Ballet Competition was her vision, and her grit, energy, and contacts in the world of ballet made it happen. Thousands of people from all over the world attend the quadrennial performances in the municipal auditorium, which is most deservedly named Thalia Mara Hall.

Advocacy of the arts in the state has been on a steady upward curve in the last three decades, likely because of many citizens' burgeoning recognition of Mississippi's heritage of creativity. A number of these salubrious advances involve the enhancement of the public schools, and are often the result of the commitment of individuals and organizations (in sharp contrast to the dismal record of legislative support for educational programs in the state). Qualified observers say that this community involvement with the public schools regarding arts-related programs is one of the most impressive among the American states, especially given how poor and underpopulated Mississippi is.

In 1999, the Mississippi Arts Commission was sponsoring a Whole Schools program, which incorporates the arts into traditional school programs by drawing on local and nationally known artists, educa-

tors, and scientists to help develop curricula, giving grants to help pay for artists-in-residence, conducting teachers' workshops, and collaborating with community arts groups to assist schools with their projects. The ultimate goal is for every child in the state to have regular instruction in the arts and to attend a school which offers instruction in music, drama, dance, and the visual arts.

In the field of drama, New Stage Theatre in Jackson set up a program to promote greater awareness of dramatic literature throughout the state. Since 1989 more than forty thousand young Mississippians have seen live professional theater, including Shakespeare's plays and *Mississippi Talking*, a composite of dramatic scenes from the works of the state's greatest writers. The project has become a model for theaters across the country. In cooperation with the Folger Library and Theater in Washington, D.C., New Stage originated a "Teaching Shakespeare" institute for teachers.

Under the leadership of Dr. Jean Simmons, who had taught in elementary schools for many years, the public schools in Jackson established a special program which engages students in the arts, the Academic and Performing Arts Complex. Teachers are working professionals in the arts community, and the program has strong ties with the International Ballet Competition, the Mississippi Museum of Art, and New Stage Theatre.

Dedicated people have been responsible for other lofty projects in the state's public schools. Throughout her career as arts consultant for the Hattiesburg schools, Vicki Bodenhamer has fostered superior arts education in the classroom. She developed *Reaching for Rainbows*, an innovative video series that has brought the arts to over fifteen hundred schools. At West Tallahatchie High School in the Delta, which previously had had no arts education curriculum, teacher Anne Hart Preus has established an agenda bringing there the visual arts, music, dance, and drama. Over the years students have attended concerts, ballets, art exhibits, and plays, presented their own plays and musicals to the student body, and benefited from visits by professional artists and special educational television programming. In Jackson,

the public schools and the Mississippi Symphony Orchestra are partners in a nationally recognized music program in which more than six hundred students a year get daily instruction in violin, viola, cello, or bass from symphony musicians. Kenneth Quinn of Jackson was named Teacher of the Year by the National Association of Secondary School Principals during his long tenure of shaping arts education for students. In Vicksburg's Beechwood Elementary School, a continuing program emphasizing the value of art, music, and drama has helped bring about an emphatic rise in standardized test scores and more involvement from parents. The city of Tupelo has sponsored an annual student art competition, a summer camp, artist-in-residence programs in the public schools, and creative writing and musical composition competitions.

The public school students in Starkville, one of the state's finest systems, have received national awards for excellence in art, creative writing, and choral music. In 1989 the high school received one of only four National Endowment for the Arts grants to establish a prototype curriculum in the arts to inspire students, in the words of principal Russell H. Johnson, "to see as well as look, listen as well as hear, create as well as make, and sense as well as feel." Nelle DeLoach Elam, who teaches in Starkville and has been a lively advocate of arts education, was named in 1990 by the Disney Corporation as the nation's most outstanding visual arts teacher. The Starkville High School students, after doing research on the state's countless musicians and composers—classical, blues, country, gospel, rock 'n' roll, R&B, and popular—established an official Web site for Mississippi musicians, and they update it regularly. Jim Timms of the Starkville elementary schools, founder and director of the singing group the Blackberries, has concentrated on working with disadvantaged students, using drama, music, dance, and puppetry in his classes.

Some years ago Johnnie Billington of Lambert, known as "Mr. Johnnie" to his students and fans, finally came back to his Mississippi Delta home from Chicago, where he had played the blues with Muddy

Waters, Earl Hooker, and Elmore James. He teaches children and young people the art of the blues, having begun giving lessons to neighborhood children at night after he closed his car repair shop. This instruction expanded into the Delta's public schools, and his students have performed in the mid-South, in Chicago and New York City, and even at the Notodden Blues Festival in Norway. He also helped form the Delta Blues Education Fund to aid in the teaching of blues to young people. Elsewhere in the Delta, the Mississippi Action for Community Education set up an arts project which led from a cotton patch celebration in 1978 to the annual Delta Blues Festival in Greenville, now one of the major attractions in the South and a conduit for enlightening everyone from schoolchildren to international visitors about the state's contributions to music.

While many Mississippians are familiar with the nineteenth-century architectural gems scattered about the state, they may be less aware of the more recent contributions made by eminent architects to the state's creative tradition.

The major Mississippi architectural firm of the first half of the twentieth century was Overstreet, which achieved national fame for such buildings as Bailey Junior High School. That edifice, designed by firm partner Hayes Town and featured in *Life* magazine in 1940, dominates the landscape on North State Street in Jackson like a fiefdom. Notable among the next generation were Chris Risher, Sr., of Meridian (see part 1) and Tom Biggs of Jackson. Among Biggs's many designs are the imposing Mississippi Arts Center and the Russell C. Davis Planetarium, both at the heart of life in the capital city, and, also in Jackson, St. Richard's Catholic Church and Temple Beth Israel.

Two of the most highly regarded architects now living and practicing in Mississippi are Sam Mockbee of Canton, who is well known for his contemporary residential designs incorporating vernacular styles and whose work as a professor at Auburn University has involved getting students to develop inexpensive, well-designed housing for low-income families, and Chris Risher, Jr., of Jackson, who has been an influential and inspiring teacher and lecturer all over the country, including at the Harvard Graduate School of Design. Although he has a national reputation, Risher has chosen to remain in the state; in addition to his practice, he teaches in the fifth year program of the Mississippi State University School of Architecture.

The nationally recognized and much-praised Crosby Arboretum in Picayune presents the habitats of the Mississippi coastal plains vicinity. The actual display area comprises more than sixty acres, and its focus is the stunning Pinecote Pavilion, designed by architect E. Fay Jones of Arkansas, which received the American Institute of Architects Honor Award. Located on a lovely pond and surrounded by rustic bridges and benches, the pavilion's splendid columns are made of indigenous pines. Ed Blake of Hattiesburg is the landscape architect who created and developed the pavilion's surroundings.

Mississippi has had an exciting record in the making of movies, in the example of its homegrown actors, actresses, producers, directors, and screenwriters. In recent years as a number of movies have been filmed on location here, respected Hollywood people have grown to admire the state's hospitable people, its landscapes, its feel for histrionics and drama and history. Directors Rob Reiner, Joel Schumacher, Jay Russell, Robert Altman, and the Coen brothers have made movies here, bringing with them an array of notable actors and actresses. This cinematic activity is not only putting Mississippi on silver screens around the country and the world but is also contributing much-needed revenue to the state and local economies and providing jobs for production assistants, extras, local actors, drivers, and others.

There may not be two more disparate places in America than Hollywood and Mississippi, which exist so distantly in the great republic as to be nearly untranslatable to each other—the unmitigatingly tragic, memory-obsessed Mississippi country on the one hand, the fashionable boulevards of popular tinseltown on the other. Yet there has been for a long while a strong Mississippi connection to Hollywood, pri-

marily in the unlikely duo of William Faulkner and Elvis Presley, each of whom spent considerable time in the motion picture business. Faulkner was chronically broke in the 1930s and 1940s, and he was forced to spend months at a time, often miserably homesick, writing scripts in Hollywood. He drank more heavily than ever, even by his own admission, and sometimes slept during story conferences. While writing a script for an improbable epic called *Land of the Pharaohs*, Faulkner claimed that neither he nor the director, Howard Hawks, knew how pharaohs talked, so he was modeling them after Confederate generals.

After Elvis moved with his family from Tupelo to Memphis, he worked as a movie usher, "studied" Brando and James Dean, and always *wanted* Hollywood, which was a long way from the tiny shack where he had grown up. When he made it there, his mother worried incessantly about him, fearing that he might be corrupted. He made thirty-four films in all, chiefly vehicles for his songs and most of them inferior to the first few. Michael Curtiz, who had directed *Casablanca*, feared that Elvis would be pompous and difficult but found him "a lovely boy" with the potential to become "a great actor."

The state has produced a muster of playwrights, actors, actresses, and producers who have dwelled in Hollywood. Tennessee Williams spent time there, Beth Henley works there today, and the producers Larry and Charles Gordon have done fine work there. Hollywood personalities with Mississippi ties include Ruth Ford, Carrie Nye, James Earl Jones, Oprah Winfrey, Diane Ladd, Ray Walston, Stella Stevens, Mary Ann Mobley, Dana Andrews, and Morgan Freeman. (Freeman, who received Oscar nominations for *Street Smart, Driving Miss Daisy*, and *The Shawshank Redemption*, built a house outside his hometown, Charleston, and lives there now when he is not working on a movie.)

Other Mississippians involved in movies and television are producer Jennifer Ogden, directors Charles Burnett, Jefferson Davis, Tag Purvis, Jason Usry, and David Watkins, and actors Cynthia Geary, Marco St. John, Sela Ward, John Dye, Parker Posey, and Gerald McRaney. Two of the most influential agents and managers in the business are Mississippians Larry Thompson and Sam Haskell.

The Mississippi Film Office, headed by Ward Emling and officially under the auspices of the tourism division of the Department of Economic and Community Development, was created in 1973, and since that time forty-four feature movies, thirty-four movies for television, six short films, and nineteen documentaries have been filmed here.

Many point to 1995 and 1996 as the watershed years for the Mississippi film program. During an eleven-month period, three big-budget productions overlapped: *A Time to Kill* and *The Chamber*, made from Mississippian John Grisham's novels, and *Ghosts of Mississippi*, which was about the 1994 retrial and conviction of Byron De La Beckwith for the murder of Medgar Evers. These movies were responsible for the direct spending in Mississippi of over $12 million, for the creation of thousands of jobs, and for presenting an increasingly enlightened Mississippi to national and international audiences. When the films were released in 1996, their directors, actors, and producers praised Mississippi and its people on almost every prominent TV talk show and in national newspapers and magazines. (More people saw Rob Reiner and Alec Baldwin talking on the *Oprah Winfrey Show* about their agreeable experiences in Mississippi than subsequently saw *Ghosts* itself.)

The future of moviemaking in the state might be more clearly discerned in the film activity of 1998, however. Although there were no large-budget projects, shooting took place in many areas of Mississippi, for the movies *Red Dirt, My Dog Skip, Forgetting Youth,* and *Smiles* and for the television series *Promised Land*. Robert Altman returned twenty-five years after he had made *Thieves Like Us* in the state to do the critically acclaimed *Cookie's Fortune*. These smaller films hired more local crew and actors than the colossally budgeted ones and told absorbing stories about real Mississippians. In 1999 Tom Rice came to make *The Rising Place*, and Yazoo County native Jefferson Davis returned to do his first film, *John John in the Sky*.

The welcoming treatment the filmmakers have re-

ceived here has led to favorable publicity for our state. "People are changing their impressions of Mississippi," said Ward Emling. "I've seen it in the talented technicians and actors who've worked here these past months. No longer is Mississippi a dark shadowy place, a place of secrets and violence, of fear and hate. Mississippi in these outsiders' minds now is the Mississippi that we see every day—not perfect, but honest and compassionate and moving forward, the Mississippi of the 1990s seeking fairness and equality."

Given the state's proclivity toward the written word, it is not surprising that a substantial number of Mississippians over the years have been widely recognized in the field of journalism. Herschell Brickell of Yazoo City became one of the most respected critics in America in the 1920s and 1930s, mainly as literary editor of the old *New York Evening Post*, where he was friends with and a help to some of the country's finest writers. For years he was also editor of the prestigious *O. Henry Memorial Prize Short Stories*. Nash Burger of Jackson was editor of the *New York Times Book Review* for many years beginning in 1945. Turner Catledge of Philadelphia was for two decades chief news correspondent for the *New York Times* and, from 1951 to 1968, was managing editor (in effect editor in chief). During my years in New York, Turner was one of the most powerful and respected men in America. He was also one of the funniest storytellers I ever knew, usually recounting Mississippi stories, and he could mimic Theodore G. Bilbo to utmost perfection. One long-ago afternoon in the lounge of New York's Algonquin Hotel, just by chance several of us Mississippians kept running into each other and ended up having drinks at a long table—Eudora Welty, Margaret Walker, Charlie Conerly, Turner Catledge, and me. "Old home week at the Algonquin," Catledge said.

Craig Claiborne, who grew up in Indianola, was food editor of the *New York Times* for many years beginning in 1957, and became the most honored food writer in the country, both for his heralded *Times* columns and for his cookbooks, especially *The New York Times Cook Book*, which contains many Mississippi recipes. Claiborne's memoir, *A Feast Made for Laughter*, devotes many pages to life in Indianola in the 1920s and 1930s.

One of the state's most eminent native sons, Lerone Bennett, has since 1958 been senior editor of *Ebony* magazine, based in Chicago. He is also a historian, poet, and writer of short stories.

The "Mississippi Mafia" is scattered throughout the country. Jack Nelson, for years Washington bureau chief of the *Los Angeles Times*, and William Raspberry, syndicated columnist for the *Washington Post*, have both won the Pulitzer Prize. Curtis Wilkie has been the star national and international reporter for the *Boston Globe*. Rea Hederman, formerly editor in chief and publisher of the Jackson *Clarion-Ledger*, is now publisher of the *New York Review of Books*. Daniel Goodgame has been Washington bureau chief of *Time* magazine. William Nichols is a national reporter for *USA Today*. Rudy Abramson was until his recent retirement one of the foremost writers for the *Los Angeles Times*, and Stephanie Soul is a national reporter for *Newsday*. Mary Lynn Kotz, a journalist and writer on the arts whose work has appeared in many of the country's prominent magazines, is also the author of the definitive book on the artist Robert Rauschenberg. Kevin Sessums is a contributing editor of *Vanity Fair* and other publications.

Among journalists who remained in Mississippi, Hodding Carter, Jr., editor and publisher of the Greenville *Delta Democrat-Times*, was an enlightening influence in the state. For his outspoken editorials he received a Pulitzer Prize in 1946. After a 1955 editorial in which he attacked the Citizens' Councils for trying to close the state's public schools, the Mississippi House of Representatives by a vote of eighty-nine to nineteen formally censured him; Carter replied that he felt as if he had been kicked in the stomach by eighty-nine jackasses. Yet eleven times during his life the Mississippi Press Association awarded his paper the General Excellence Prize. Bill Minor chose to remain during the difficult times and is still here, and the times are in fruitful measure better because of his brave and unerring reportage. For years

he covered Mississippi for the New Orleans *Times-Picayune* and now writes a column syndicated around the state. In 1997 Minor was recipient of the first annual John Chancellor Award for Journalistic Excellence in the United States.

Sui generis in the communications world is Zig Ziglar of Yazoo City, whom I remember as a boy growing up by the Illinois Central Railroad tracks. He began his career as a footware salesman in Mississippi and is now a motivational speaker in high demand around the country. His books, such as *See You at the Top* and *Confessions of a Happy Christian*, are torrential bestsellers.

Mississippi's remarkable literary tradition derives from the complexity of a society which still, despite the conflicts of technological change, has retained well into the late twentieth century much of its communal origins and along with that a sense of continuity, of the abiding land and the enduring past and the flow of the generations—an awareness, if you will, of human history. It has been remarked that Mississippi has produced so many fine writers because the state is such a complicated place that much interpretation is required.

What is the relationship between this writing and the culture which nurtures it? It is an elusive question. This was and remains a society of storytellers, and of bountiful remembrance, a place that cares passionately for words. It is incredibly rich in resources for the writer. "Place is where the writer has his roots," Eudora Welty has written. "I think the sense of place is as essential to good and honest writing as a logical mind. Our critical powers spring up from the study of place and the growth of experience within it. Place never stops informing us, for it is forever astir, changing, reflecting, like the mind of man itself."

And everything is so inextricably bound to *race*. The deep palpitating shadows of race both as a moral and a human dilemma and as nuance and contradiction, the encompassing legacies of the past, have indelibly shaped the work of Mississippi's writers, both white and black: the tragedy and endurance and dig-nity, the sorrow and anger and courage: the *relationships*. Having offered various explanations, however, we may still come back to the question of why there has been such a remarkable literary output. The state's writers are no unified monolith; they are different people, but something has united them in spirit, whatever that might be. Reasons can be given, but perhaps, ultimately, as with all good things, this should remain in the heart of it a mystery.

Literary juxtapositions are inevitable because of the numerical odds. In present-day Jackson, for one instance among many, within a modest distance of where my wife and I live are the domiciles of Eudora Welty and Ellen Douglas and Beth Henley's family. Richard Ford grew up directly across the street from the house where Welty grew up. Richard Wright and Welty were the same age, and he attended junior high only a few minutes' walk from where she went to school.

William Faulkner, of Oxford, was born in 1897 and died in 1962. Basically a self-educated man, he absorbed and learned from the turbulent aesthetic currents of the modern day. Except for periods in New Orleans and Hollywood and late in life in Charlottesville, he chose to remain at home. (Incredibly, between 1929 and 1931 in Oxford he wrote *Sartoris, The Sound and the Fury, As I Lay Dying*, and *Sanctuary*.) In the corpus of his work, his sense of the tragedy and dishonor of even the worst of human beings gradually softened, to be replaced by compassion and pity. "Man ain't really evil," the sewing machine agent V. K. Ratliff says, "he jest ain't got any sense." Running through these words is a profound recognition of the awful brevity of life, that people are only tenants of the earth and at its mercy in the end. "It was the land itself which owned them," Mink Snopes acknowledges, "and not just from a planting to its harvest but in perpetuity." Among the many awards Faulkner received were the Pulitzer Prize (twice) and the Nobel Prize in literature.

Richard Wright of Natchez and Jackson, who was born in 1908 and died in 1960, was by the time of his death the best-known black writer in the world. His unmitigating *Native Son* is one of the most important

American novels; upon reading it, Faulkner wrote Wright a note of encouragement, which Wright kept framed above his work table. But it is his autobiography, *Black Boy*, written out of the bitterness he felt about the treatment of black people during the World War II years, that drew directly on his Mississippi experiences. Yet despite his alienation and his later exile in Paris, as a writer he was always rooted in Mississippi. When I was a student in Europe in 1957 and reading his work, I visited Paris and hoped to meet him. I got his telephone number, and, when I called, he answered. He was cool and aloof at first, but when I told him I was from Yazoo City, Mississippi, his tone suddenly changed. "You're from Yazoo? Well, come on over." We ended up having drinks in an Arab bar, during which time he asked me one question after another about Mississippi.

Eudora Welty of Jackson was born in 1909. Many consider her the Jane Austen of American letters and the nation's greatest living writer. With the exception of her occasional sojourns in Wisconsin, New York, and Europe, she has lived and worked for seventy-five years in her family house on Pinehurst Street; she is abidingly revered in her hometown. One of her fictional characters had occasion to remark that against old mortality life "is nothing but the continuity of its love." She has charted this continuity in thirteen books, including three novels, five collections of short stories, two novellas, and an acclaimed memoir. Her work has won every literary prize except the Nobel, for which she has frequently been mentioned. Her friend and fellow writer Reynolds Price declares, "In all of American fiction, she stands for me with only her peers—Melville, James, Hemingway, and Faulkner—and among them she is, in some crucial respects, the most life-giving."

Tennessee Williams of Columbus, who was born in 1911 in the parsonage of the Episcopal church there and died in New York in 1983, is perhaps America's most widely known playwright and is usually ranked with Arthur Miller as one of the two greatest of the postwar years. He moved to St. Louis with his family when he was young, but over the years constantly returned in his writing to Mississippi, especially to the Delta, the temperamental profligacy of which ideally suited him as a source of artistic material. A number of his memorable characters and plays have Mississippi associations drawn from his own haunted family and past, but at his finest he draws on the universal themes of loneliness and vulnerability against all-too-pernicious circumstances.

Margaret Walker Alexander, who was born in 1915 and died in 1998, moved permanently to Jackson in 1949. She was a novelist, poet, essayist, and scholar. She taught English at Jackson State University and founded an institute for black studies, now known as the Margaret Walker Alexander Research Center. Her most famous work, the internationally best-selling novel *Jubilee*, is a book of sweeping proportions that deals fictionally with her great-grandmother's struggles during the years from slavery to Reconstruction.

Walker Percy, who died in 1991 at the age of seventy-five, came as a youngster with his brothers to live in Greenville with their older cousin, William Alexander Percy, after the Percy boys' parents had both died. As a medical intern in New York, Percy contracted tuberculosis; he left medicine and began reading in literature, philosophy, and psychiatry. With his first novel, *The Moviegoer*, which won the National Book Award, he began to achieve a wide and loyal following, enhanced by later books such as *Love in the Ruins, Lancelot*, and *The Second Coming*.

Shelby Foote of Greenville, who was born in 1916 and now lives in Memphis, is best known for his extraordinary three-volume history, *The Civil War: A Narrative*, which was twenty years in the writing. He is America's Homer, and his novelist's perspective and narrative talents make this work not merely distinguished history but a literary epic. He is also an accomplished writer of fiction, with works including *Shiloh, Jordan Country*, and *September, September*.

Ellen Douglas (whose real name is Josephine Haxton) was born in 1921 and currently resides in Jackson, having spent many years in Greenville. Most of her fiction is strongly placed in Mississippi; her lyrical prose breathes life into her stories of everyday relationships. Among her books are *A Family's Affairs; Black Cloud, White Cloud; The Rock Cried Out; Can't*

Quit You, Baby; and *Truth: Four Stories I Am Finally Old Enough to Tell*.

Elizabeth Spencer was also born in 1921, in Carrollton, and is writer-in-residence at the University of North Carolina. Her first three novels, *Fire in the Morning, This Crooked Way*, and *The Voice at the Back Door* are powerful evocations of the historical, cultural, and social realities that shape the people of north Mississippi and the nearby Delta; her everyday scenes have a luminous immediacy. In *The Light in the Piazza*, her setting shifts to Italy, and in books such as *Knights and Dragons, No Place for an Angel*, and *The Snare* her themes become more American and international than southern. She is considered one of the foremost writers of short stories in the language.

Will Campbell, born in extreme poverty near Liberty in Amite County in 1924, became an ordained Southern Baptist preacher at age seventeen and to this day from his farm near Nashville is a roving pastor without an organized church. In the 1950s and 1960s he was actively involved in the civil rights movement at Ole Miss and elsewhere and was the only white person allowed to help organize Martin Luther King's Southern Christian Leadership Conference. Over time he grew increasingly aware of the discrimination against poor southern whites as well. Perhaps his best-known book is *Brother to a Dragonfly*; others include *Race and Renewal of the Church, The Glad River, Forty Acres and a Goat*, and *Providence*.

Born in Shelby in 1924, Charles East grew up in Cleveland and later had a professional career as an editor and publisher (he was director of the LSU Press and the University of Georgia Press). His short story collection is entitled *Where the Music Was*, and he has published numerous essays in literary magazines. Robert Canzoneri, born in 1925, grew up in Clinton. His books include *"I Do So Politely": A Voice from the South, Barbed Wire and Other Stories*, and *A Highly Ramified Tree*.

Richard Ford has been hailed as one of the best writers of his generation in America. He was born in Jackson in 1944. In 1996 his novel *Independence Day* was awarded both the Pulitzer Prize and the PEN/Faulkner Award, an extraordinary accomplish-

ment. He has lived in many places, from the Mississippi Delta to Montana to Europe. "I still think of Mississippi as home," he says, "but then I was never really married to the idea of home in the first place." His other books are *A Piece of My Heart, The Ultimate Good Luck, The Sportswriter, Rock Springs, Wildlife*, and *Women with Men*.

Currently writer-in-residence at Ole Miss, Barry Hannah was born in Meridian in 1942 and grew up in Clinton. Hannah's fiction, beginning with the 1972 *Geronimo Rex*, which won the William Faulkner Prize, and continuing through *Airships, Ray, The Tennis Handsome, Hey Jack!*, and other books, has received wide critical acclaim. A veritable Hannah cult exists around America for his one-of-a-kind candid and supercharged insights.

The well-deserved reputation of the Center for Writers at the University of Southern Mississippi comes in large part from the prestigious writers on the faculty there. A resident of Hattiesburg, Mississippi, since 1977, Frederick Barthelme, a professor of creative writing, is the author of the novels *Tracer, Natural Selection, The Brothers, Painted Desert*, and *Bob the Gambler*. His brother, Steve Barthelme, a professor at USM since 1986, is best known for his short story collection *And He Tells the Little Horse the Whole Story*.

Born in Jackson in 1952, Beth Henley is yet another of the state's writers to win the Pulitzer Prize, for her play *Crimes of the Heart*; her other plays include *The Miss Firecracker Contest, The Debutante Ball*, and *The Wake of Jamey Foster*.

Ellen Gilchrist of Vicksburg was born in 1935 and lives now in Fayetteville, Arkansas. At Millsaps College she took a writing class under Eudora Welty, who introduced her to Faulkner. She is best known for her dazzling works of short fiction such as *In the Land of Dreamy Dreams, Victory Over Japan, Light Can Be Both Wave and Particle*, and *I Cannot Get You Close Enough. Victory Over Japan* won the 1984 American Book Award for Best Fiction.

Larry Brown of Oxford has an unusual background for a writer. Born in 1951, he served in the U.S. Marines in Vietnam and then worked for years in the Oxford Fire Department. His novels and short

story collections include *Dirty Work* (the story of two Mississippians, one white and one black, wounded in Vietnam combat who get to know each other in a hospital), *Facing the Music, Big Bad Love*, and *Joe*.

Billie Jean Young, born in Jackson in 1936, is not only a poet and playwright but also a stage actress and director, a lawyer, and a professor of drama at Jackson State University. Her one-woman show *Fannie Lou Hamer: This Little Light* presents an engrossing portrait of the black Mississippi activist's life. Her collection of poems entitled *The Child of Too* is a compelling work that expresses the deepest experiences of southern blacks.

Beverly Lowry, who was born in 1938 and grew up in Greenville, is the celebrated author of, among other books, *Come Back, Lolly Ray; Emma Blue;* and *Daddy's Girl*. Mort Crowley, born in Vicksburg in 1936, wrote the hit Broadway play *Boys in the Band*. Born in Ocean Springs in 1939, Al Young has written novels, poetry (his collected poems is entitled *Heaven*), screenplays, and several books of essays about music, *Bodies & Soul, Kinds of Blue*, and *Things Ain't What They Used to Be*. The late Frank E. Smith, born in the Delta hamlet of Sidon in 1918, was a U.S. congressman from 1951 through 1962 and was then appointed by his friend John F. Kennedy to be director of the Tennessee Valley Authority, where he served for ten years. His books include *The Yazoo, Look Away from Dixie, Mississippians All*, and his best-known *Congressman from Mississippi*, published in 1964, the autobiography in which he set forth his views on the contorted issue of race in the state.

Born in 1939, Lewis Nordan grew up in Itta Bena. His books include *Wolf Whistle, Music of the Swamp*, and *Sharpshooter Blues*. Rebecca Hill was born in 1944 and moved to Soso at the age of two. She has written *Blue Rise* and *Among Birches*. Mildred D. Taylor, born in Jackson in 1943, is well known for her children's books; *Roll of Thunder, Hear My Cry*, based on her family's history, won the Newberry Award, the most prestigious award in children's literature. Thomas Harris, born in 1940, is a writer of bestsellers whose books include the very scary *Silence of the Lambs* and *Hannibal*. Harris lives in Sag Harbor, Long Island, but comes back to the Delta frequently to visit his family.

Ann Moody, born to sharecroppers in Centreville in 1940, participated in civil rights demonstrations when she was a Tougaloo student in the 1960s. Her autobiography, *Coming of Age in Mississippi*, was published in 1968 and has gone through multiple printings. Her later books include *Mr. Death* and *Farewell to Toosweet* (a sequel to *Coming of Age*). Clifton Taulbert, born in Glen Allen in 1945, writes of his Delta upbringing in the 1940s and 1950s in his autobiography *Once Upon a Time When We Were Colored*. It is a rich account of the values he learned from his great-grandparents and his mother, who was a schoolteacher.

Jack Butler, born in 1944 in Alligator, is now director of creative writing at the College of Santa Fe. His novels include *Jijitsu for Christ, Nightshade, Living in Little Rock with Miss Little Rock*, and *Dreamer*, and he has also published a cookbook, *Jack's Skillet*.

Among our younger fiction writers receiving national attention are Donna Tartt, Steve Yarbrough, and Greg Iles. Born in Greenwood in 1963, Tartt grew up in Grenada and went on to write *The Secret History*. Yarbrough was born in Indianola in 1956 and has written *Family Men* and *Mississippi History*. Iles, born in 1960, grew up in Natchez; his books include *Spandau Phoenix* and *Black Cross*.

And, of course, there is the phenomenal success of John Grisham, born in 1955, the towering best-selling novelist of our day, who was elected to the Mississippi legislature while he was still a law student at Ole Miss. Grisham lives in both Oxford and Charlottesville, Virginia, and publishes the nationally respected literary and journalistic magazine, *The Oxford American*. Generous in his donations to the writing and literary programs at Ole Miss and elsewhere, he is also a lover of family, dogs, and baseball.

Mississippi has also been home to a number of distinguished poets, among them James Autry, Angela Ball, D. C. Berry, Turner Cassity, Carol Cox, Brooks Haxton, T. R. Hummer, Etheridge Knight, William Mills, Sterling Plumpp, James Seay, John Stone, Jerry Ward, and James Whitehead.

For those who wish to learn more about Mississippi's writers and to read selections from their works, I recommend the excellent *Mississippi Writers: Reflections of Childhood and Youth*, edited by Dorothy Abbott, which consists of separate volumes on fiction, nonfiction, poetry, and drama, and *Mississippi Writers: An Anthology*, also edited by Abbott.

I conclude this section on my fellow Mississippi writers with a quotation from the distinguished author Sterling Plumpp, who was born in Clinton in 1940 and teaches at the University of Illinois at Chicago. He has written a volume of essays, *Black Rituals*, and books of poetry including *Portable Soul, Steps to Break the Circle, Clinton*, and *The Mojo Hands Call, I Must Go*. Plumpp has said the following of his growth as a writer:

> *You can say I found my voice in my Mississippi background. In Mississippi*
> *I found a place to house the uncertainty of chaos ushered in by fear and anxiety, and*
> *I found in the people I had known a language and a music to complement my voice. . . .*
> *By viewing my soul through Mississippi, I could maneuver into the reservoir of my*
> *being without first having to plod through attacks against whites; I could see*
> *the survival lines of my people concealed in the many ways they did things.*
> *Though there will be other places in my life none will be home,*
> *as close and as painfully or joyfully familiar as Mississippi.*

EPILOGUE

One cannot help but wonder what those Mississippians who might come across this volume in the year 2100 will make of what is contained here. Will they perceive resonances in their own society? Will they deduce lessons for their own times? What will they think of how we Mississippians in the year 2000 took care of our children and their future? Will it seem that our progeny was valuable in our own eyes? Or did we let them down? Will there continue to be an ineluctable link between the state's passing generations? What will be gone, and what will remain?

Not long ago I was having an earnest conversation with my friend Patti Carr Black, a Mississippi woman for all seasons—writer, painter, historian, teacher, curator, intellect of the heart—who has traveled the world and always comes home, out of those indwelling fealties that so many of us mysteriously share. Patti understands the sweep of history, the human beings who shape it and who are in turn irrevocably shaped by it. We were talking about that immeasurable irony—why Mississippi remains at the bottom in the whole of the great American republic in social and educational and human services while perhaps being first in creativity and imagination and artistic accomplishment. How to explain at the new millennium this most catastrophic of divides?

She thought about this. "It's curious," she said, "but Mississippi lacks a sense of *community*. We have a deep sense of place, but no sense of 'we're in this together, let's make life better for everyone.' For most of Mississippi's existence, our focus has been on keeping ourselves apart from each other. Segregation dominated the twentieth century, and, although it was outlawed thirty years ago, it lives in our spirit. White society has been in power throughout our history, and it has lacked the will to deal with social problems because it has wrongly perceived the main beneficiaries to be black. We've not comprehended that we sink or swim together.

"No," she continued, "I don't see a dichotomy between our low standing in social measurements and our high standing in the arts. Writers and other artists have always been radical thinkers about the human heart, and much of the outpouring of creativity is, to use a Welty phrase, 'an attempt to part a curtain, that invisible shadow that falls between people, the veil of indifference to each other's presence, each other's wonder, each other's human plight.'"

In working on this book over the past months, I have found myself returning time and again to a similar recognition. It is a truthful one. Despite our spirit of belonging, there is no lasting spirit of commonweal.

The state remains at the nadir in education—fiftieth in America in total expenditures for elementary and secondary students, fiftieth in percentage of high school graduates, fiftieth in salaries for its university teachers, and, most disturbingly of all, fiftieth in overall child development programs that would benefit those in their early years, a period judged by the experts to be absolutely critical, at a time when technological advances demand as never before that the

young be educated and trained and counselled for the challenging and complicated future. To me, this reality amounts to nothing less than a societal death wish. The most essential question for all of us, I submit, is how long the citizenry of this state will allow this collective nihilism to continue. It is mere common sense to acknowledge that Mississippi will never begin to realize its true potential if this mentality persists in carrying the day. The state's gloomy performance in health care, general literacy, job training, humane services, and other areas likewise severely hampers the incipient development of its young. For that matter, the number of talented Mississippians in *athletics* alone, with their wonderful national achievements, seems an embarrassing anomaly when compared to the people who do not support or pass civilizing laws.

The children must be saved. Our organized power structures have too often failed this state, as have those citizens who, for whatever reason, have voted to keep things the way they have always been.

The author Stephen Schiff, writing in the *New York Times* shortly after the 1999 mass killings in the high school in Littleton, Colorado, the town where he was raised, noted the modern obliterations of that archetypical American setting: "I grew up in a town endowed, however humbly, with a character and a sense of place, and I had those things, too. What sense of place can there be in the Littletons of America now, in these mall-lands where each Gap and McDonald's is like the next, where the differences between things are neither prized nor scorned but are simply wiped from existence? Growing up in an anonymous landscape, how can anyone escape his own encroaching sense of anonymity?"

Our state, however, has been blessed with much: life-giving waters, powerful landscapes, fecund earth, clean air, agreeable weather, vast solitude and greenery, a sensitivity to history, the self-identity of its multifold people. From those to whom much is given, we have been taught, much is required. I was driving not long ago through the verdant terrain with a prominent Mississippi black leader. "God, this is a beautiful state!" he said. "If we could just be able to take care of this race thing." This reminded me of the recent remark made by my neighbor William Winter: "We all need to live together. We all have so many common interests." I thought also of the Reverend Jesse Jackson's observations during one of his many visits to the state to espouse civilized social agendas and voter registration. He had been invited to deliver the sermon at Galloway United Methodist Church in Jackson, where I was christened as a child. "You can't sow seeds tonight and grow food tomorrow morning," he said. "But if you keep on doing it, you begin to see fruit emerge. I still think Mississippi holds the key for healing in the nation. There's something magic about Mississippi—its pain, its problems, and its possibilities."

A few years ago at an arts festival in the Delta a member of the local chamber of commerce asked me, "What can we do to improve Mississippi's image?" I replied that we could let the people in Boston, Des Moines, or LA worry about Mississippi's image as much as they desired, but that we Mississippians should concern ourselves with how we seem to each other.

Perhaps in the end, the old, inherent, devil-may-care impulses of Mississippians will remain abundant and will sustain and ameliorate conditions in the state's uncertain future. The reckless gambler's instinct that led to the fighting and the losing of that war. Archie Manning or Steve McNair or Brett Favre calling a bootleg play on fourth and eight. A wildcatter in the Piney Woods staking it all on one big strike. Medgar Evers going with his feeling to face the fight at home. A black mother in the Delta working sixteen hours a day to educate her children, a woman borrowing from the banker so that she can send her daughter to a school where she will marry well. It is gambling with the spirit, it is a glass menagerie, it is something that will not let go.

One of my favorite books in college, W. J. Cash's 1941 *The Mind of the South*, remains to this day an influence in my life, and his concluding words are as evocative to me now as they were when I was young. I will ask the reader to substitute my "Mississippi" for his "South":

Proud, brave, honorable by its lights, courteous, personally generous, loyal, swift to act, often too swift, but signally effective, sometimes terrible, in its action—such was the South at its best. And such at its best it remains today, despite the great falling away in some of its virtues. . . . In the coming days, and probably soon, it is likely to have to prove its capacity for adjustment far beyond what has been true in the past. And in that time I shall hope, as its loyal son, that its virtues will tower over and conquer its faults and have the making of the Southern world to come.

I was reading my Faulkner back then, too, and I remember when I first came across these words: "Loving all of it even while he had to hate some of it because he knows now that you don't love because: you love despite; not for the virtues but despite the faults."

Mississippi may not be the most perfect spot on earth, but there is no other place I would rather be.

W. M.
12 July 1999

PHOTOGRAPHER'S NOTE

I left Mississippi as a young man, at a time when there was only one issue and that was race, the albatross of race. As a writer, as an American, as a southerner, I simply could not deal with it in a human way. But, with the passing of time, I have learned how to deal with that burden. I have learned through a lot of work and a lot of experience to appreciate the very burden itself. And now that I am back here in good ole whoop-down, crazy Mississippi, the burden is something that I deal with on a day-to-day basis, and, in fact, I am rather proud of the burden.

—WILLIE MORRIS, Interview, *Portrait of America: Mississippi,* Turner Broadcasting System, 1986.

Like a fine wine, this project has been fermenting for many years. Its origins date back to the late 1970s when I was a student at Hampshire College in Amherst, Massachusetts. In spite of the fact that I had not spent more than a total of a few weeks in Mississippi in my years as a child and a young adult, I proposed to my father that we collaborate on a book about the state. Although he was a Mississippi native, he was then living on the eastern end of Long Island. (He had taken me to his hometown, Yazoo City, on a number of occasions, the most memorable being after the publication of his first book, *North Toward Home,* when he spoke to the student bodies at both the white and the black high schools.) As best as I can remember, he was polite about the idea, writing me that "our Mississippi book will be a great one," but he let the matter drop. I was nineteen at the time, and, while I was an aspiring young photographer and had actually had a few photographs published, I had nei-

ther the maturity nor the perspective to pursue an extensive study on much of anything at all. I quickly forgot about my grandiose proposal, and my father and I did not discuss the idea again for more than twenty years.

Instead, I continued my studies and began to pursue serious photographic endeavors, which ranged from making my own young man's journey across the country to documenting the defeat of a longtime Texas congressman and to capturing the faces of Vietnam veterans struggling to come to terms with their experiences in the war. My photography was steadily evolving, and, at the age of twenty-three, I had already had a number of publications and exhibitions and was being courted by a respected national newspaper. However, I didn't follow the most obvious path to success. A year after I graduated from Hampshire I found myself living in Forest, Mississippi, working for Sid Salter at the *Scott County Times.* While on many days I felt as though I had stepped off the edge of the world, it was perhaps the most meaningful and constructive period of my life. In that year, I learned everything I needed to know about the day-to-day workings of a small-town newspaper. In subsequent years I moved on to daily newspapers in Greenville and Vicksburg before finally leaving Mississippi in 1987 for a job in Tennessee and then for graduate school in Minnesota.

Although I was still living within walking distance of the great river in Minneapolis, I was constantly being drawn downstream back to Mississippi. I am not sure whether it was my family connections or my

passion for the tragedy of the state's history, but I kept coming back. I wrote my master's thesis on Dr. Jane Ellen McAllister, an eccentric and spirited ninety-one-year-old woman from Vicksburg who had been the first African American woman to receive a Ph.D. from Columbia University Teachers College in 1929. I had met her on a warm spring day while I was working for the *Vicksburg Evening Post*. Although we had virtually nothing in common—she was old, I was young; she was black, I was white; she was a native, I was not—we became fast friends and spent hours sitting around her old dining room table ruminating about her experiences as a pioneering black educator. In many ways Dr. McAllister was a catalyst in my life: not only was she one of the primary reasons I kept coming back to Mississippi, but my work with her rekindled my interest in pursuing an in-depth and long-term photographic project. I had grown tired of the limitations of day-to-day newspaper work, and I saw Dr. McAllister as a way to explore and confront Mississippi history and the human struggle that informs and defines it.

After I finished graduate school, I bided my time as an assistant photographer for the Minnesota state senate. It kept me busy for four to six months of the year, but I would inevitably hit the road in the summer and fall, and I always ended up in Mississippi. My father was, of course, delighted to have me around, and I had cultivated enough friendships over the years so that I was never without a place to stay. I exhibited my work on Dr. McAllister, and, all the while, I was photographing Mississippi as it unfolded around me.

In the fall of 1994, it was finally time to leave Minnesota. We had thoroughly enjoyed our lives there, but, on a whim, my partner, Susanne, and I decided to move downriver to New Orleans. I quickly established myself as a photojournalist in the Crescent City, but was constantly in and out of Mississippi working on assignments and on a variety of small, short-term documentary projects. In the ensuing four years, I managed to eke out a modestly successful career as a photojournalist, but I was still not satisfied with the overall quality of my work. I

needed another big project, something that I could really sink my teeth into. Perhaps it was time to give the Mississippi project another try.

My relationship with my father had undergone many transformations in the intervening twenty years. Like all father-son relationships, ours had its share of ups and downs. My father had always been very proud of me, but at times the eccentricities of his lifestyle had caused great friction and resentment. There were times when we did not communicate very well and others when we did not speak at all. However, much of that had changed in the early nineties. His second marriage, to JoAnne Prichard, and the cathartic experience of the publication of *New York Days*, in which he confronted and put to rest many of the demons of his past, had transformed him into a happier and mellower person. We could finally communicate on a more personal and familial level.

It was at Galatoire's, my father's favorite restaurant on Bourbon Street in New Orleans, in the late summer of 1998, that I decided to again propose a joint venture. My desire to photograph and document Mississippi had grown stronger, and I knew that it was time for us to work together. We had done small projects, and photographs of mine had been published with a few of his articles and essays, but we had not undertaken anything this extensive. It would be a collaboration between father and son: representing two generations, we would examine the Mississippi of today through different art forms. My father was immediately taken with the idea, and within three months I had begun active shooting.

Setting out to photograph the people and places of Mississippi was like no other experience I had ever had. For how does one "document" a whole state? The intensity of the creative process and the confusion and frustration of trying to force something that would not always work made for many sleepless nights. In describing my situation to friends, I said that I was like a V-8 engine running on three cylinders, unable to get the proper fuel-to-air mixture that was needed for a fine-tuned engine. I solicited the advice of other artists and creative people in an at-

tempt to understand the nature of creativity. I questioned painters, musicians, scholars, potters, athletes, gallery owners, and duck hunters, as well as journalists and other photographers. How did they create? And how did they cope with the inevitable stresses and dangers of the creative process? We had long conversations over coffee or dinner, often well into the night, as they attempted to help me work through my fears and creative blocks.

I stumbled on in frustration through the winter. While I still managed to get a few good frames here and there, I felt I was digging myself deeper and deeper into a hole. At times, the images I wanted to capture or felt would be most representative of the state were simply not there. In such circumstances it was pointless to force the situation and was a waste of valuable energy. This period was perhaps the most stressful and frustrating experience of my life. To make matters worse, it became clear that my father and I were not collaborating at all but were operating independently of each other. In reality, our working styles were simply not compatible. He liked to work discreetly, surveying the landscape on leisurely drives, reading and doing research. He began quoting from a long list of obscure and wonderful statistics he had discovered. He quizzed friends and neighbors, taking notes not only on three-by-five cards but on napkins and scraps of paper. Slowly he gathered the materials for his prose. He planned to rewrite and edit later. He could afford to keep a low profile.

I was exactly the opposite. As a photographer, I like to throw myself into the middle of a situation. It is harder to be a detached observer when you're carrying a camera. People react to you differently. You have to gain their trust, stick out your neck. At the same time, I had to wait for the images to come to me. This took time. What might have seemed like an obvious picture was not always the one that I wanted to capture; in fact, what I sought was often exactly the opposite. I came to understand only later that I was attempting to reach a creative space that the musician Jerry Garcia has described as "the form that follows chaos." When you throw out all the rules, he said, let go of your own preconceptions, and stop try-

ing to make things happen on *any* level, other "stuff" starts to happen. It was a great lesson, and, once I began to understand these concepts of creativity, I slowly started to find a rhythm in my work. By April, after nearly six months of frustration, I had finally tweaked the V-8 and was up to seven cylinders. By the middle of the summer I was on a roll, and photographs were pouring out of me. I was exploring creative places I had never been before, and had learned to trust the process.

At the end of July, I had been on the road for a week, starting in Jackson at a gospel festival and wedding reception. I went on to church camp in Ackerman on Sunday morning and then to Grenada for a livestock auction; after a day off, I spent time in Yazoo County photographing on the set of a low-budget film, in Philadelphia at the Neshoba County Fair, and in Meridian taking pictures at Peavey Electronics. I returned home on Friday, 30 July, exhausted. I planned to rest for a few days, edit my film, and hit the road again the following week. I had much to do—many ideas to pursue and places to go.

My father died the following Monday, 2 August. The magical creative wave I had been riding all summer quickly evaporated. I had more immediate issues to deal with, and trying to be productive in the midst of grief was too difficult. Although I was in the last month of active shooting, I simply could not continue. The most I could do was attempt to fill in a few holes. While there was much left to photograph, I believed not only that the project should be put to rest but that any further efforts would actually endanger my own ability to work. I had lost my creative edge. As far as I was concerned, the creative aspect of the project ended on that day in August.

While the book may fall somewhat short of its desired goal, I believe that it realistically reflects Mississippi at the dawn of the twenty-first century. It is an intergenerational meditation on this place, and its strengths lie not in the similarities that my father and I brought to it but in the differences. My father came of age in Mississippi during a period of great social and political change. He left in 1952 to go off to the University of Texas and did not return for almost

thirty years. He remained in self-imposed exile partly because of opportunities elsewhere but also because he could not reconcile himself to the tragedies of racial injustice in his home state. The situation pulled at his heart, and the contradictions fueled his creativity.

Make no mistake about it. My father never stopped loving Mississippi. But it was not until the 1980s that he felt comfortable about returning to live in the state. Once he was back, he embraced the political and social changes that had occurred in his absence and reestablished himself as a resident Mississippian. He looked at where Mississippi had been and where it was now, and he was proud of the changes that had taken place during his lifetime.

I am younger, of a more cynical generation. I was born during my father's exile and raised in New York City. I was baptized both in the violence and insanity but, more so, in the hope and promise of the 1960s. I have vivid memories of protests and demonstrations, yet I was too young to understand their significance at the time. The night that Martin Luther King, Jr., died, I thought my mother was crying because I had knocked a large wooden salad bowl off the top of the refrigerator and broken it. Many years later, after I moved to Mississippi, I began filling in some of the gaps and putting my memories in proper perspective.

I look at where Mississippi is today and imagine where it should be. The love my father had and that I share for the state and its people is what makes this work important. At the same time, he realized as I do that hope for the future lies in an understanding of the past. In order to do any kind of honest study of Mississippi today we *must* confront the past, and to do that we have to take a strong stance not only against the racism in Mississippi's history but against the racism of today. This is challenging, because racism at the beginning of the twenty-first century can take forms that are considerably different from those of the past. While racial violence has all but vanished, economic disparities and de facto segregation still exist. In some places, the public schools, once all white, are now almost all black. And while the barriers that separated blacks and whites in the past may be gone, there is little social integration. Mississippi has cer-

tainly made progress, but it has a ways to go yet. We must continue to face these struggles on a day-to-day basis.

With that in mind, I have attempted to portray the places and the people of Mississippi as they have been shaped by history. Contrary to popular belief, Mississippi has never existed outside of time. In arranging and sequencing these photographs, I have attempted to thread a visual narrative that reflects historical consciousness but does so in a respectful manner. Therefore, I have tried to present not a book of pretty pictures, but one that is inviting and also challenging. Indeed there are images in this collection that are neither pretty nor complimentary. But then, neither is the past. The land and the people are always witness to history, and to understand this can be a great burden. It is a lifelong challenge and one of the greatest lessons I have learned from my father. It has become central to my vision as a photographer.

In many ways, my father's legacy is not unlike that of the white postal worker Bill Moore. Moore had been raised in Mississippi, but was living in the North when he decided to stage a one-man march from Tennessee to Jackson. Horrified by the violence during James Meredith's attempt to integrate the University of Mississippi in 1962, Moore hoped to hand-deliver a personal letter to Ross Barnett, who was then governor, expressing his concerns about racism in Mississippi and Barnett's role in resisting Meredith. "I dislike the reputation this state has acquired as being the most backward and most bigoted in the land," he wrote. "Those who *truly love* Mississippi must work to change this image."★ Moore was shot and killed in northern Alabama. His killers were never brought to justice.

As I drive the back roads and byways of rural Mississippi today, I know that my father is with me, as is his commitment to change. My father loved Mississippi and through his work sought to help in the fight for social justice and the end of racism. Like-

★Quoted in George Lipsitz, *The Possessive Investment in Whiteness: How White People Profit from Identity Politics* (Philadelphia: Temple University Press, 1998), ix. [Emphasis mine]

wise, I consider it my responsibility to carry on this legacy and to continue to work for a more democratic Mississippi. In that regard, my work finds its origins in the same need to explore the contrasts and contradictions of the beautiful and tragic place that preoccupied my father throughout his life and literary career.

Over the course of my travels, I have had the help of friends, colleagues, and strangers alike whose assistance has been invaluable to me in the process of creating this work. I would like to extend my sincerest appreciation for all their support and kindness. They gave ideas and advice, not to mention food and shelter, and have been with me throughout the year helping to shape and define this work. I could not have done it without William Albert Allard, Homer Best, Scott Boyd, Jane Rule Burdine, Tommy Cadle, Bobby Cleveland, Rick and Liz Cleveland, Billy Cochrane and Lisa Whitney, Jani Mae and Emmett Collier, the staff at Colorpix, Rose Doumit, Arlene Dowd, Bill and Susan Elderton, Charles Evers, Bill Ferris, JoAnne Gordon, Simon Gunning, Bill Haber, Peggy Hampton, Macy Hart, Jere Hess, the staff and membership of Impact Visuals, Chris Jenkins, Crystal Kile, George Lipsitz, Sherry Lucas, Charlie Mitchell, Don Mitchell, Modie, Milly Moorhead, my mother, Claudette Murphree, Rev. Dr. Roland Myers, Geneva Nightengale, David Oakes and my former colleagues at Senate Media Services in Room B-44 of the Minnesota State Capitol, the People's Institute, Leilani Pope, JoAnne Prichard Morris, Peyton Prospere, Kent and Faye Prince, Elizabeth Rappaport, Faye Richardson, William "Brother" Rodgers, Sid Salter, Scott Saltzman, Richard Saxer and Orissa Arend, Reggie Scanlan, Lesley Silver and Daniel Boone, Rogelio Solis, David Spielman, the spirits of 76 (the apartment, not the year), Sharon Stallworth and Adam Nossiter, Virginia Stallworth and Susan Mackenzie, Creta Stewart, Bertie Sullivan, Delores Terrell, Jeannette Thompson, T. Tidwell and C. J., Mike Tonos, the gang around the wheel at Vaughan's, Carol Vickers, Chris Waddington and Shelley N. C. Holl, Jerry Ward, Larry and Dean Wells, Malcolm White, Toby Wilson, Bob Yarbrough and Stacy Hite, and Samantha Rae.

I am also deeply indebted to Dave Stueber and David Blumenfeld, cofounders of our spirited support group, The Three Daves, who provided untold support and advice and gave this photographic narrative its first signs of life and truth in a cabin on the Wolf River in Hancock County.

Finally, I thank Susanne, my partner of thirteen years, for her unwavering support and love. With her commitment to education and social ideals, she has guided me through the days of confusion and uncertainty.

D. R. M.
May 2000

Look Away

Photographic narrative by David Rae Morris

PRECEEDING PAGE:

Confederate memorial in Greenwood
Cemetery, Jackson, Hinds County

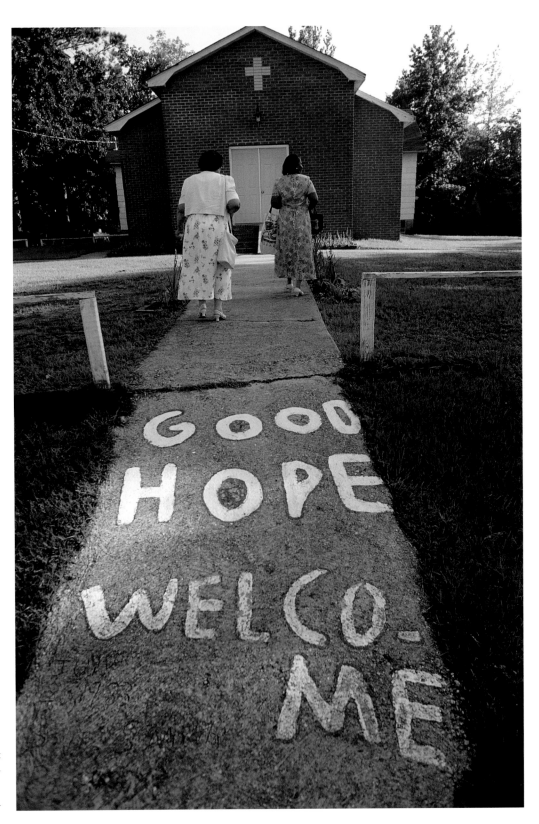

Sunday morning services at
the Good Hope Missionary
Baptist Church, Hickory,
Newton County

Cotton pallet along Highway 6 during the fall harvest, near Marks, Quitman County

Abandoned store along U.S. Highway 61, Nitta Yuma, Sharkey County

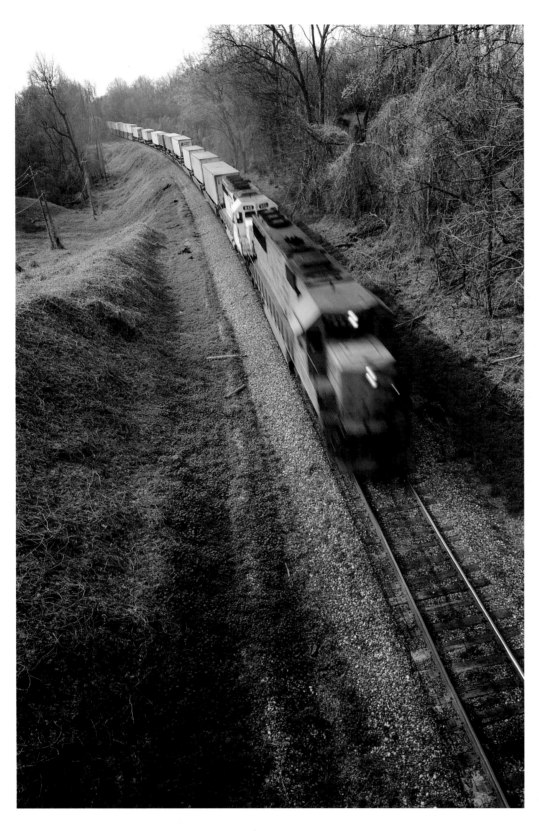

Freight train,
Vicksburg, Warren County

Bill Ferris at the Virlillia store, Madison County

Jane Rule's back porch after a rainfall, Taylor, Lafayette County

Local actors backstage at a presentation of the Confederate Pageant during the Natchez Pilgrimage, Adams County

Mural on the wall of downtown nightclub, Jackson, Hinds County

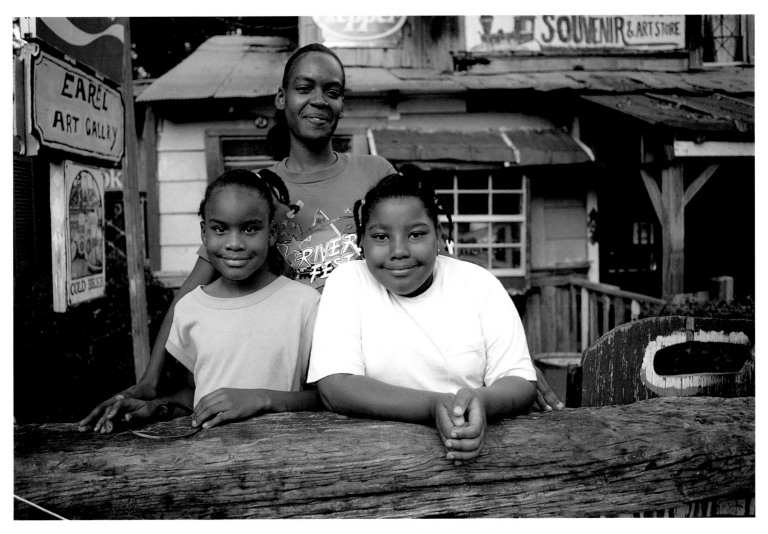

Michelle and friends in front of Earl's Art Shop, Bovina, Warren County

Locals hanging out on the porch at Mary's store, Taylor, Lafayette County

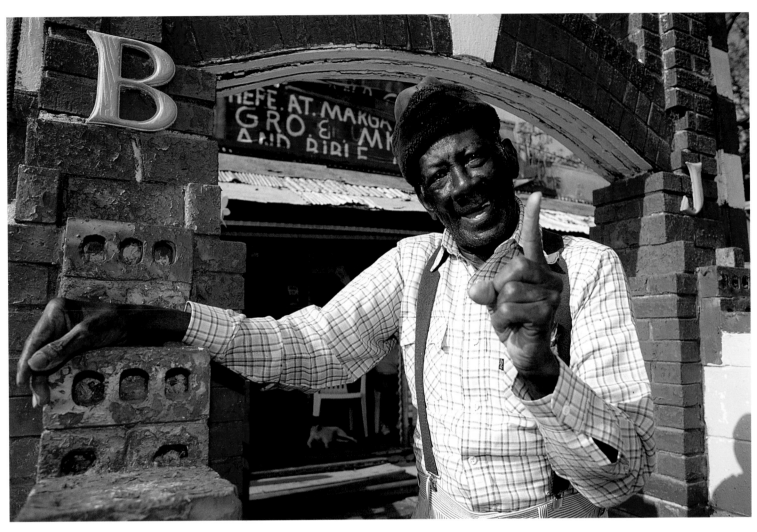

Reverend Dennis offering a sermon to a visitor at Margaret's Grocery on U.S. Highway 61, Vicksburg, Warren County

Casino express along U.S. Highway 61 from Tunica to Memphis, Tunica County

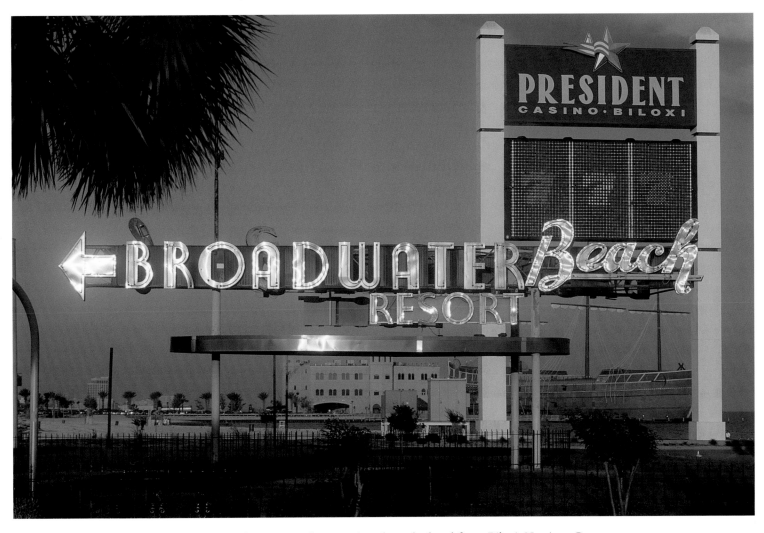

Broadwater Beach Resort and new casino along the beachfront, Biloxi, Harrison County

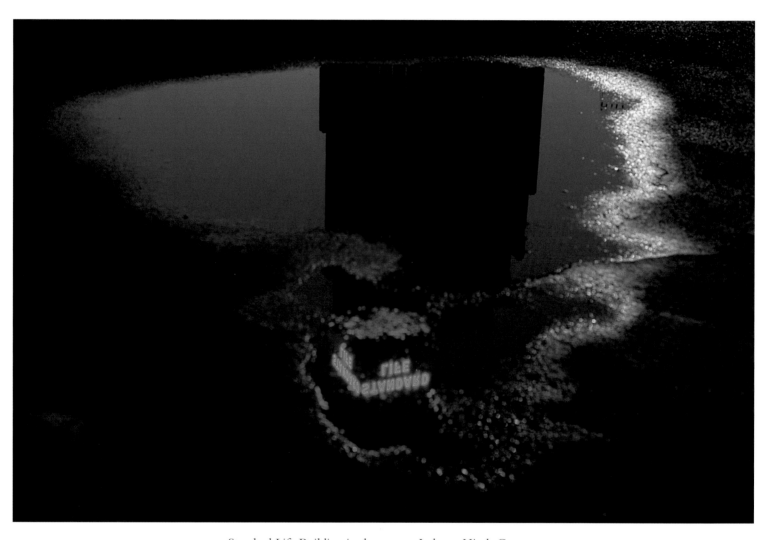

Standard Life Building in downtown Jackson, Hinds County

House in the Delta built on the top of an Indian mound, Rolling Fork, Sharkey County

White supremacist Byron De La Beckwith during jury selection for his third murder trial in Batesville in 1994
(he was subsequently convicted for shooting civil rights activist Medgar Evers in the back in 1963), Panola County

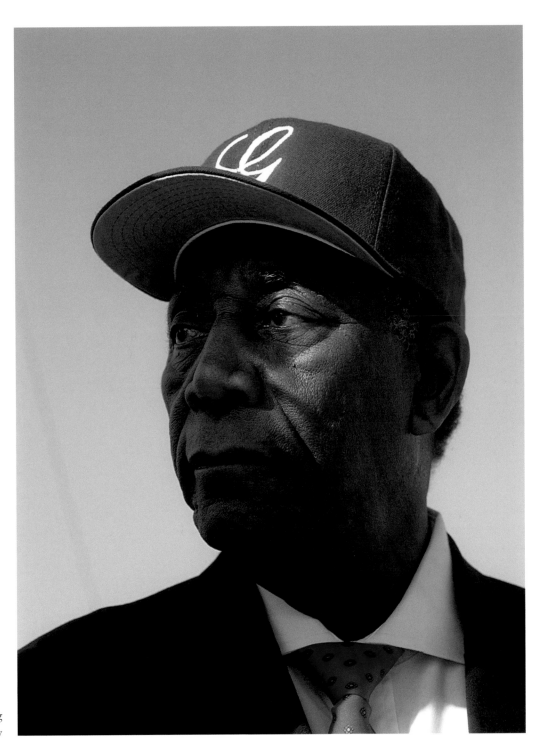

Medgar's brother, Charles Evers, visiting
the Delta, Indianola, Sunflower County

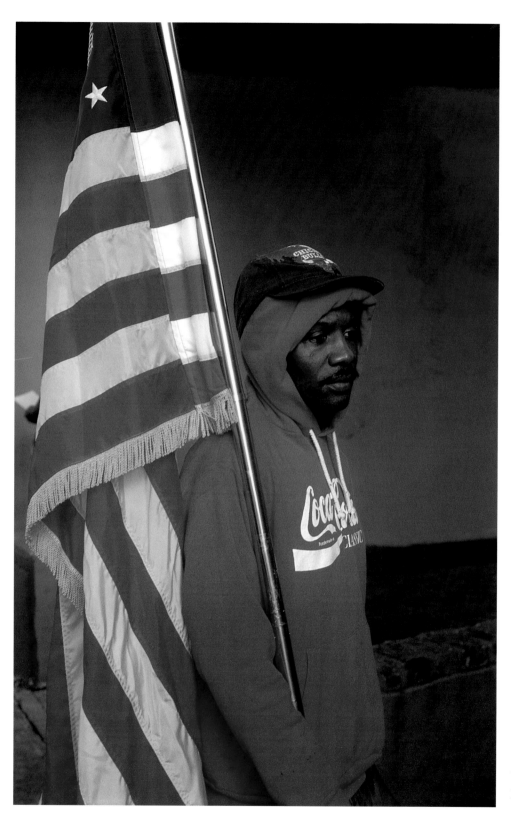

Leon Gray, flagbearer for
Martin Luther King Day parade,
Yazoo City, Yazoo County

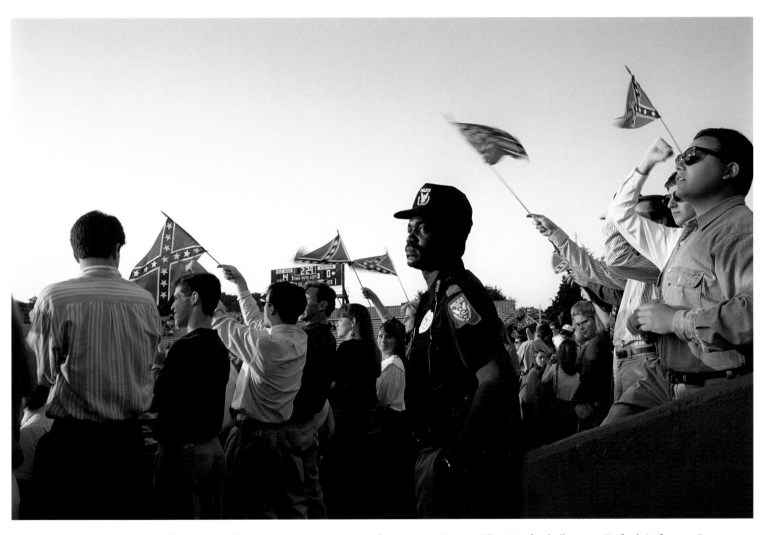

Student section at Vaught–Hemingway Stadium at the University of Mississippi during Ole Miss football game, Oxford, Lafayette County

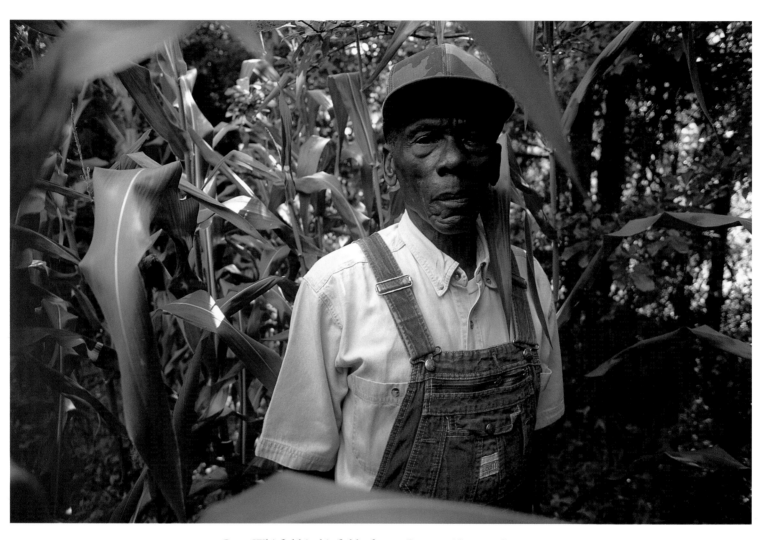

Oscar Whitfield in his field of corn, Decatur, Newton County

Bluesman James "Son" Thomas on the front porch of his shotgun house, Leland, Washington County

Martin Luther King Day parade, Belzoni, Humphreys County

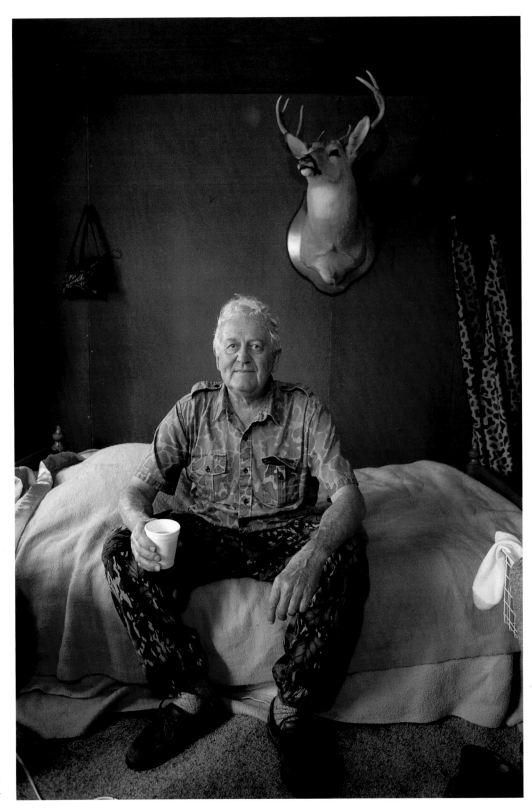

Jim Stewart in his trailer,
deer camp, rural Madison County

Young couple with baby, Forest,
Scott County

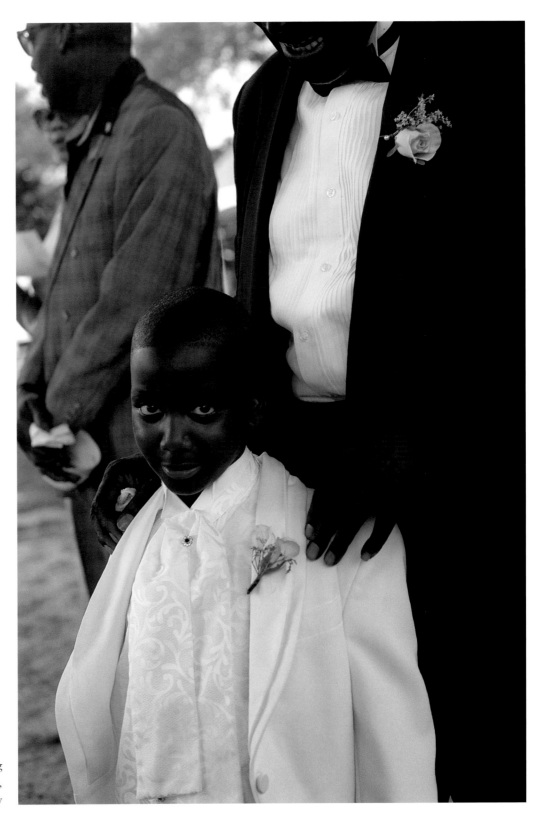

Ring bearer during wedding
ceremony on the courthouse square,
Canton, Madison County

John Green, visitor
at the Natchez Senior Center,
Natchez, Adams County

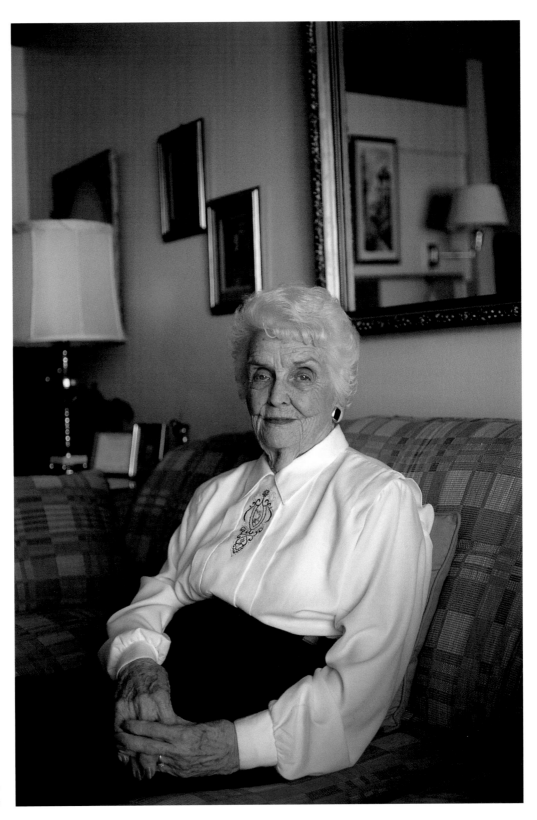

Retirement community,
Tupelo, Lee County

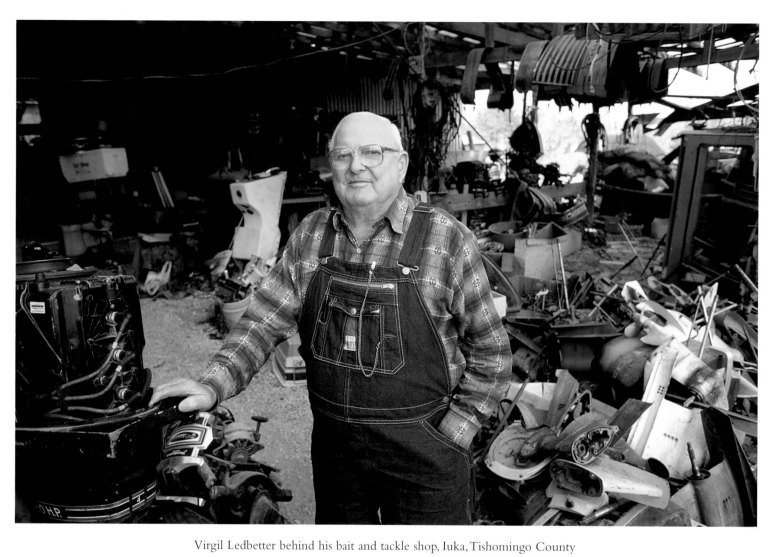

Virgil Ledbetter behind his bait and tackle shop, Iuka, Tishomingo County

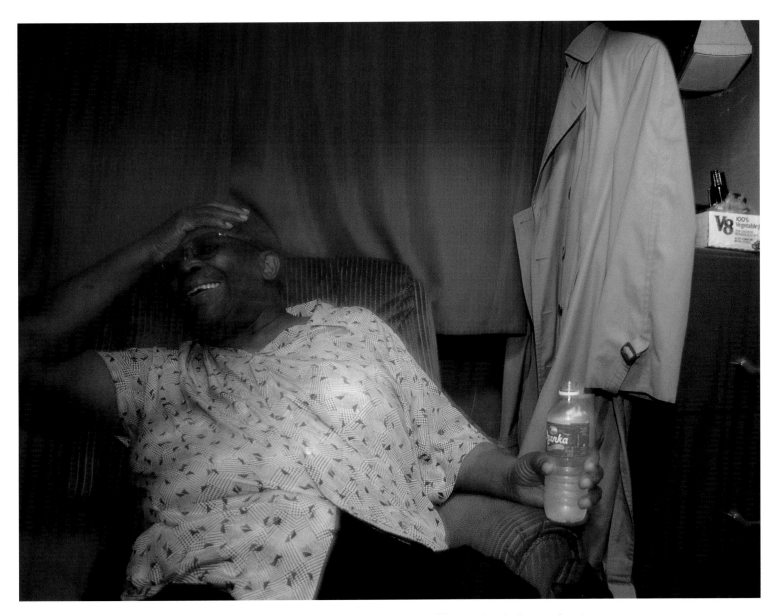

Indianola native Riley "B. B." King in the back of his tour bus before performing
at the thirty-sixth annual Medgar Evers Homecoming, Canton, Madison County

Winner of the greased-pole-climbing
competition during county extension
activities at the first annual Green
River Bluegrass Festival, Leakesville,
Greene County

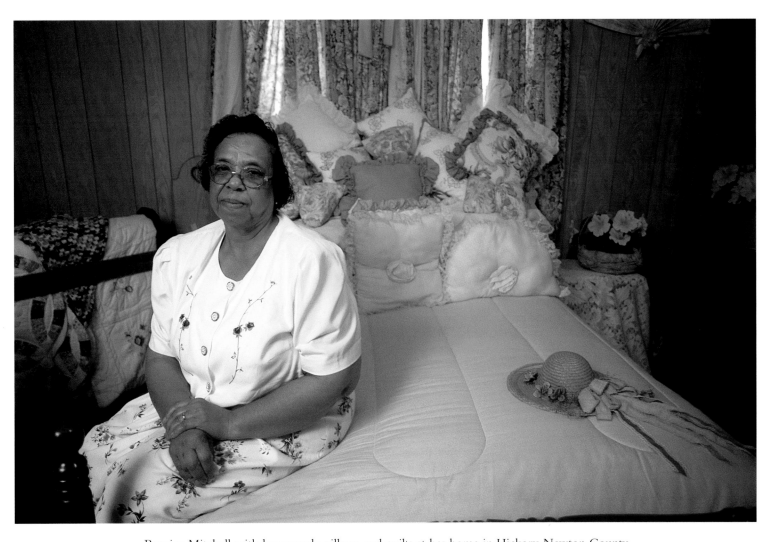

Bernice Mitchell with homemade pillows and quilts at her home in Hickory, Newton County

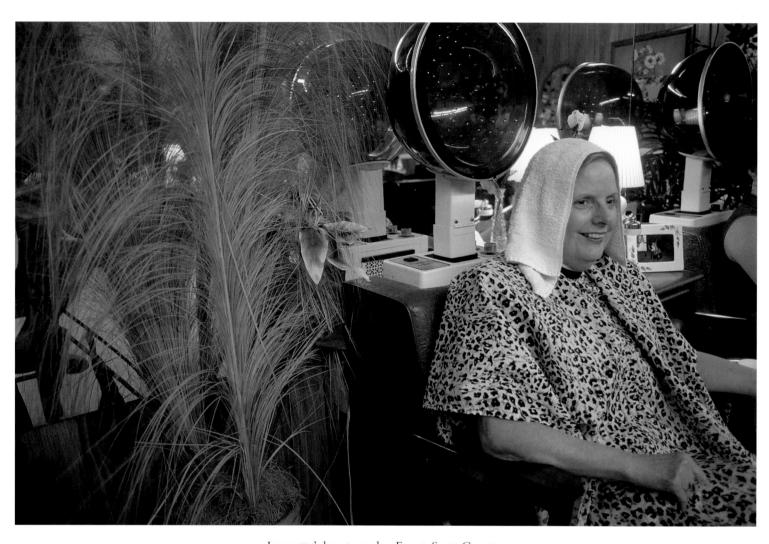

Jeannette's beauty parlor, Forest, Scott County

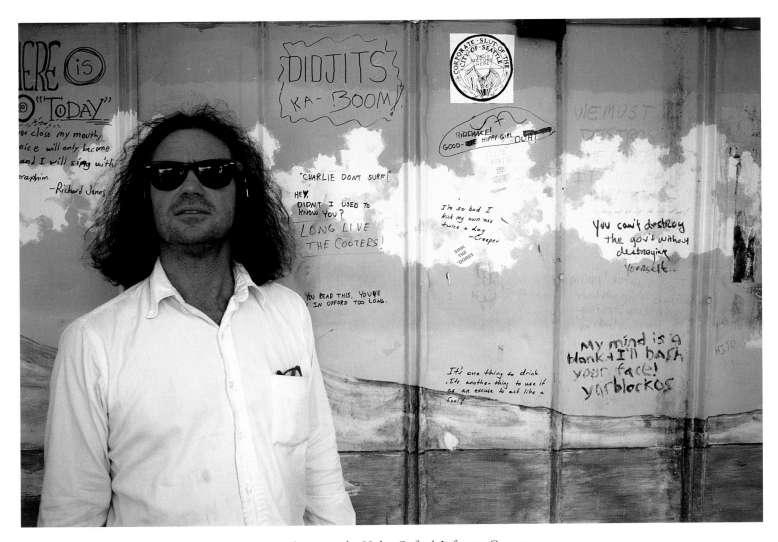

Ron Shapiro at the Hoka, Oxford, Lafayette County

Girls' softball team from Randolph during opening ceremonies of the Mississippi Games, Meridian, Lauderdale County

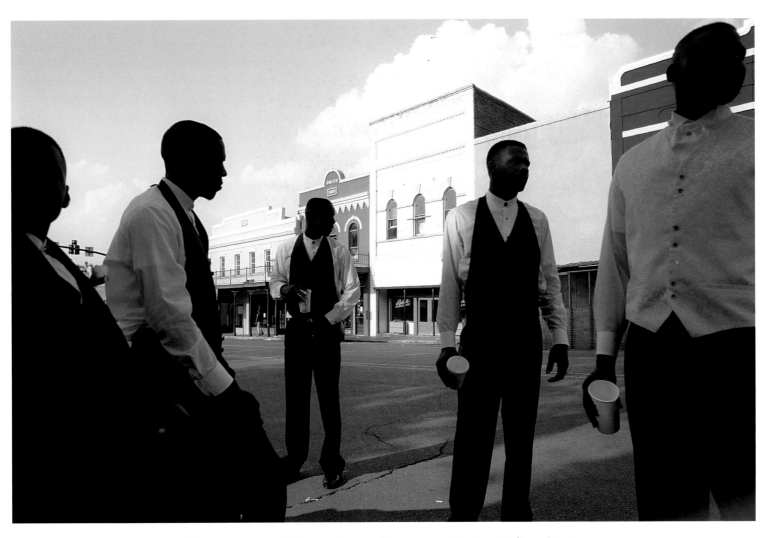

Groomsmen at wedding on the courthouse square, Canton, Madison County

Jill Conner Browne (right) and the Sweet Potato Queens during the annual
Mal's St. Paddy's Day Parade through downtown Jackson, Hinds County

Presentation of the American flag and the singing of the national anthem
during the Confederate Pageant at the Natchez Pilgrimage, Adams County

Local ladies doing their nails before Martin Luther King Day parade, Belzoni, Humphreys County

Contestants for the Miss Catfish crown, Belzoni, Humphreys County

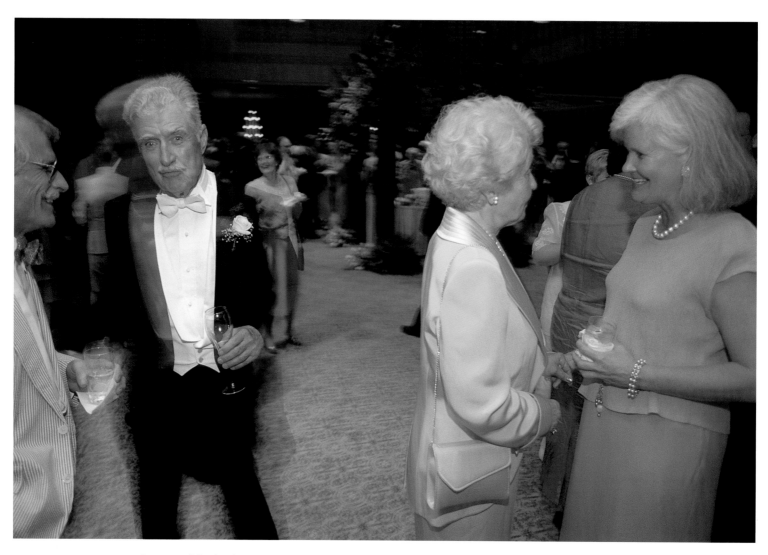

Parents of the bride at wedding reception at the Jackson Country Club, Jackson, Hinds County

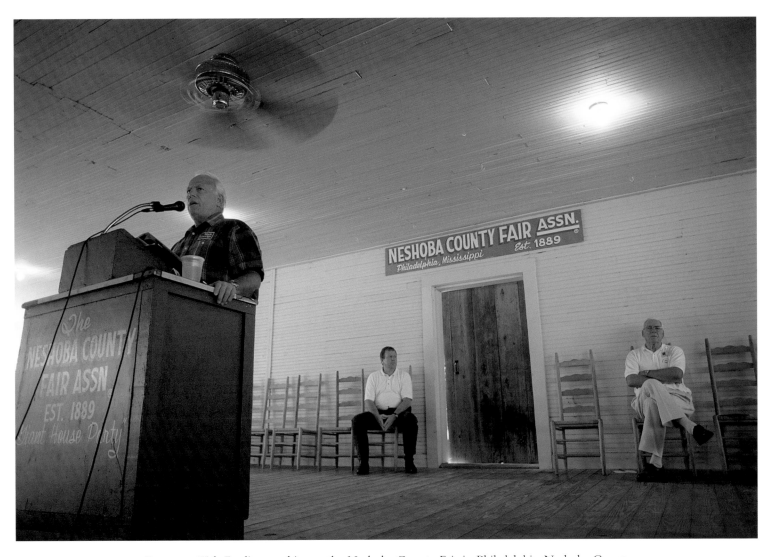

Governor Kirk Fordice speaking at the Neshoba County Fair in Philadelphia, Neshoba County

State capitol building and downtown Jackson from the roof of the Sillers Building, Hinds County

Debate in the state legislature,
Jackson, Hinds County

Portrait of the 1960-64 Mississippi Legislature on the third floor of the state capitol, Jackson, Hinds County

Livestock barn at the Mississippi State Fair, Jackson, Hinds County

Duck blood, Leland, Washington County

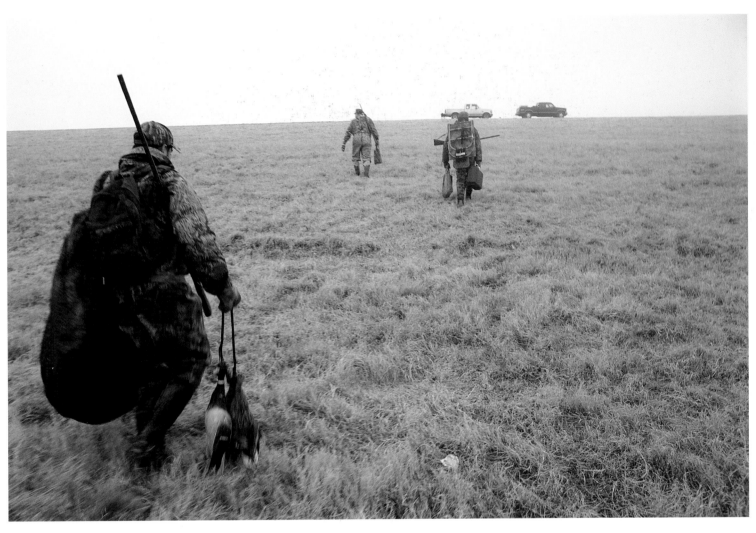

Duck hunters on the levee, returning from a morning hunt, Greenville, Washington County

Oscar Whitfield, Decatur, Newton County

Baptist church, McComb, Pike County

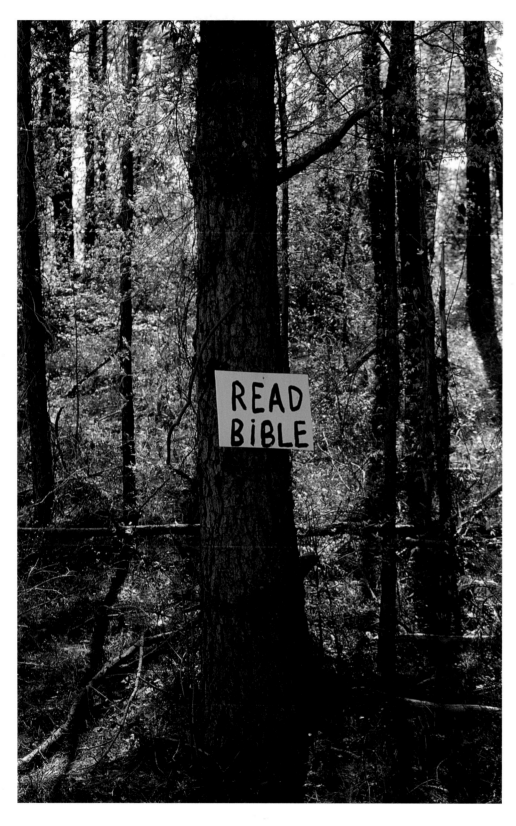

Call to worship, Highway 20 East, Brandon,
Rankin County

Seder at Macy Hart's on Passover, Jackson, Hinds County

Alcorn State University fans celebrating a touchdown against Jackson State University
during the first half of the Capital City Classic, Jackson, Hinds County

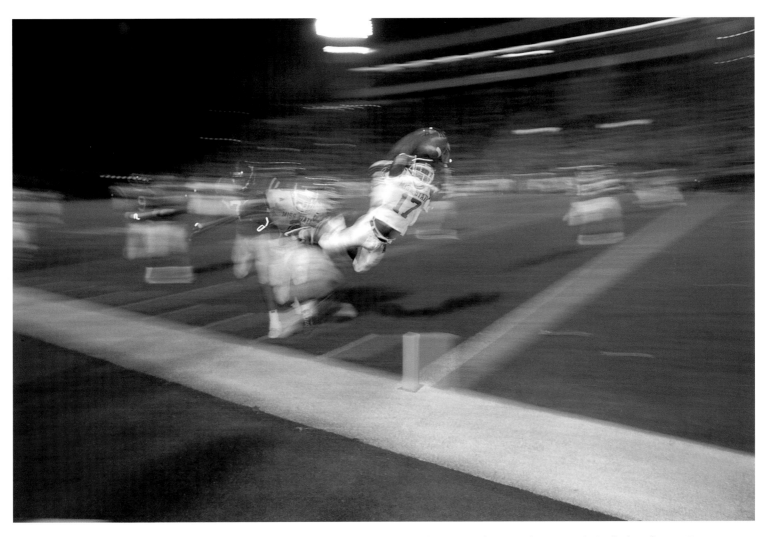

Mississippi State University scoring a fourth-quarter touchdown against Ole Miss in the annual Egg Bowl, Oxford, Lafayette County

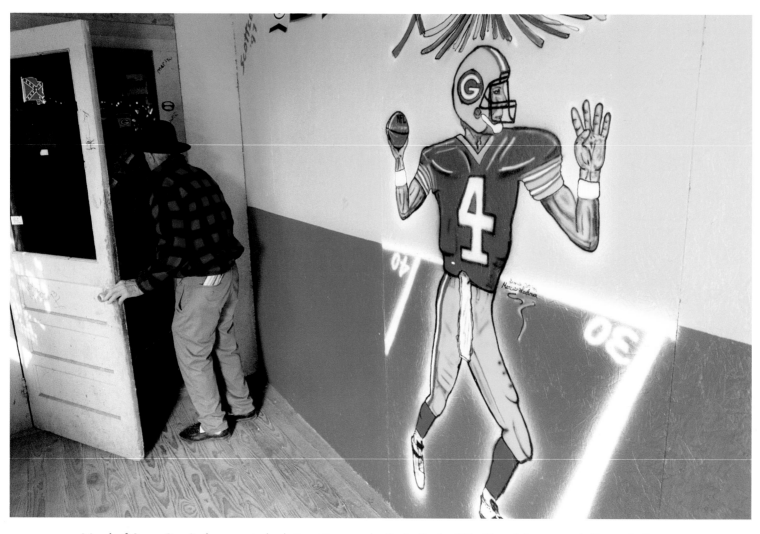

Mural of Green Bay Packers quarterback Brett Favre at the Broke Spoke, Kiln (Favre's hometown), Hancock County

Coronation of Miss Catfish 1999, Belzoni, Humphreys County

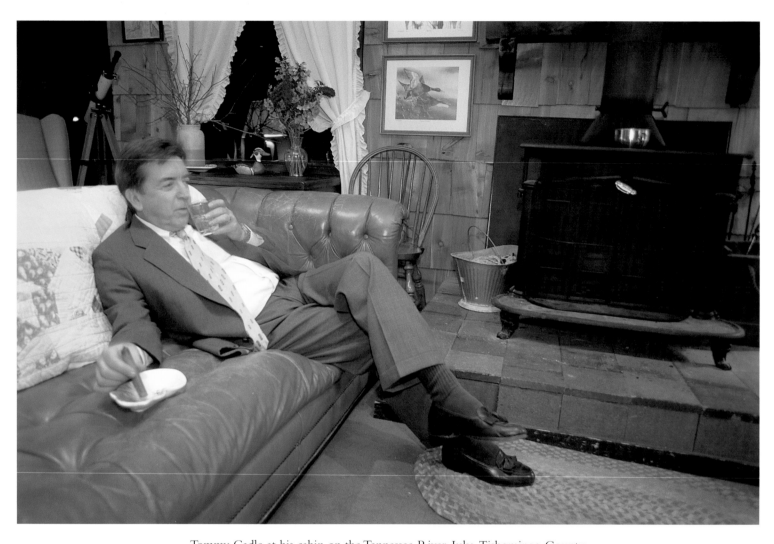

Tommy Cadle at his cabin on the Tennessee River, Iuka, Tishomingo County

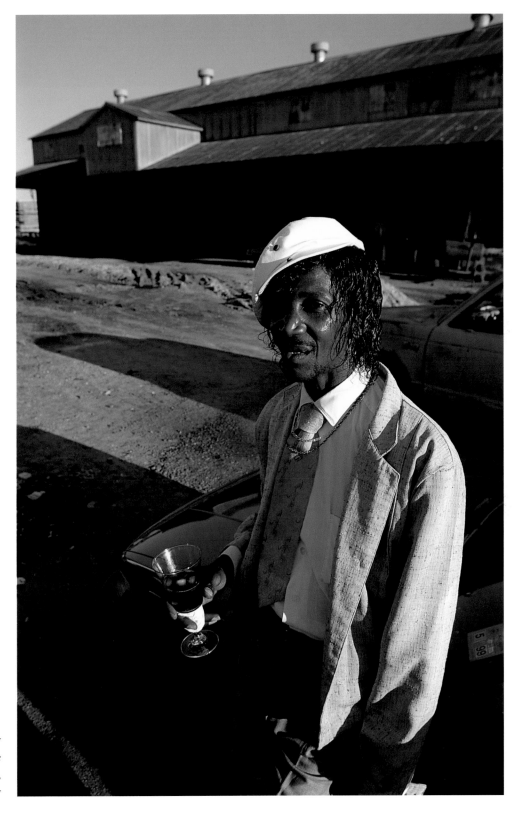

Hanging out on Sunday
afternoon at the Blue
Front Cafe, Bentonia,
Yazoo County

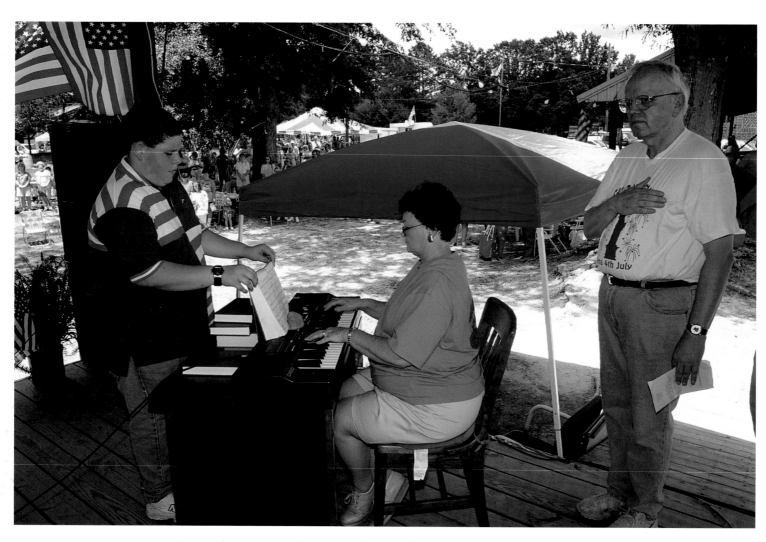

Singing the national anthem during Fourth of July festivities, Lena, Leake County

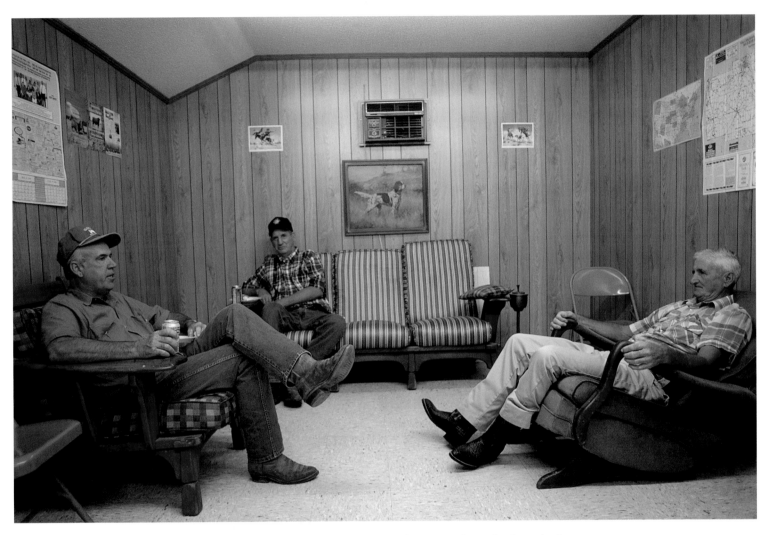

Lunch break at stockyard before the livestock auction, Grenada, Grenada County

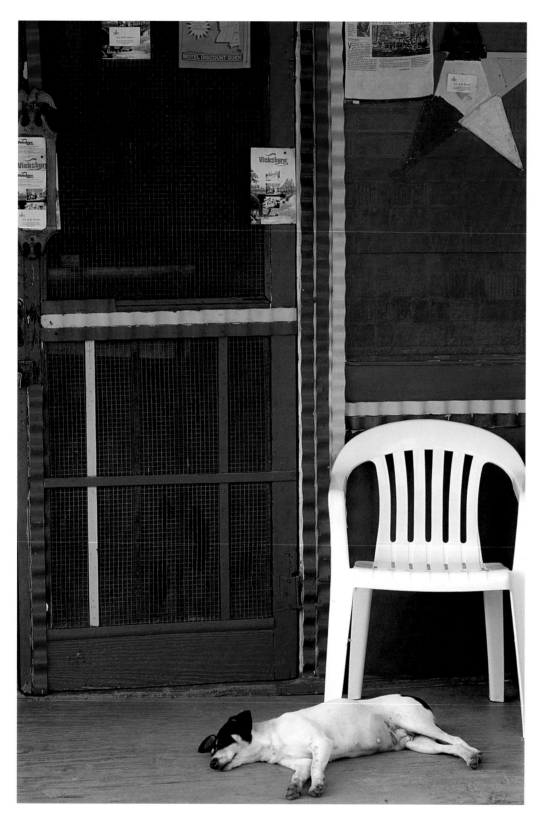

Margaret's Grocery
on U.S. Highway 61,
Vicksburg, Warren County

Lawn display, Ethel, Attala County

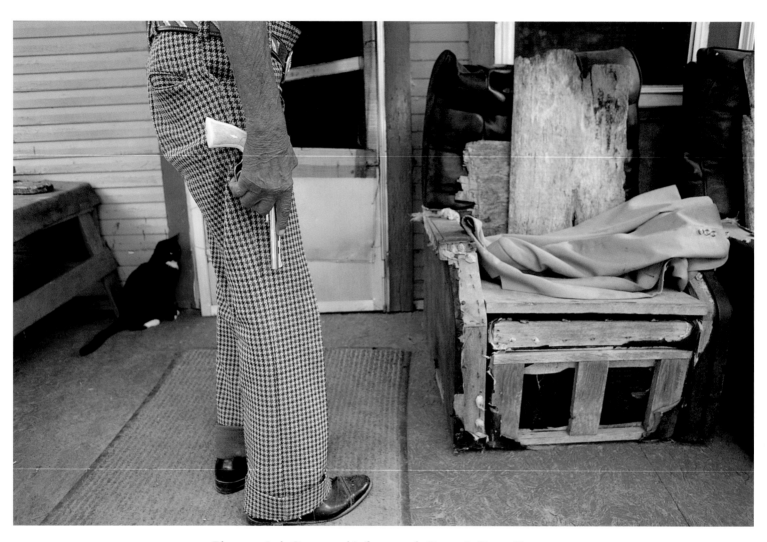

Bluesman Jack Owens on his front porch, Bentonia, Yazoo County

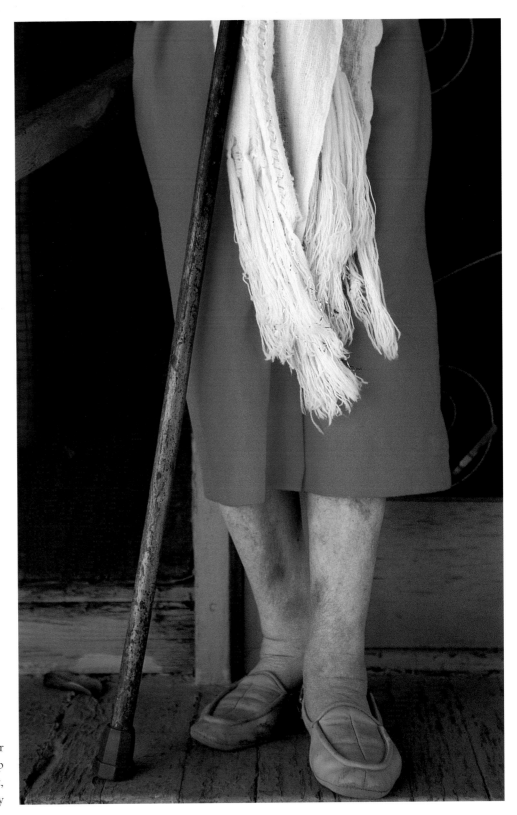

Dr. Jane Ellen McAllister wearing one of her
sister's old dresses on the front stoop
of the old family house on Main Street,
Vicksburg, Warren County

Local musicians in the jam session tent at the first annual Green River Bluegrass Festival, Leakesville, Greene County

The Mississippi Mass Choir performing at gospel festival, Jackson, Hinds County

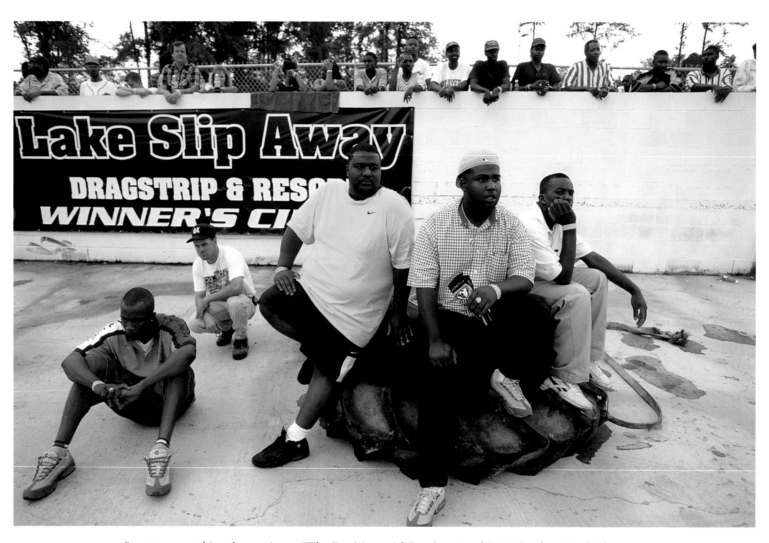

Spectators watching drag racing at "The Pre-Memorial Day Street and Strip Grudge Match Shootout and Bikini Girl Contest for the New Millennium," out from Lena, Attala County

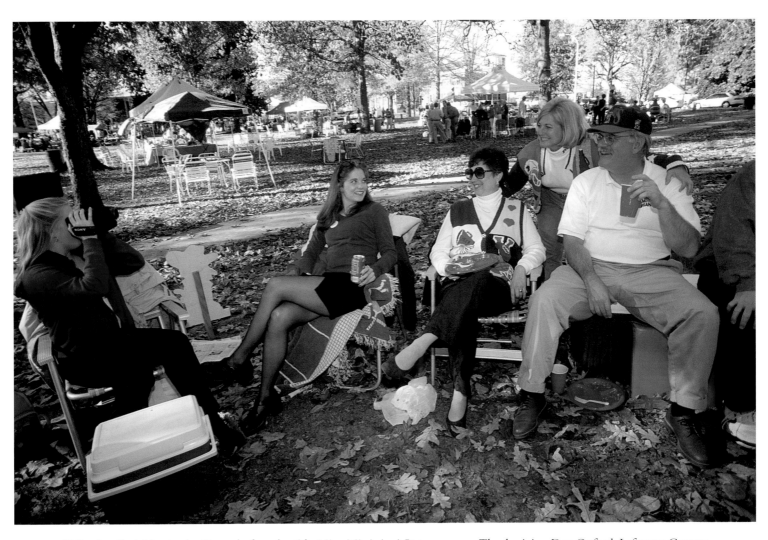

Tailgating festivities in the Grove before the Ole Miss–Mississippi State game on Thanksgiving Day, Oxford, Lafayette County

Jackson State University's Sonic Boom of the South performing at halftime at the Capital City Classic, Jackson, Hinds County

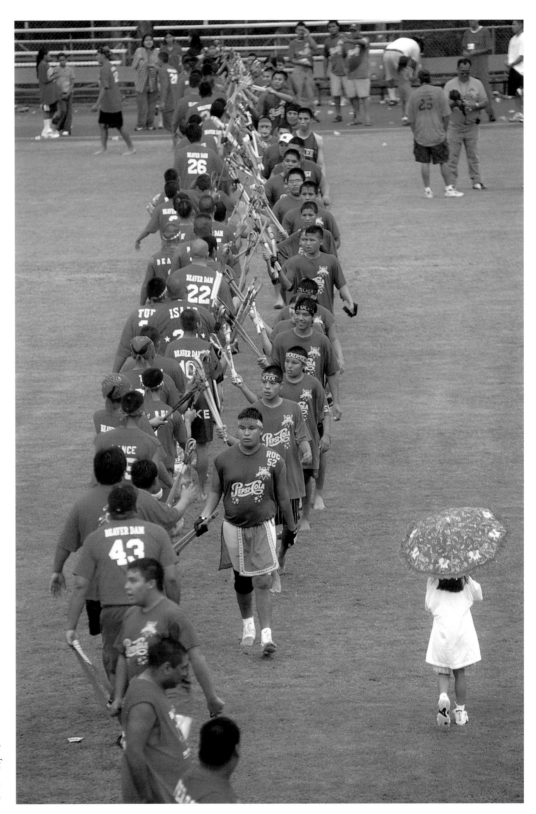

Teams greeting one another after competing in the world series of stickball on the Choctaw reservation, Philadelphia, Neshoba County

Ruby Mitchell on her stoop on Grove
Street overlooking downtown Vicksburg,
Warren County

Cafeteria, Stennis Space Center,
Hancock County

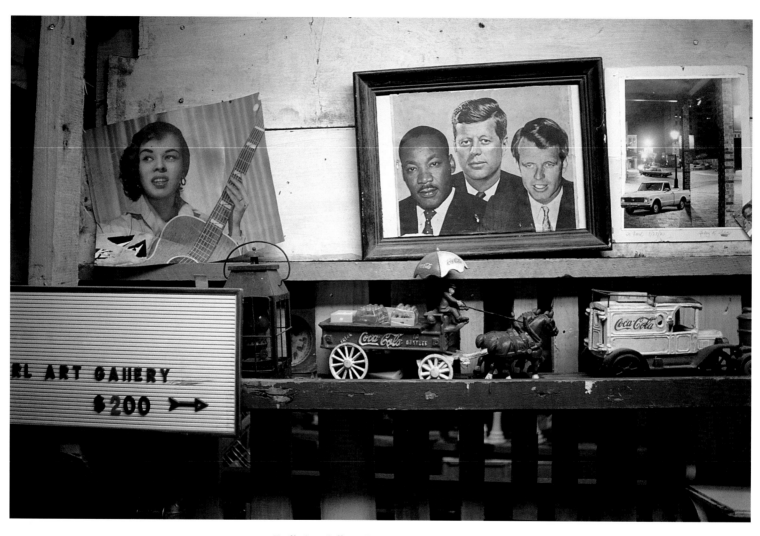

Earl's Art Gallery, Bovina, Warren County

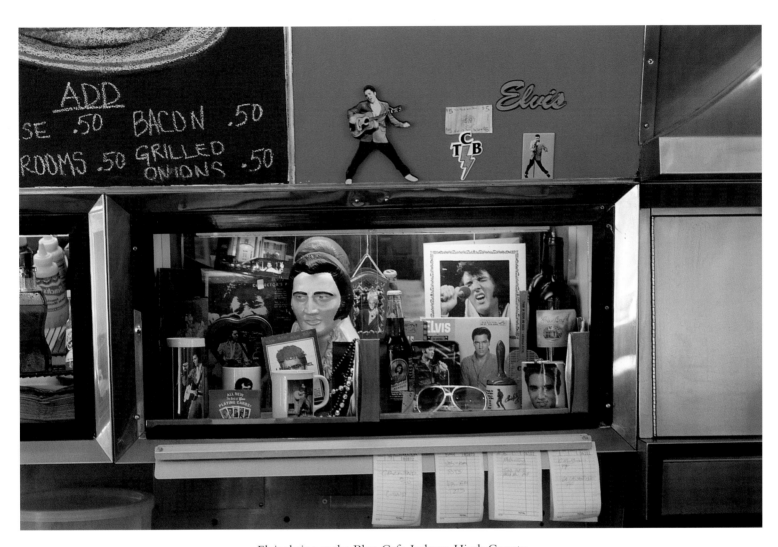

Elvis shrine at the Blue Cafe, Jackson, Hinds County

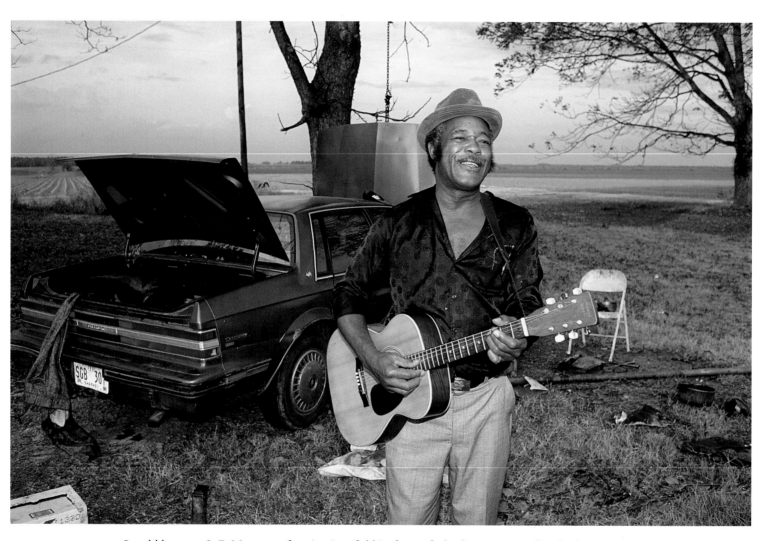

Local bluesman J. C. Moore performing in a field in front of a broken car, Anguilla, Sharkey County

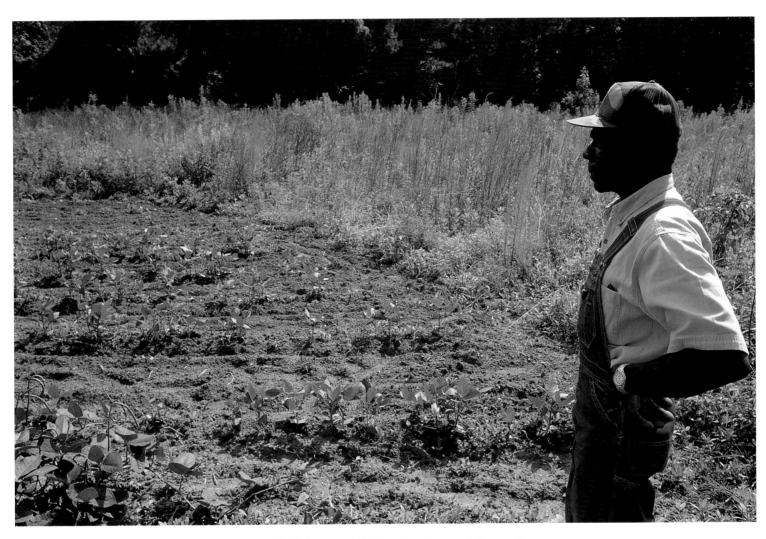

Oscar Whitfield showing off his garden, Decatur, Newton County

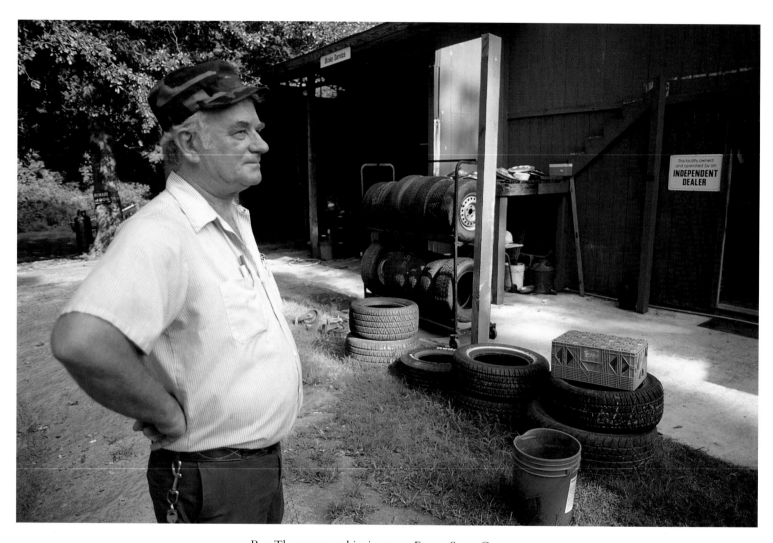

Ray Thompson at his tire store, Forest, Scott County

Sketch artist's booth at the Mize Watermelon Festival, Mize, Smith County

Tour of antebellum home
during Pilgrimage, Natchez,
Adams County

Jeannette's beauty parlor, Forest, Scott County

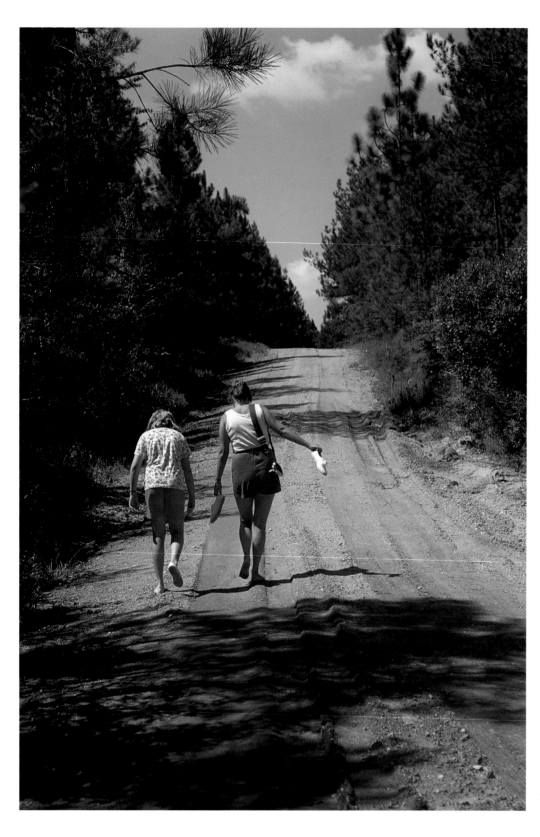

Jennifer and Tammie,
Purvis, Lamar County

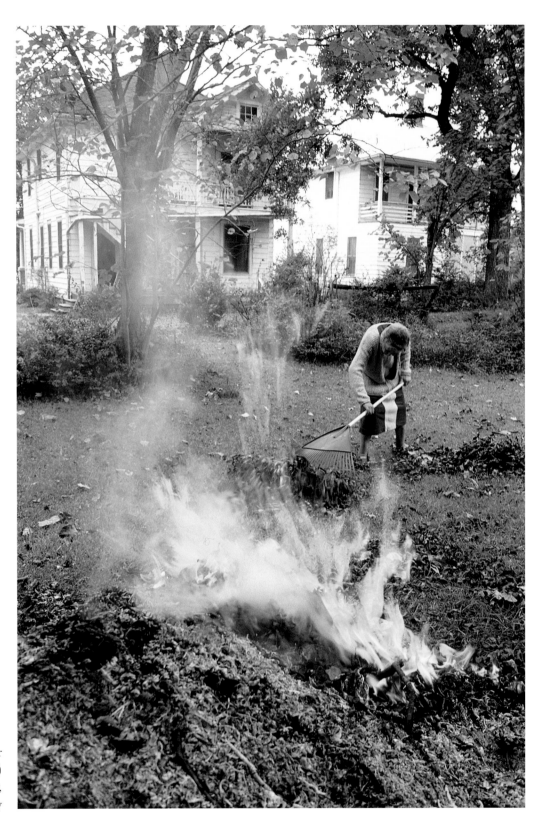

Dr. Jane Ellen McAllister
burning leaves (without a permit)
on her ninety-fourth birthday,
Vicksburg, Warren County

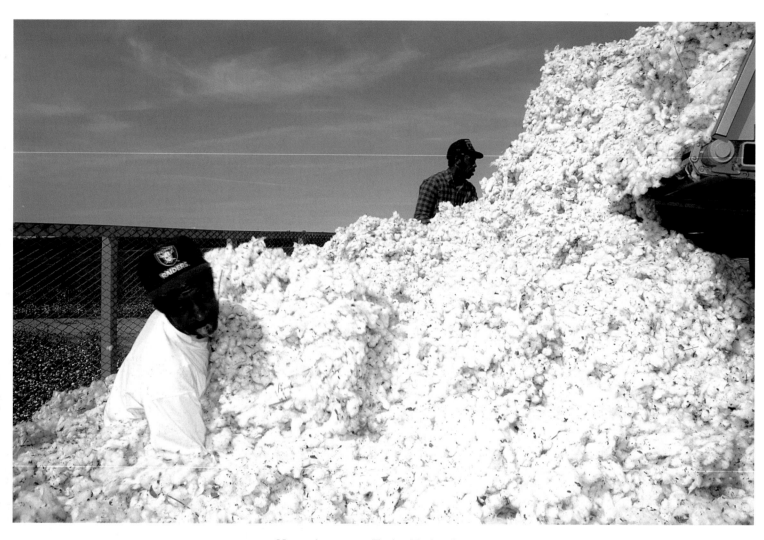

Harvesting cotton, Tunica, Tunica County

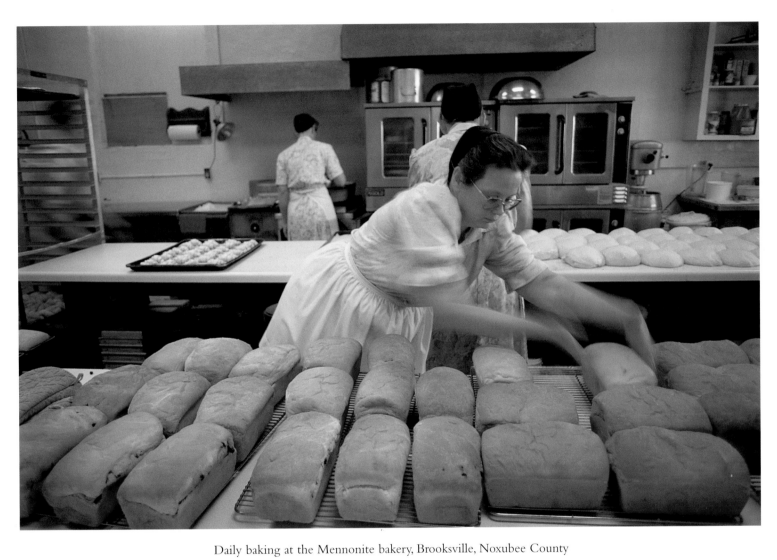

Daily baking at the Mennonite bakery, Brooksville, Noxubee County

Custom bass plant, Peavey Electronics, Meridian, Lauderdale County

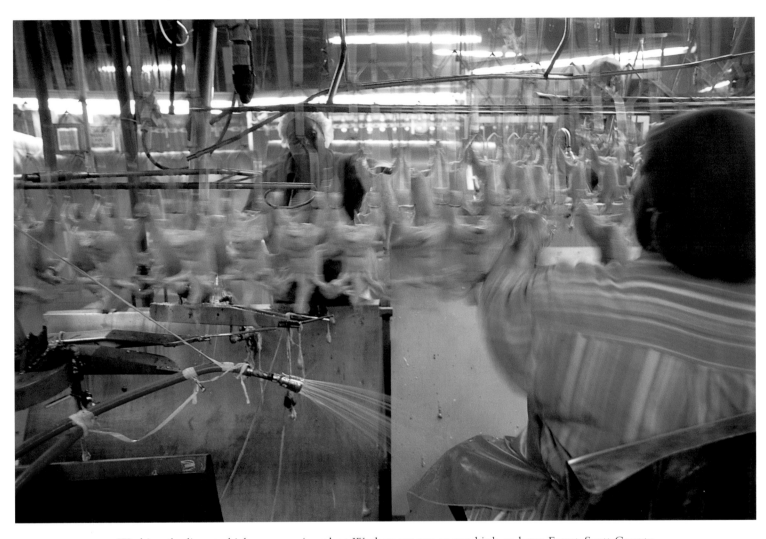

Working the line at chicken processing plant. Workers process 10,000 birds an hour, Forest, Scott County.

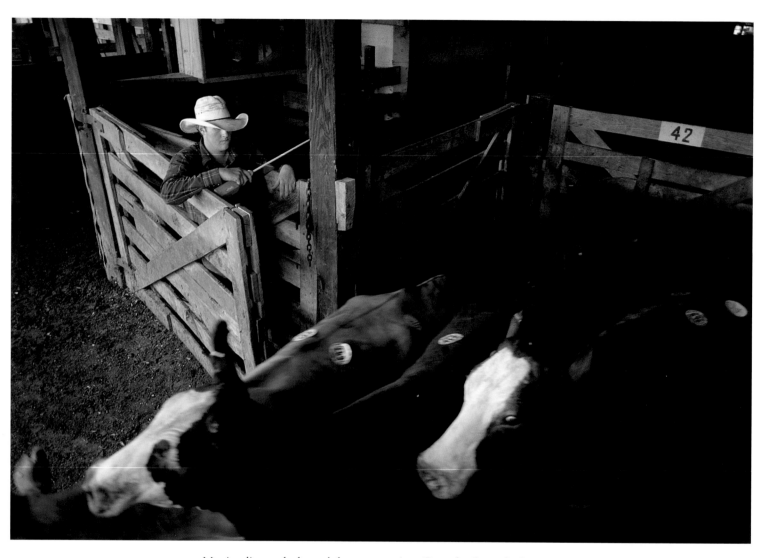

Moving livestock through barn to auction, Grenada, Grenada County

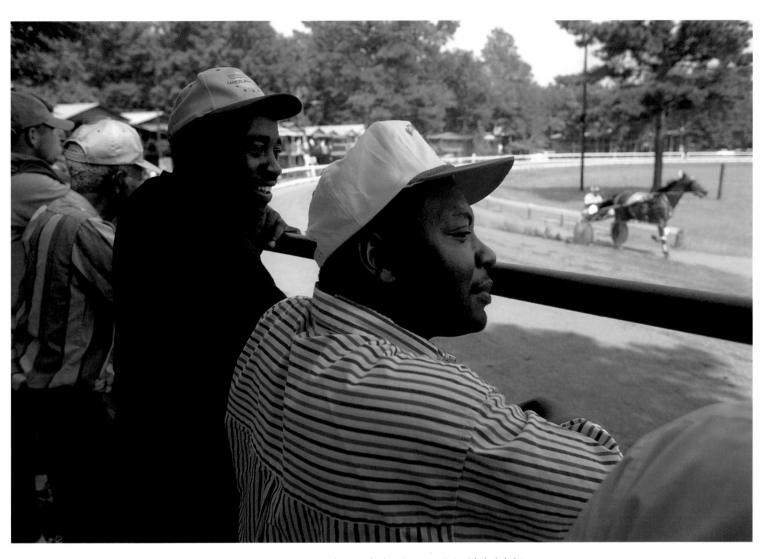

Harness racing at the Neshoba County Fair, Philadelphia

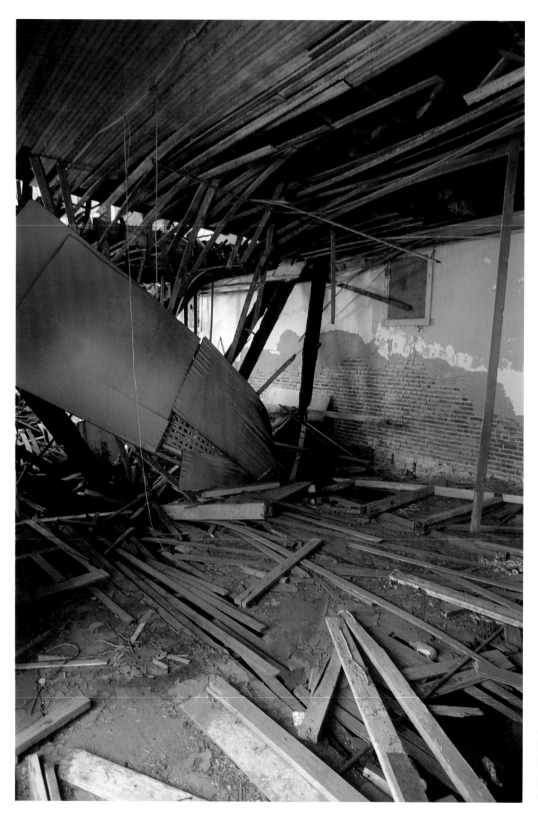

Remains of the old Bryant store where
fourteen-year-old Emmett Till, who was
later shot and dumped in the Sunflower
River, allegedly whistled at a white
woman, Money, Leflore County

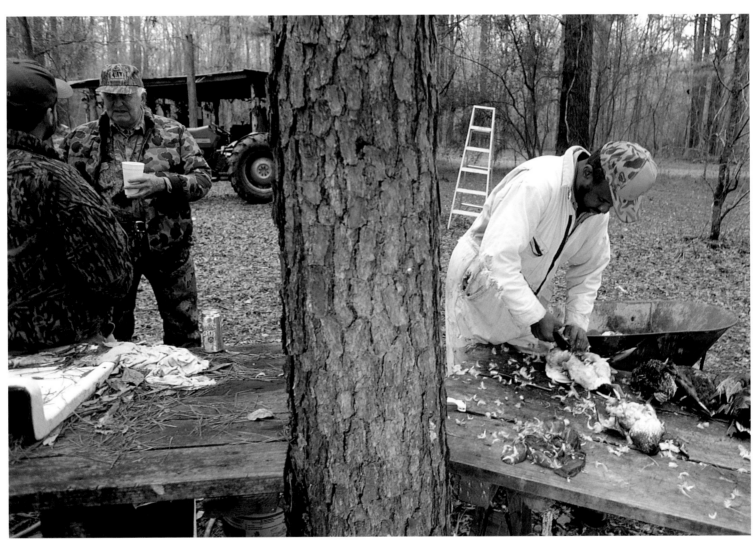

Dressing ducks after a morning hunt, rural Madison County

Playing checkers on Martin Luther King, Jr., Drive, Jackson, Hinds County

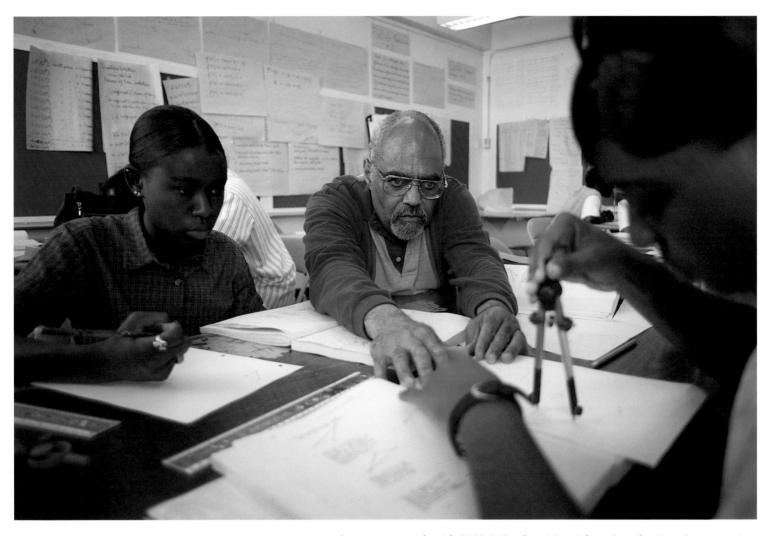

Civil rights activist Bob Moses, who came to Mississippi in the 1960s to work with SNCC (Student Nonviolent Coordinating Committee) and returned later with his Algebra Project, teaching math to students at Lanier High School, Jackson, Hinds County

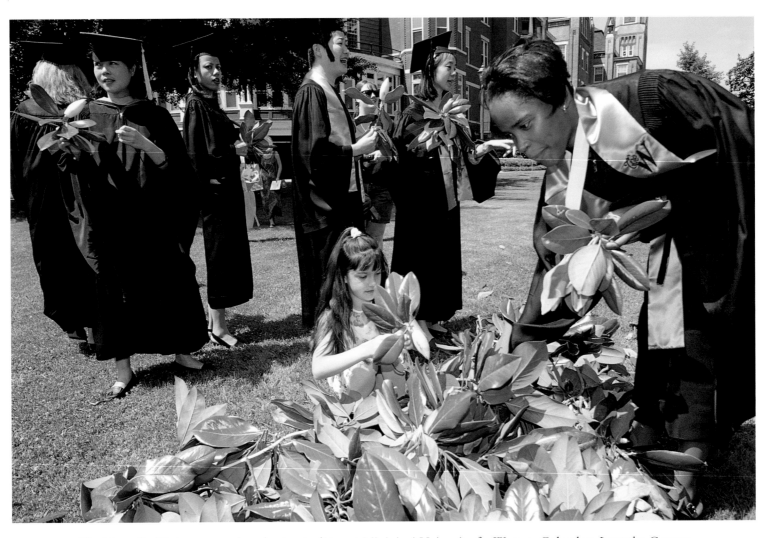

The Magnolia Chain, an annual graduation tradition at Mississippi University for Women, Columbus, Lowndes County

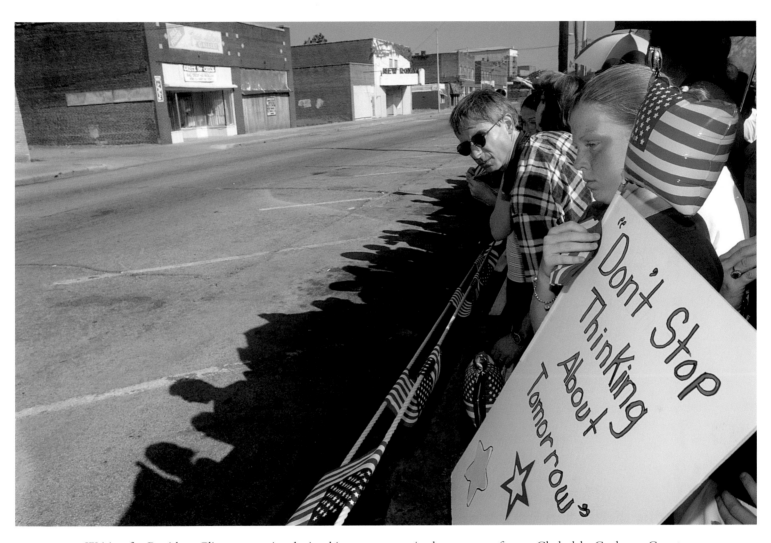

Waiting for President Clinton to arrive during his poverty tour in the summer of 1999, Clarksdale, Coahoma County

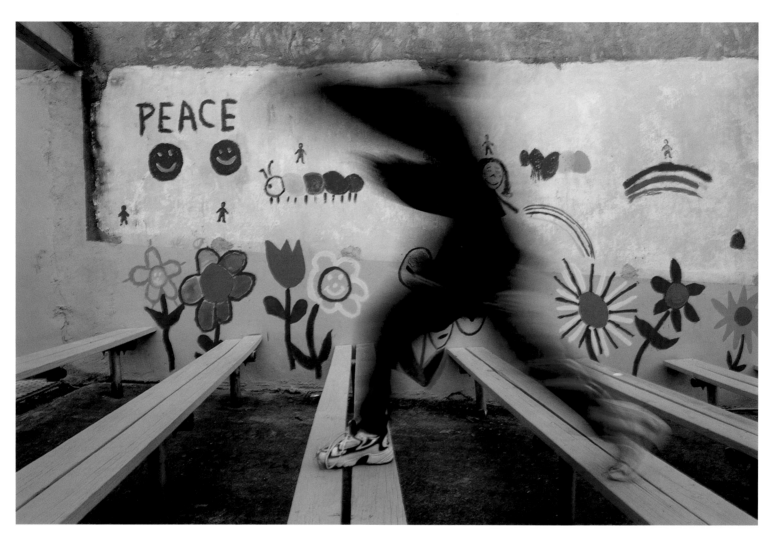

Leaping toward peace, Yazoo City, Yazoo County